basics of DESIGN

layout and typography for beginners
second edition

Lisa Graham

THOMSON
™
DELMAR LEARNING

Australia Canada Mexico Singapore Spain United Kingdom United States

Basics of Design, 2E
Lisa Graham

Vice President, Technology and Trades SBU:
Alar Elken

Editorial Director:
Sandy Clark

Senior Acquisitions Editor:
James Gish

Development Editor:
Jaimie Wetzel

Marketing Director:
Dave Garza

Channel Manager:
William Lawrensen

Marketing Coordinator:
Mark Pierro

Production Director:
Mary Ellen Black

Production Manager:
Larry Main

Production Editor:
Tom Stover

Editorial Assistant:
Niamh Matthews

Cover Design:
Lisa Graham

Library of Congress Cataloging-in-Publication Data:
Graham, Lisa.
 Basics of design / Lisa Graham.-- 2nd ed.
 p. cm.
 Includes index.
 ISBN 978-1-4018-7952-5
 ISBN 1-4018-7952-7

 1. Layout (Printing) 2. Graphic design (Typography) I. Title.
 Z246.G676 2005
 686.2'252--dc22

 2005007133

NOTICE TO THE READER

Publisher does not warrant or guarantee any of the products described herein or perform any independent analysis in connection with any of the product information contained herein. Publisher does not assume, and expressly disclaims, any obligation to obtain and include information other than that provided to it by the manufacturer.

The reader is expressly warned to consider and adopt all safety precautions that might be indicated by the activities herein and to avoid all potential hazards. By following the instructions contained herein, the reader willingly assumes all risks in connection with such instructions.

The publisher makes no representation or warranties of any kind, including but not limited to, the warranties of fitness for particular purpose or merchantability, nor are any such representations implied with respect to the material set forth herein, and the publisher takes no responsibility with respect to such material. The publisher shall not be liable for any special, consequential, or exemplary damages resulting, in whole or part, from the readers' use of, or reliance upon, this material.

Contents

Preface

INTENDED AUDIENCE

This book is for beginning designers from all walks of life. I use the term "beginning designer" to refer to all who are earnestly interested in improving their pages, whether they are students studying design at community colleges and universities or professionals from varied fields trying to create their own pages. This book takes the approach that anyone, regardless of innate "artistic talent," can be taught how to design better pages. Fifteen years of teaching university level graphic design courses have taught me that often the most successful students are not the ones loaded with talent, but instead, those individuals who closely study the design principles and then actively apply them to their own pages. An individual's success in design depends more upon hard work and motivation than exclusively on innate talent.

I wrote this book from my unshakeable belief that design should not be limited to those with elite talent, but that anyone with motivation and a thorough grounding in the design principles can learn how to create great looking pages. Therefore, this book is for anyone who, regardless of formal training or official job titles, needs to create effectively designed and visually well organized pages. These people may already under-

stand that their pages need improvement, but are not quite sure why. This book, through down-to-earth explanations, examples, and exercises covering the basic design and layout principles, will benefit anyone who would like to improve page designs. Some of the people who will gain the most from this book include (but are not limited to) the following:

- Design students studying beginning typography and layout

- Teachers who need to create interesting displays, banners, and handouts for their classes

- Small business owners wanting to design their own logo, business card, and ads for their growing business

- Students who understand that a good paper is one that is both well written and visually well organized

- The secretary who suddenly "inherits" the job of designing newspaper ads for the company

- Professionals of all sorts who must present text, charts, diagrams, sales figures, and other material in formal reports to their bosses or their boss's bosses

- The seasoned professional and the newly-graduated student who want to create a well-laid-out resume

- Anyone else who, with little or no design training, must create easy-to-read, attractive, and well-laid-out designs on paper

BACKGROUND OF THIS TEXT

This book has evolved out of my experiences as a university professor who has taught all levels of graphic design and graphic design technologies. In my many years of teaching I have taught a broad range of art and graphic design concepts and courses: two-dimensional design, papermaking, drawing, color theory, creative design methodologies, traditional and digital illustration, digital art, advertising design, typography, layout, packaging design, portfolio design, print production, publication design, branding design, motion typography, web design, and multimedia. In every course I have found that

students produce the best work if they continually refer to the basic design principles and actively apply them to their own work. Over time I have learned how to present the design principles simply in a way easily grasped by my students: this book is the result.

Basics of Design: Layout and Typography for Beginners, 2nd edition, introduces the basic design principles through textual explanations, visual examples, and hands-on exercises. As a foundation text, it is understood that the reader will have little or no formal background training in design.

TEXTBOOK ORGANIZATION

This book is written with the assumption that you may have limited time to study design in depth but would like to design better pages. With this in mind, the design principles presented in this book are intended to quickly help you improve the design and layout in your pages.

Chapters 1 through 9 explain foundation design principles as well as how to use images, color, and layout to add impact to your designs. To enhance your understanding of the design principles, at the end of each of the principles chapters is an advanced page analysis section. In each one of these sections a "before" page design is analyzed, and its design flaws are corrected in an "after" page design. Arrows with descriptive text point directly to weaknesses and strengths in the designs, allowing you to clearly see what works and what doesn't. This unique feature of the text clearly identifies why a portion of a design is "bad" and why a portion is "good," assisting you to develop a critical eye. Many design texts will show purportedly good and excellent design, but lack explanation of why something is considered bad and how a designer can correct those flaws. Exercises at the end of each chapter reinforce key concepts through hands-on exercises.

Chapters 10 and 11 concentrate on the centuries-old basics of typography and how to identify, select, and apply typography with the goal of enhancing your message. Chapter 12 focuses on a number of common design projects (such as logos, newsletters, and business cards) and contains a brief listing of some of the special considerations involved with each type of design project. The exercises at the end of these chapters provide opportunities for readers to learn

through doing: design is best learned through active participation. The exercises at the end of Chapter 12, with higher-level execution, may yield work that can be incorporated into a design portfolio, including logos, stationery, posters, book jackets, and CD labels. Chapter 13 includes a critique guide intended to help you analyze your own and others' work; a brief discussion of typical design tools and technology; and a list of design books and other resources that you may find useful.

FEATURES

The features in this book have been carefully compiled to provide a comprehensive coverage of essential design principles. The information presented here is intended to quickly boost the reader's knowledge of design. The following list provides some of the salient features of the text:

- Coverage conveys practical, ready-to-use information about basic design principles, without the technical jargon.

- The text is thoughtfully structured to provide an easy-to-understand grounding in graphic design.

- Before and after illustrations show readers how to apply design principles, color, images, and typography to improve their own design works; they also show how they may increase the visual impact of their page design while improving organization and readability.

- Advanced Page Analysis section sharpens analytical skills, assisting readers to identify good and bad applications of the basic design principles.

- Skill building exercises and quizzes at the end of most chapters reinforce crucial design concepts.

- Comprehensive overview of typography terms increases reader awareness of this fundamental building block of the written and electronic page.

- Compact format encourages quick scanning to inform the reader of crucial design information.

NEW TO THIS EDITION

This edition functions as a reading resource for both the beginning designer learning these concepts independently of a structured course and those students enrolled in a focused study of design. New to this edition:

- Expanded, more descriptive captions explain design concepts in practical, down-to-earth terms.

- New exercises added to the end of each chapter allow readers to practice what they just learned. Sprinkled throughout the text are more advanced exercises which, with a little time and effort, may yield a good start on a visual portfolio.

- More than 65 new images, 23 of them color, make this a highly visual text.

- Advanced Page Analysis section visually compares bad versus good design, including explanations that point exactly to the weak visual elements and what corrective steps the designer undertook to make the design stronger.

E.RESOURCE

This guide on CD was developed to assist instructors in planning and implementing their instructional programs. It includes sample syllabi for using this book in either an 11- or 15-week semester. Where available, student examples of project solutions are included. It also provides quizzes and test questions and answers, exercises, instructional handouts, PowerPoint slides highlighting the main topics, and additional instructor resources.

ABOUT THE AUTHOR

Lisa Graham is an Associate Professor and the area head of Graphic Communication in the Department of Art at the University of Texas at Arlington. Her students have won numerous design awards (over 100 between 2001 and 2004) and are employed in advertising and graphic design agencies in Texas and throughout the United States. Lisa has taught electronic design and web design for over 15 years and has

instilled that professional knowledge into her publications. Besides this book, Lisa authored *The Principles of Interactive Design* (Thomson Delmar Learning, 1998). In 2002, the American Institute of Graphic Arts selected her for one of its prestigious Illumina Teacher Awards. Her illustrations have appeared in the MIT publications *Computer Music Journal, Leonardo,* and *Terra Nova.* She has produced graphic designs, illustrations, and informational graphics for clients in the fashion, high-tech, energy, military, and geology industries. New and upcoming research endeavors include articles in gestalt theory, experience design, and green design.

ACKNOWLEDGMENTS

Many thanks to my students who willingly served as guinea pigs by trying out the exercises and projects in this book. Without their interest in this project it would not have progressed as quickly as it did. I am amazed and gratified at how genuinely interested my students were in this project and how open they were to my asking them "What do you think about this...?"

The support of the Thomson Delmar Learning team was critical in the development of this second edition of this text. Thanks to Jim Gish and Jaimie Wetzel for believing in this book and, through their encouragement and support, helping me believe in it too. Also at Thomson Delmar, Larry Main, Tom Stover, and Niamh Matthews all helped with professional guidance at key moments.

Love and many kisses to my wonderfully supportive husband Curt, who only whimpered a little when I told him that I was going to work on a second edition of this book. His upbeat support was crucial as I sat long hours into the night tapping away on my keyboard.

And, as always, thanks to my great parents Don and Mary, who know when to praise and when to apply a swift kick to the pants.

Thomson Delmar Learning and the author would also like to thank the following reviewers for their valuable suggestions and expertise:

Frank Abnet
Graphic Communications Department
Baker College of Owosso
Owosso, Michigan

Rebecca Gallagher
Chair, Digital Media Communications
Katharine Gibbs School
New York, New York

Mary Griffith
Graphic Communications Department
Southeast Technical Institute
Sioux Falls, South Dakota

Therese LeMelle
Visual Communications Department
Katharine Gibbs School
New York, New York

Don Mangione
Chair, Graphics and Web Department
Baker College of Muskegon
Muskegon, Michigan

Phyllis Owens
Computer Graphics Department
Camden County College
Blackwood, New Jersey

Elaine Reeder
Computer Graphics Department
Camden County College
Blackwood, New Jersey

Terry Rydberg
Graphic Communications Department
Waukesha County Technical College
Pewaukee, Wisconsin

Carl Schumann
Visual Communications Department
Katharine Gibbs School
Norwalk, Connecticut

<div align="center">

Lisa Graham
2005

</div>

QUESTIONS AND FEEDBACK

Thomson Delmar Learning and the author welcome your questions and feedback. If you have suggestions that you think others would benefit from, please let us know and we will try to include them in the next edition.

To send us your questions and/or feedback, you can contact the publisher at:

Thomson Delmar Learning
Executive Woods
5 Maxwell Drive
Clifton Park, NY 12065
Attn: Graphic Communications Team
800-998-7498

Or contact the author by e-mail at:
lsergraham@sbcglobal.net

part one

Design & Layout Basics

The first part of this book deals specifically with the basics of page design and layout: what happens before you start to design; identification of the design principles and their impact on a page's layout; the power of color; and discussion of the different types of images and when it is appropriate to use them. To clarify the design principles, I've broken them into separate chapters explaining what they are, how they can improve a page design, and why you should use more than one design principle at a time. In addition, I've sprinkled each chapter with a variety of visual examples to help illustrate the concepts presented.

Keep in mind that even though I've broken the design principles into separate chapters, they are rarely used separately. In selected figures, all of the design principles interacting within a page layout are identified to clarify your understanding of their impact. The power of the design principles to improve a page's layout is magnified when they are thoughtfully combined.

Chapter 1

Before You Begin to Design

OBJECTIVES

- Learn how to define your design project.

- Consider the importance of identifying your audience.

- Appreciate the importance of tailoring your project to appeal to your audience.

- Gain a basic awareness of copywriting and its use in page design.

- Survey design principles to boost understanding.

- Become familiar with the design process.

- Achieve a working familiarity with basic design elements and process terminology.

Many beginners just start to arrange images and text on the page before defining exactly what they want to say. Before you invest your valuable time and effort on a design, it helps to have a purpose and a plan firmly in mind. You will need to know four things before you begin to design:

1. What you want to say (the purpose)

2. Who you want to hear your message (the audience)

3. The kind of page **format** (the size, shape, and function of a page) you want your audience to view your message on

4. A basic knowledge of design principles

Knowing these four things will streamline your design efforts. The faster you can finish one task, the faster you can move on to another project.

DECIDE WHAT YOU WANT TO SAY

Knowing the purpose of a page will help you decide what you want to say and how you want to say it. Ask yourself, what exactly is it that you want to communicate, and what is your intent? Is it to inform, educate, entertain, persuade, sell, direct, provide an experience, or serve as a reference? As you can imagine, the words and images on a page intended to entertain may be quite different from those on a page intended as a reference.

What you want (or need) to say will help you determine how many **visual elements**—the individual elements on the page such as lines, type, and images—you need to arrange in your design. It helps to know exactly what words you want to use on the page to convey your message (Figure 1-1). The amount of those words and

COPY FOR SLEEPY OWL HOLLOW TRAVEL AD

HEADLINE: The Bass Never Sleep at Sleepy Owl Hollow

AD TEXT COPY: Yes, it's true, the bass are always biting in the beautiful
 blue Ozark Mountain lakes. Here at Sleepy Owl Hollow
 Fishing Lodge, we have the most active fish
 alive—they almost jump out of the lake into
 your frying pan. My Great-Granny Hannah eats fresh fish
 every day by simply catching the flying fritters out
 of the air with her fishing net.

 And those are the fast ones. Just think what you
 could do on a sleepy summer day with
 a well-baited line.

 Visit Sleepy Owl Hollow Fishing Lodge.
 We'll tell Great-Granny Hannah to fry you up
 a mess of fish.

CONTACT INFO: Sleepy Owl Hollow Fishing Lodge
 1-555-555-BASS

Figure 1–1 Writing the copy information before trying to design the page will clarify your goals and let you know just how much text you need to work into your design.

Figure 1–2 A suggested motto for design (and maybe even life).

the message will affect how you design your page layout. **Layout** is the design and placement of visual elements on a page. I recommend that you write down, or ask your boss to write down, if he is the one "requesting" the design, the exact words, phrases, or sentences on a sheet of paper before you start to design the project. This way you know exactly what you want and need to say and have concrete goals. If you are not a professional copywriter, I have included in this chapter a few copywriting hints to get you started. Perhaps the best advice, however, is to try to keep the message short and simple. As you might imagine, the more stuff you try to put in your layout, the more complicated the task will be. My personal motto in writing text or designing layouts is "KISS" or Keep It Simple, Stupid (in your case, "Sandy," "Sam," "Sassy," or "Self") (Figure 1-2).

DECIDE WHO YOUR AUDIENCE IS

The more you know about your audience, the better equipped you are to attract their attention and communicate your message. Knowing more about your audience's demographics (age, gender, education, occupation, income, marital status, and so on), will help you target your audience and speak to them in a voice they will understand. For instance, if you are hosting a New Year's Eve party, you would design the invitation one way if the guests were your closest friends (Figure 1-3), and in a totally different way if the guests were your boss, your boss's boss, and the CEO of the company (Figure 1-4).

When you are defining who your audience is and how you can best visually speak to them, try to put yourself in their shoes. Try to design pages that appeal to their "what's in it for me" instincts. If your design has no perceived immediate value or takes a long time to read, your audience may lack the motivation to read your message, and the message will, metaphorically, fall on deaf ears.

TIP

Identifying your audience will help you determine what sort of images and graphics will best appeal to that audience. A target audience of science fiction lovers might find photographs of planets and space technology interesting and appealing, whereas a target audience of avid gardeners might not. Pick your images to both enhance your message and to attract your reader's attention.

Figure 1–3 A playful, informal invitation to a party.

Figure 1–4 Centered alignment and script type convey an impression of sophistication.

PICK A DESIGN FORMAT

Knowing who your audience is will also help you determine the best format in which to communicate with them. The format you choose will influence how much information you should put within the space, as well as the size and shape of the page you will work in. These considerations have obvious implications for how you will place elements on the page, and, therefore, how the final piece will look. For instance, if you have to communicate a message to a large group of people at a public event, a poster or a banner may be a good choice. Because posters or banners are large size formats, they have a lot of space to work within, but because they are meant to be viewed at a distance, all type and images should be very big to be readable from far away. With these formats, large, simple type and images work best (Figure 1-5). In contrast, if you wish to communicate to individuals on a one-by-one basis, you may want to try a newspaper ad, flyer, or some other small format. The physical size of the page is smaller, but because most people view these formats at approximately arm's length, you can place more information within them (Figure 1-6).

These are just a few considerations to keep in mind when designing for certain formats. Part 3 in this book focuses on a number of common design formats. You can glance through that section to quickly gain an understanding of what some of the special considerations are for each format and how these considerations may affect your designs.

6'

▶ **Grand Opening Sale!**

Bargains Galore October 1-31

Figure 1–5 Simple messages and large type work best in banner designs. Try to limit the word count in banners to six words or less.

4"

► ► ►Grand Opening Sale!

A⊕A Supply Solutions
100 Main St. Anytown

Bargains Galore October 1⊝31

Office Supplies ○ Computers ○ Copiers ○ Paper

Figure 1–6 Sample newspaper advertisement. Newspaper ads can contain more information than a banner because they are viewed at a closer distance.

A List of Design Formats

As stated earlier, the term, format, refers to the size, shape, and function of a design. Format is not limited to two-dimensional paper projects exclusively but also applies to three-dimensional and four-dimensional designs such as product designs, box designs, web design, video graphics, multimedia, and so on. The following is a partial list of design formats you might encounter daily:

- business cards, envelopes, letterheads
- newsletters, brochures, magazines
- posters and banners
- CD booklets, DVD packaging, videotape labels

- software manuals, boxes, disk labels

- annual reports, stock reports, financial statements

- book jackets

- desk calendars, wall calendars

- billboards

- souvenir postcards, bumper stickers

- shopping bags, store signs

- sales flyers of all types

- newspaper ads, telephone book ads

- promotional t-shirts, baseball caps

HINTS FOR EFFECTIVE COPYWRITING

Unless you are a professional writer, writing effective copy can be an intimidating task that even professional writers sometimes find scary. The term, **copy**, refers to all the words in a message, including the headlines, subheads, captions, and body text. As with many tasks, the overall project will seem less intimidating if you break it down into several smaller, more achievable steps.

The first step in copywriting is to figure out what you want to accomplish with the copy. Are you selling something? Are you buying something? Are you providing information? Is it an invitation? Is it a call to action? Is it a special fund-raising event? Asking yourself what you hope to accomplish with the message will help you define the project's mission. While you're asking questions, write down all the project goals you can think of. Don't worry about proper grammar at this point: just write down any snippet of information that comes to mind. Try not to edit yourself at this stage—you're brainstorming. For now, just write.

Step 2 involves the making of another list, this time a list of "what's in it for the reader." Readers, in general, are canny folks, who are unlikely to continue reading your message unless you can make it clear how

your message will benefit them. Ask yourself why a reader would be interested in looking at your message. What are the special features in your message? How do they benefit your reader? List the features and benefits of your message even if you know them by heart. Writing down benefits will help you organize your thoughts and further define the project's goals. It's best at this stage to just jot down a features and benefits list without worrying about perfect grammar. You'll edit later. Features and benefits lists don't have to be formal, but don't assume that readers will already know why the special features of your message are important to them. Spell it out. Take a look at the following list for examples of features and benefits.

Feature: We deliver office supplies 24 hours a day.
Benefit: So the reader docsn't have to take the time away from a pressing deadline to run errands for staples.

Feature: We groom your pet(s).
Benefit: So you don't have to chase a soapy Fido around your house because he resents cleanliness and refuses to stay in the bathtub (Figurc 1-7).

Feature: We remove tattoos. No questions asked.
Benefit: Removal of now-inappropriate tattoos. No smarty pants comments or verbal speculation about the circumstances involved in the choice and placement of the tattoo—the ultimate in discretion.

Step 3 in the copywriting process involves organizing your information. Organizing your information will help you focus and gather scattered thoughts into a coherent pattern. A common organizational tool is an outline. Start your outline by gathering together the most

Figure 1-7 Fido avoiding personal cleanliness!

important information from your lists and placing them as headings in an outline. Once you have major headings in place, you can fill in more details, either from your lists or from new ideas that arise naturally during the outline-developing process. Don't get into too much detail, you're only forming the skeleton of your copy—you'll flesh it out in step 4.

In step 4, your main goal is to flesh out your outline. Don't obsess over perfect grammar (yes, you'll eventually focus on grammar in step 6), just write. If you can't think of something to say under a particular outline heading, move on to the next one. It's okay to jump around if you have to. The point of this step is to get some words onto the paper so that later you can have something to work with and to push around. If you find that the outline isn't working quite as well as you'd hoped, don't be afraid to change it. Try to write as you'd speak—write as if you were having a conversation with someone. Formal writing usually just sounds stiff, and unless you're writing for stuffy academic presses, your text will be easier to write and easier for your audience to read if you keep it simple. When writing during this stage, it's okay to at first produce garbage; getting your ideas down in print will help you refine your ideas. A full trashcan isn't necessarily a sign of failure (Figure 1–8). If your trashcan resembles the one on this page, however, find a moment to take out the trash!

After you have fleshed out the details of your outline, then you're ready for step 5—the dreaded editing stage. Reread what you've written, with an eye for clarity, spelling, grammar, and relevance. Whenever possible, cut out any material that is unnecessary, duplicative, or downright irrelevant. Longer does not always mean better. If you are using a word processing program on a computer, make sure to run a spell check and grammar check. Always proofread the copy to catch any mistakes the spell check may not catch, such as the inappropriate use of "their" instead of "there" and so on. If you're not using a computer, try reading your copy into a recorder. Often, hearing your copy helps identify stiff passages or rambling sentences. Whenever possible, put the text down for a day or so before looking at it again. A rested mind often brings fresh perspective to a project.

The primary advantage of juggling the hats of copywriter, editor, and designer is that you have the opportunity to control exactly the elements that go onto your page. You can expand or condense pas-

Figure 1–8 Try out many different design ideas. A full trashcan isn't necessarily a sign of failure!

sages of text to better integrate with graphics. You can set points you think need to be highlighted into bulleted lists to add visual emphasis (Figure 1-9). You can sprinkle in liberal amounts of headings and sub-heads to provide visual interest and to assist the reader in gaining a quick overview of the entire page (Figure 1-10). Writing copy and designing the page are often more difficult than anticipated by begin-ners or even professional writers, for that matter. But along with the hassle of wearing multiple hats is the advantage that you have a lot more control over the final look and feel of the page. You'll be able to better plan the entire project and have the opportunity to massage the message to fit your graphic ideas. A word of warning, however: don't procrastinate. It always takes longer to both write and design than to write or design alone. Waiting until the last minute to write and design will make you crazy!

- **Bulleted lists help readers see important information quickly.** Condense important information into bulleted lists.

- **Bold important information** in bulleted lists.

- **Don't mix bullet characters in the same list** (for example, a check mark with a bullet). Lists with mixed bullet characters often appear unorganized.

Figure 1–9 (Above) Bulleted lists are a great way to emphasize important points. These lists look best when the bullets "hang" to the left of the words. A "hanging" bullet catches the read-er's eye and naturally leads him into the text.

Figure 1–10 (Right) This figure uses a promi-nent head and subheads to help make the docu-ment's structure clear and to add visual interest.

Financial Outlooks

President's Message Lorem ipsum dolor sit amet, con secteteur adipsicing elit, sed diam vulpatate nibh euisnod. Tempor inci dun et labore ut dolors magna ali quam erat volupat. Duis vel autemeum irure dolor in henderit in nonumy velit esse consequat. Vel illum dolor faciseti at vero eos.

Performance Nam eu feugiat mulla liber tempor, cum solutanobis eligent optius, conquenius nibil impe doming id quod. Maxim facer possin diet omnis voluptatias. Plecat possin diet omnis. Lorem ipsum dolor sit amet, con secteteur adipsicing elit, sed diam vulpatate nibh euisnod. Tempor inci dunt et labore ut dolors magna ali quam erat volupat. Duis vel autemeum irure dolor in henderit in nonumy velit esse consequat. Vel illum dolor faciseti at vero eos. Nam eu feugiat mulla liber tempor, cum solutanobis eligent optius, conquenius nibil impe doming id quod. Maxim facer possin diet omnis voluptatias. Plecat possin diet omnis.

Investment Changes Duis vel autemeum irure dolor in henderit in nonumy velit esse consequat. Vel illum dolor faciseti at vero eos. Nam eu feugiat mulla liber tempor, cum solutanobis eligent optius, conquenius nibil impe doming id quod. Temp inci dunt et labore ut dolors magna ali quam erat volupat. Duis vel autemeum irure dolor in henderit in nonumy. Lorem ipsum dolor sit amet, con secteteur adipsicing elit, sed diam vulpatate nibh euisnod.

Financial Statement Plecat possin diet omnis. Maxim facer possin diet omnis voluptatias. Vel illum dolor faciseti at vero eos. Lorem ipsum dolor sit amet, con secteteur adipsicing elit, sed diam vulpatate nibh euisnod. Tempor inci dunt et labore ut dolors magna ali quam erat volupat. Duis

QUICK GUIDE TO DESIGN PRINCIPLES

Streamlining your design effort involves some forethought and planning, as well as an idea of what kind of design principles you may later be able to employ within your layouts. Once you know what the design principles are, and how to apply them, you can consciously use them to improve your designs. Although the next six chapters explain each design principle along with visual examples of how to use them, I will briefly define them here so you can survey them all at one time.

Emphasis

The principle of **emphasis** states that the most important element on the page should be the most prominent, the second most important element should be second to the most prominent, and so on. For example, headline type, as the element that summarizes what the rest of the information is about, is often the biggest and boldest type. Emphasizing the most important elements provides a foundation that you can build the rest of the layout on and is the quickest way to draw attention to your message.

The principle of emphasis works hand in hand with the principle of contrast. The primary focus of emphasis is the intellectual analysis of your message to determine which words and phrases and graphics are the most important and, therefore, should be the most visually prominent. After identification of the important meat of your message, then you'll vigorously apply the principle of contrast to really visually highlight those important words or phrases or graphics.

Contrast

Variety, it has been said, is the spice of life. The principle of **contrast** states that visual elements on a page should look distinctly different from one another. It is used to add visual variety to your layouts and to keep everything on the page from looking alike. Contrast takes up where emphasis leaves off by really stressing the visual difference between words and phrases and graphics.

Balance

The principle of **balance** is concerned with the distribution of visual elements on a page in order to achieve a pleasing and clear layout. The idea behind balance is to avoid clumping elements in one location on the page, which can result in one section of the page looking overloaded or busy. An important component of balance is learning how to group important information together in a logical way. Items that are related should be placed close together. Once you start to group information together, you will need to counterbalance it on another part of the page with another element or group of information.

Alignment

The fastest way to make your pages look organized is to visually connect, to align, elements on the page with other elements on the page. **Alignment** is the visual connection among words, graphics, images, shapes, and lines on a page when their edges or axes line up with each other. You can quickly build the principle of alignment in your pages by lining up, for example, the top of a picture with the top of a headline. Often it is the subtle lack of alignment in a beginner's page that makes the pages seem somewhat disorganized. When beginners start to visually connect elements on the page, the pages suddenly seem much cleaner and organized and have a stronger working balance.

Repetition

Repetition is the principle that states that repeating lines, shapes, images, colors, textures, and other visual elements within a page helps establish a unified, cohesive design. Repetition, if used carefully, also adds a sense of controlled sophistication to the design. Too much repetition, on the other hand, quickly clutters up the page.

Flow

Flow is the visual and verbal path of movement that a viewer's eye follows through a page or sequence of pages. Effective use of the prin-

ciple of flow demands purposeful arrangement of visual elements in the page layout to control the way the viewer's eye scans through the design. Placement of text should take into account that readers in Western cultures tend to read from left to right and top to bottom. Placement of images should take advantage of this tendency. You can use this principle to present information in a controlled order to the viewer.

AN OVERVIEW OF THE DESIGN PROCESS

Although it is beyond the scope of this book to detail the entire design process from first initial idea all the way through a finished piece, Figure 1–11 depicts a lighthearted view of the design process. In all seriousness, professional graphic designers proceed through a number of steps before arriving at a finished design. The first step, after receiving a design project assignment, is to research the problem. The following questions are asked at this stage:

- What are the goals? Are there multiple goals? If so, what is their order of importance?

- Who is the audience? Does the audience have any special interests? What are the audience's demographics (age, sex, income, geographical area, etc.)?

- Are there any limits or constraints on the format, time, and budget?

- What kind of page designs did other people create when presented with a similar problem? Of course, you do not want to plagiarize other people's page designs, but looking at other people's page layouts can help you identify what works and what to avoid in your own work.

The second step in the design process is to generate as many ideas as possible through thumbnail sketches. **Thumbnail** sketches are small, quick, exploratory sketches. They are the visual proof of the thinking and analyzing process. They don't have to be pretty or refined, but they must be legible to someone other than yourself. If they are too rough and look like chicken scratches, your ideas won't come across to your colleagues or your boss. And frankly, who wants to look like all they produce are chicken scratches?

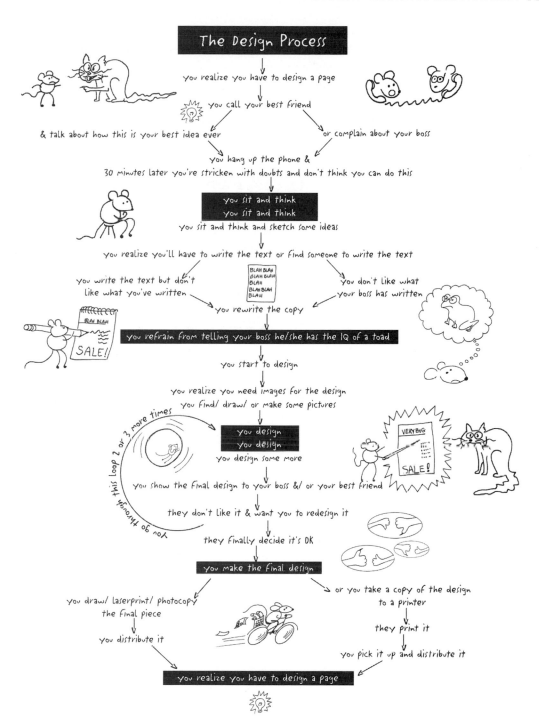

Figure 1–11 A playful peek at the design process.

Once you have a body of thumbnail sketches on the page, you can pick and choose pieces and parts from them, which, if needed, may be recombined into better thumbnails (Figure 1–12).

Many beginner page designers are tempted to shortchange this step, but it is vital for the long-term development of creative muscles. Exerting the mind and exercising creativity are like exercising any

Figure 1–12 Sample thumbnail sketches. They aren't pretty, but they can help you try out lots of different ideas quickly. These were done with a felt-tip marker on the back of waste inkjet printer paper.

muscle in the body. In order to get stronger, faster, and more power-ful, the mind, like the body, must be exercised. Thumbnails are an essential step of the design process: the more you do, the stronger your creativity will become, and the more visually interesting your pages.

The third stage of the design process is to select two or three of the stronger thumbnails and develop them into roughs. A rough is a half-size or full-size version of an original thumbnail, with an eye toward refining the layout, typography, placement, and overall con-cept. The purpose of working up two or three roughs is to provide a small group from which you may select the best visual solution to pro-ceed onto the next stage, the comprehensive.

A **comprehensive**, called simply "comps," is the artwork present-ed to the client for review (Figure 1–13). It is common practice to present several comps to the client for review. There is a designer's version of Murphy's law that might be phrased this way: "The client will always pick the weakest design (i.e., the one you hate)." Avoid this situation by allowing ample time to construct a variety of good comps for the client. Projects usually take longer to complete than you think,

TIP
Eventually if you choose design as your profession, interviewers may want to see a presentation of the complete design process (thumbnails, roughs, and comprehensives) for a project. They are the visual proof of your thinking process and clearly show how much you can "push" a design *and* your own creativity.

Figure I–13 A simple comprehensive. This comp was constructed on a Macintosh computer using Adobe Illustrator and printed to an inkjet printer to show to the client.

whether you are a beginning or an advanced designer. For those designers presenting work to a client for approval, a comp is necessary and must have a high degree of polish.

In the situation where you are the client, you may be able to gloss over this step, instead constructing a full-scale rough to gain adequate insight into the strengths and weaknesses of your design. In the situation, however, where a client must approve a project, the comp must have a high degree of polish—as close to a final printed piece as possible. Graphic designers use a variety of techniques to construct a comp, including photographs, tight drawings and illustrations, silkscreens, computer-generated type, or entirely computer-created designs.

For design students working on class projects, the comp is often the last stage of the design process. For individuals needing to produce multiple copies of a page design, however, the design process continues. Projects requiring a small number of copies, such as a single banner or a few flyers, may be hand drawn, laser printed, photocopied, or printed in full color on a digital printer. Projects that are to be produced in large quantities are best printed commercially, requiring the design be made ready for printing either through construction of camera-ready artwork or prepress digital files.

This is the final, and a very complicated, stage of the design process. There are quite a number of books that detail the techniques of taking projects to press; it is beyond the scope of this book to discuss these techniques. Entire books have been written about preparing projects to go to press through either camera-ready artwork or prepress digital file methods. If you are interested in more information about this step, consult Chapter 13, Tools and Resources, for suggested books.

In general, however, preparing a page design for printing is usually done either through the creation of traditional camera-ready artwork or through the careful preparation of digital files using desktop publishing software. To send a job to press through traditional mechanicals involves converting the design into black and white prints. All of the headlines and copy must be set in the appropriate size and typefaces, and the size and position of photographs and illus-

trations precisely detailed. Type, rule lines, and images all must be exactly placed and pasted in position on the board with no room for error. Ink colors must be specified, and for every color of ink used in the design, a separate overlay must be prepared. This method is used less and less nowadays because it has been largely rendered obsolete by the capabilities of desktop publishing software. Fewer and fewer printing companies support this method. I mention it here mostly for the historical perspective.

The more common method of preparing a page design for press is the creation of digital prepress files. To send a job to press via digital files involves the careful creation of files using desktop publishing and illustration software such as QuarkXPress, Adobe InDesign, Macromedia FreeHand, and Adobe Illustrator (to name a few programs). Digital files must contain images and type precisely placed with all ink colors specified.

It is this point of the design process that the selection of a printer occurs. Projects are often "bid" to two or three printers in order to estimate costs. The final choice of printer, however, should not rest exclusively on the cheapest bid but also on the overall quality and deadline orientation of the printer. Request to view samples of jobs they have printed. Try to pick a printer who will take the time to talk to you—try to establish a working rapport, because printers are excellent sources of practical real-world production knowledge. Pick their brains.

SUMMARY

For the visual beginner, confronting a blank page that you need to fill with your design can be an intimidating task. You can make this task easier and more achievable by planning. Before attempting to fill the page, you need to know what your message is, who your intended audience is, and what format you can use to best reach them, and possess a basic knowledge of the six design principles. The better prepared and knowledgeable you are, the easier it will be for you to create good-looking and easy-to-read pages.

MINI QUIZ #1

The following questions are a mix of short answer and fill-in-the-blank questions. Fill in the blanks with the words in the following list.

formats	thumbnail
roughs	comprehensive or comp

1. Billboards, posters, flyers, store banners, brochures, magazines, and business cards are all examples of different kinds of page _____.

2. List the six design principles.

3. _____ sketches are small, quick exploratory drawings that serve as a fast way to visually record your initial ideas on paper.

4. Designers take the stronger thumbnail sketches and develop them into _____ to better refine the layout, typography, placement, and overall concept.

5. The final polished artwork presented to a client is called a _____.

Chapter 2
Emphasis

- Appreciate the importance of the principle of emphasis.

- Consider the effect of emphasis in a design.

- Comprehend key emphasis techniques.

- Learn what visual hierarchy is and why you should use it to improve your designs.

- Gain familiarity with the use of emphasis through the study of examples in this chapter.

Picture yourself in a lecture class staring at the most notoriously boring professor on campus. As you slump dejectedly in your desk, you listen to the professor drone incessantly on in a nasally monotone. It's not that the subject is uninteresting; it's the delivery. Professor Design's voice never changes, never wavers, never *emotes* as she reads directly and unemotionally from the textbook. Behind the prof's shoulder, the scanty class outline faintly written on the whiteboard with an almost dry marker provides little visual assistance to the lecture. You valiantly attempt to take notes, but since "Professor Design's" flat monotone provides you with zero verbal clues on what is important, you either have to guess what is important, or just give up and write down everything, a clearly impossible task. You'd scream, but you're too dazed. Despite your best efforts to stay respectfully awake, your impossibly

heavy eyelids slide inexorably down across your glazed eyes. Just before you doze off, you sleepily wonder, "When will it ever stop? This is so booorring … zzzzz."

In the classroom, it is a well-known fact: you snooze, you lose. Don't do the same thing to your reader. Presented with a page where everything is the same size, color, and font your readers will, to put it politely, find the page lacking in general appeal. They might even find the page so uninteresting that they simply lay it down without taking the time to puzzle out the important pieces of information. Understanding the importance and uses of the principle of emphasis will help you guard against this lackluster fate.

So, just what is emphasis? As was briefly highlighted in the previous chapter, the principle of **emphasis** states that the most important element on the page should be the most prominent, the second most important element should be secondary in prominence, and so on. Just what you choose to emphasize in your page depends on two major points: the content of the message, and which parts of the message are most important. Effective use of the principle of emphasis begins first with an analysis of your project to determine which words and phrases are the most important. Once you've decided which information is the most important, then you can make it bigger, bolder, or add color. Visual techniques you can use to emphasize information are listed later in this chapter.

Many people find the principles of emphasis and contrast a bit like gum welded onto their shoes. Where one goes, so must the other. They are, indeed, similar in visual effect. What makes them distinctly different principles, however, is that determining what visual elements to emphasize involves intellectual analysis in a) determining what is the most important information and then b) proceeding to visually stress the important information. Contrast, on the other hand, concentrates primarily on developing strong visual differences between visual elements on the page. Emphasis proceeds in a logical manner, where contrast may be more fun and frivolous. They also differ in degrees of visual "oomph." Emphasis is to contrast as a mild green bell pepper is to a hot-as-heck jalapeno pepper (Figure 2-1).

Figure 2–1

WHY USE EMPHASIS?

Using emphasis in your pages simplifies the reader's task and helps her pick out the essentials in your message faster than having to wade through nonemphasized information (Figure 2–2). Too much wading makes some readers give up and go away, and your message won't be received.

An additional benefit to emphasizing elements on your page is that they are more visually interesting to look at. Successful emphasis of an element is achieved by making it look somehow different from the other elements on the page, such as making an emphasized word bigger and/or bolder than unemphasized words.

Equity Income

	1998	1999	2000	2001
Income From Investment Operations:				
Net investment income	0.51	0.56	0.61	0.58
Net realized gains (losses)	1.29	1.89	1.03	2.50
Total from investment operations	1.80	2.45	1.64	3.08
Less Distributions				
Dividends from net investment income	(0.16)	(0.50)	(0.59)	(0.71)
Distributions from net realized gains	(0.04)	(2.41)	(2.22)	(0.51)
Total Distributions	(0.20)	(2.91)	(2.81)	(1.22)

Equity Income

	1998	1999	2000	2001
Investment Operations Income:				
Net investment income	0.51	0.56	0.61	0.58
Net realized gains (losses)	1.29	1.89	1.03	2.50
Total from investment operations	**1.80**	**2.45**	**1.64**	**3.08**
Less Distributions:				
Dividends from net investment income	(0.16)	(0.50)	(0.59)	(0.71)
Distributions from net realized gains	(0.04)	(2.41)	(2.22)	(0.51)
Total Distributions	**(0.20)**	**(2.91)**	**(2.81)**	**(1.22)**

Figure 2–2 Two versions of a portion of a financial report. Both reports contain the same information, yet emphasizing important information by making it bold helps the viewer pick out the information in the bottom report better than in the top, unemphasized report.

Determining the hierarchy and order of emphasis takes some effort, initially, until you become more familiar and skilled with the process, but that time is well invested. The effort invested analyzing the hierarchy is paid back by increased efficiency in designing your pages. You'll also save your reader a bit of time because a page with clear emphasis is easier for the reader to interpret. Knowing what elements need to be emphasized also helps you proceed with your design task with increased confidence and greater efficiency. This sounds simple, but it really helps to know that a newsletter's headlines should be bigger than the article text or that the title of a book is more important than the publisher's name. Or that a photo's caption should be much, much, smaller than the headline. When you don't know what to emphasize, you might end up emphasizing everything. Emphasizing everything and still having it all work together is likely impossible and definitely a time sink (Figure 2–3) for both you and your reader.

Figure 2–3 What is most important on this page? Is it "Tire Sale!" or is it "Big"? When everything is emphasized, then nothing seems very important.

DECIDE WHAT IS MOST IMPORTANT

Almost all pages benefit from the use of emphasis to help structure the visual space and to clarify presentation of the information. But how do you know what to emphasize? Begin by deciding which words or phrases or graphics are the most important. You should also consider what parts of your message might attract the largest amount of your audience. Later, you can emphasize those words or phrases or graphics as a visual hook to draw in your viewers. Once you have decided which visual elements to emphasize, and in which order, then you have developed a visual hierarchy game plan for your page. The term, **visual hicrarchy**, simply rcfcrs to thc arrangement of visual elements such as type and images on the page according to their order of importance and, consequently, emphasis.

Establishing Visual Hierarchy

When analyzing what you should emphasize, ask yourself the following questions:

- What is your primary message?

- Which element best communicates this primary message?

- Is there a secondary message?

- Which element best communicates this secondary message?

- Is there a tertiary message?

- Which element best communicates this tertiary message?

- Which visual element is the most interesting?

- Which visual element is the most likcly to attract or spark the reader's attention?

- Is there a piece of information, which, if unemphasized or unclear, could undermine the usefulness of your message? For instance, if you are designing a charity poster for a play, the location of the play is absolutely critical information; without this information, you may send people roaming the streets searching for the theater.

- What, if any, information can you afford to delete from your page? Simpler is often better: simple designs make it easier for you to establish a clear visual hierarchy. Just because a design is simple doesn't mean it can't also be sophisticated.

Graphic designers use visual hierarchy in their pages to direct the reader's attention to key points, starting with the page's primary focal point. A **focal point** is the visual element or part of a page that is most emphasized and therefore where the reader's eye goes first. Secondary and tertiary focal points are called **accents** because they obviously accent other important points in the page (Figure 2–4). Too many accented words and phrases and graphics cause visual hierarchy problems, clouding your message. If possible, limit the amount of **content** (the words and phrases and graphics) on your pages and keep them as simple as possible. If you have a lot of content to deal with, then pick out only the most important words and graphics and make them the most visually interesting. Emphasize only the most important information.

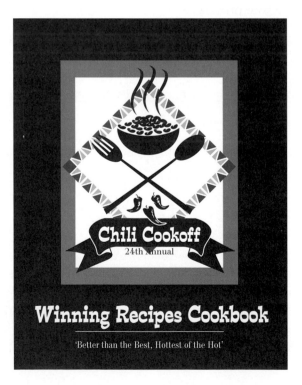

Figure 2–4 The designer of this cookbook cover has deliberately established strong primary, secondary, and tertiary focal points. The logo design is biggest and most prominent and is the primary focal point. "Winning Recipes Cookbook" is second largest and serves as the secondary focal point. The slogan is smallest and is the tertiary focal point. Strong visual hierarchy in a page helps lead the reader's eyes through the information.

Developing Sensitivity to Visual Hierarchy

Look at other people's work as inspiration for improving the visual hierarchy in your own pages. You can become more sensitive to visual hierarchy through intelligent observation. Just ask yourself the following questions when you're looking at other people's pages. What do you look at first? What do you look at second? What do you look at third? Why do you think you looked at these visual elements in this order? What visual techniques did the page designer use to create their visual hierarchy? Was it color, texture, size, visual weight or positioning, or some other technique?

Over time you'll become much more sensitive to design and the use of emphasis in design. You'll likely even find inspiration in the way another designer uses a particular technique to draw attention to important points in their pages and hopefully you'll draw upon that source as inspiration to improve your own work. Don't be shy about asking the first four questions when looking at your own work. Once you become more sensitive to the use of visual hierarchy and emphasis, you'll be better equipped to pinpoint—and improve—emphasis problems in your own pages.

EMPHASIS TECHNIQUES

Professional graphic designers use a number of visual techniques to emphasize key elements and establish a strong visual hierarchy. The following techniques are a partial list. I have found from over a decade of teaching university students that lists rarely limit creative individuals, and they often irrepressibly improvise far beyond the scope of the original list. This list is presented to help jump-start your creativity. Glance over this list, but feel free to experiment and improvise. To emphasize an element you can try:

- Making it the biggest

- Making it the boldest

- Making it the brightest

- Setting type in bold or italic or both

- Adding a special visual effect to the element; for example, adding texture to it (Figure 2–5)

Dry Skin?

Dry Skin?

Figure 2–5 Applying a special effect to a word makes it more visually interesting.

- Placing the element in a shape that is different from the other graphics or text on the page

- Adding a border to the shape around the element

- If an image, silhouetting it (Figure 2–6)

- Changing its color so it is different from other visual elements (Colorplate 1)

- Using a contrasting color in it

- Surrounding the element with lots of white space

- Adding a drop shadow

- Tilting it at an angle when other elements are horizontal

- Making it full intensity when everything around it is faded (Figure 2–7)

Figure 2–6 An example of a silhouetted image (above). Silhouetting the image is not only visually interesting, but in this case, a necessity given the damage to the top and bottom edges of the original image (below).

Figure 2–7 The faded photo in this book cover makes the title block seem more prominent.

- Making it bright if everything else is dull, or vice versa

- Making it sharp if everything else is out of focus, and vice versa

- Positioning the item so all of the other elements lead to or point towards it

- Positioning the item in the optical center of your page (Figure 2-8).

- Combine several of the previously listed emphasis techniques (Figure 2-9).

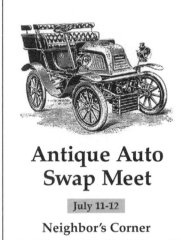

Antique Auto Swap Meet

July 11-12

Neighbor's Corner

Figure 2–8 Placing elements in the optical center of a page emphasizes them. You can find the optical center of a page by dividing the page in half horizontally and vertically; then, using the horizontal line as a guide, move up the page one third of the remaining distance (as seen by the X in the page on the left). The page on the right uses a single large image parked on the optical center for emphasis and increased visibility.

Lightness of Being

a seminar on traveling light.

coming soon.

Figure 2–9 This flyer combines several emphasis techniques: the image is silhouetted, tilted, and has an accompanying drop shadow. These techniques strongly emphasize the visual image itself and the concept of lightness.

Flowers
By Mary

Figure 2–10 Compare the unemphasized original logo (top) with the emphasized reworked logo (bottom). Using the principle of emphasis, as seen in the bottom logo, adds visual interest.

EMPHASIS EXAMPLES

Emphasis Example I

The words at the top in Figure 2–10 are part of a simple, unemphasized logo. All of the words have the same weight and emphasis; consequently, although the logo is very readable, it is also uninteresting. As you can see, a few changes completely alter the emphasis and impact of the logo as seen in the type at the bottom of Figure 2–10. Changing the typefaces dramatically changes the overall impression of the logo. The original logo was plain and boring and seemed a little old-fashioned because of the serif typeface. The calligraphic typeface in the revised logo adds a more personal and artistic touch and reinforces that the business is "by Mary," an individual.

Although picking new typefaces dramatically changed the overall tone of the logo, altering the size of the words in the logo improved the visual hierarchy and emphasis. To emphasize the business's product, "Flowers" is bigger than "by Mary." "Flowers" therefore becomes primary in the visual hierarchy of the logo; "by Mary" is clearly visible and definitely a strong part of the logo, but its smaller size indicates it is less important. "Flowers" is curved slightly to add visual interest as well as harmonize with the curves of the black lozenge shape beneath it. The typeface choice and emphasis in the new logo implies that the business focuses on providing personal service.

An important concept to understand, especially in logo design, is that a well-thought-out emphasis plan can help you influence what people think of first when they see your design. An unemphasized logo comes across as being bland and boring, whereas a well-emphasized logo allows you to visually state the focus and mission of your business. The original "Flowers by Mary" logo implied that the business (and their product) was boring and stodgy. In marked contrast, the reworked logo implies that the business bustles with energy and excitement, and that its proprietor focuses on the personal touch. Do not underestimate the power of emphasis. Even in the shortest phrases, establishing a clear visual hierarchy of information is important and has a dramatic effect on the reader's perception of your design.

Emphasis Example 2

The fictional résumé on the left in Figure 2–11 has emphasis problems that contribute to its overall lackluster impression. Applying emphasis in subtle ways to résumés, reports, flyers, or newsletters often results in a stronger impression and a much more readable page. Résumés in particular should be easy to scan and digest, with concise text and a clear priority of information. They provide the chance for you to show off your design skills: often a one-shot opportunity to describe your work experiences and exhibit your communication design skills on a highly condensed page format.

The résumé on the left in Figure 2-11 seems condensed enough but lacks emphasis and, consequently, is visually uninteresting. In this particular example, the unemphasized headings don't contrast enough with the **body copy** (the small type), and the awkward

Figure 2–11 Applying the principle of emphasis to the résumé on the left resulted in a stronger, more readable résumé as seen in the revised résumé on the right.

Jane Quincy Doe
4300 Sentry Drive
Anytown, IA 50703
(555) 255-5555

Objective

Lorem ipsum dolor sit amet, con secteteur adipsicing elit, sed diama nonnumy eusidnod tempor inci dunt ut labore.

Education

Joetown Technical School, August 1999-present Vel illum dolor eu feugiat mulla facilsi at vero eos. Nam liber tempor cum soluta nobis.

Joetown High School. Graduated in top 10% of class. Special interests in automotive technologies, geography, geometry and related mathematics. Eligent option conque nibil impediet doming id quot maxim plecat facer possum omnis voluptas.

Experience

Work Study Automotive Lab Monitor, August 1999-present. Duties include eligent option conque nibil impediet doming id quot maxim plecat facer possum omnis voluptas.

Joey's Grill, December 1999-August 1999. Nam liber tempor cum soluta nobis.

Skills

Nam liber tempor cum soluta nobis. Lorem ipsum dolor sit amet.

Jane Quincy Doe

4300 Sentry Drive
Anytown, IA 50703
(555) 255-5555

Objective

Lorem ipsum dolor sit amet, con secteteur adipsicing elit, sed diama nonnumy eusidnod tempor inci dunt ut labore.

Education

Joetown Technical School, August 1999-present. Vel illum dolor eu feugiat mulla facilsi at vero eos. Nam liber tempor cum soluta nobis.

Joetown High School. Graduated in top 10% of class. Special interests in automotive technologies, geography, geometry and related mathematics. Eligent option conque nibil impediet doming id quot maxim plecat facer possum omnis voluptas.

Experience

Work Study Automotive Lab Monitor, August 1999-present. Duties include eligent option conque nibil impediet doming id quot maxim plecat facer possum omnis voluptas.

Joey's Grill, December 1999-August 1999. Nam liber tempor cum soluta nobis.

Skills

Nam liber tempor cum soluta nobis. Lorem ipsum dolor sit amet.

double space between the headings and the body copy is too wide. The headings seem to float in this wide white space, unanchored to the body copy they introduce. Removing some white space between the headings and the body copy tightens up the overall appearance of the page and groups the information together visually. This is an important consideration because placing related information next to each other helps the viewer interpret the information not only as a visual group but also as a conceptual group. Furthermore, this page has two major types of alignment present: the centered alignment of the name and address, and the flush left alignment of the rest of the text. In a condensed format such as a résumé, it is best to stick to a single strong alignment. Sticking to a single alignment makes for a cleaner, more organized page, and contributes to the impression that you are in full control of the information on your page.

The revised résumé on the right in Figure 2–11 corrects the major faults of the original résumé on the left. Scooting the name and address over to the left aligned them with the rest of the text, contributing to a unified feel. Increasing the size of the name and setting it in bold makes it more prominent, and therefore more important in the visual hierarchy scheme. The increased size and boldness of the headings make them much easier to see. When headings are emphasized, they become more visually prominent, and this prominence helps the reader quickly scan over the résumé to pick out areas of interest. To further assist the reader, the job titles within the Education and Experience categories were set in bold. Tightening up the spacing between the headings and their body text firmly anchored the headings to their text. Adding rule lines under the headings further emphasizes them, and the repetition of the lines brings a unified order to the page. That the rule lines are all the same length adds to the organized appearance of the page, and helps define a consistent margin space on both the left and the right margins. As you can see by reviewing the total amount of changes between the two versions of the résumé, subtle changes in emphasis have a dramatic effect on the organization and readability of a page.

TIP

Grouping bits of related information together strengthens their conceptual relationship.

TIP

Graphic designers often use rule lines to further emphasize words and phrases and to organize the page layout.

Emphasis Example 3

The family reunion flyer in Figure 2–12 contains only the most essential information, with the possible exception of the "Welcome One and All!" Perhaps because of its simplicity—and that there isn't a scrap of excess information—the page designer has typed all of the text in capital letters. The words are large and centered in the page in an attempt to fill up the page.

A lot of beginner page designers use all capital letters to fill up more space and to emphasize important information, blissfully unaware that long passages of text set in "all caps" letters is visually awkward. **All caps** is designer speak for all capital letters. WORDS SET IN ALL CAPS LETTERS SEEM TO VISUALLY SHOUT. IN GENERAL, READERS FIND READING LINE AFTER LINE OF TEXT SET IN ALL CAPS DIFFICULT TO READ. READING LINE AFTER LINE OF ALL CAPS LETTERS SIGNIFICANTLY SLOWS DOWN READING SPEEDS. Using all caps letters also seems amateurish and naive.

Another problem with this flyer is that the centered alignment is dull. Under most circumstances a centered alignment tends to convey a sense of dignity and formality; however, the visual awkwardness of all capital letters negates that sense of dignity. Between the overwhelming use of all caps, the size of the letters, the centered alignment, and the complete lack of imagery, this flyer seems overwhelmingly amateurish.

Figure 2–13 shows a completely reworked flyer. The title of the family reunion is big, bold, and underlined,

Figure 2–13 The redesigned flyer. Adding pictures and emphasis increases its visual appeal. The viewer is more likely to look at this page, and your message is more likely to be received.

BLAYLOCK-GAINES
FAMILY REUNION

SATURDAY, JULY 3, 1999

9:00 a.m.-3:00 p.m.

DIAMOND CITY SOCIAL CLUB

DIAMOND CITY, ARKANSAS

WELCOME ONE AND ALL!

Figure 2–12 A simple family reunion flyer. It lacks emphasis and, consequently, interest.

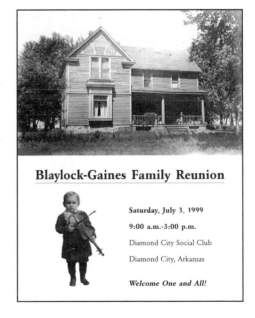

Blaylock-Gaines Family Reunion

Saturday, July 3, 1999
9:00 a.m.-3:00 p.m.
Diamond City Social Club
Diamond City, Arkansas

Welcome One and All!

making it the primary element in the visual hierarchy scheme. The date and time of the reunion are secondary in importance, and although the same size as the rest of the body copy, are set in bold to catch the reader's eye. Together, the boldness of the date and time forms a visual grouping, which is visually counterbalanced by the "Welcome One and All!" Setting the personal message, "Welcome One and All!" in bold italic helps counterbalance the visual weight of the date and time grouping, and reemphasizes the essentially personal nature of the family reunion.

Reducing the size of the type and setting it in upper and lowercase letters leaves plenty of room to add images. A quick scavenger hunt through an older relative's family photo collection produced several usable antique photos. Inclusion of the antique photos lends a nostalgic feeling to the page while showing a bit of the family's history. Because the edges of the little boy's picture were in dire shape, the designer chose to conceal those edges by silhouetting the image, as seen earlier in this chapter in Figure 2–6. The silhouetted edges of the boy's image allows white space to flow virtually unimpeded through the bottom half of the flyer. This feeling of open white space contrasts nicely with the large picture of the house occupying the top half of the flyer. The open white space also draws attention to the simplicity of the copy and, with the changes in typeface, size, and alignment, makes this page design seem much more sophisticated than the original design. Another possible route to take in emphasizing certain parts of your message is to draw on the power of imagery. Adding imagery to this design, as well as adding emphasis to the words, substantially improves its visual interest and appeal. Using images with historical relevance and value to this family enhances the nostalgic and homey feel to this invitation and conceptually enhances the words "Family Reunion."

TOO MUCH OF A GOOD THING

One problem that novices experience when they are first applying the principle of emphasis to their page is that they overuse it. This is actually a common tendency with most of the principles. Very few people are natural designers with an innate mastery of design principles. Most aspiring designers have to learn design as a skill, through practice, practice, and more practice. Learning a skill means that missteps will occur, and mistakes will happen. My advice to you is to accept that becoming a skilled designer takes time and forgive your mistakes while always aspiring to do better. You may be able to avoid some missteps by keeping in mind that it is easy to overuse design principles. Too much of a good thing can ruin a design as quickly as not applying the design principles at all to the page. Keep your message as simple as possible, and avoid emphasizing everything on the page. Restraint is necessary for clear communication.

ADVANCED PAGE ANALYSIS

In each of the design principle chapters there is an advanced page analysis section. The purpose of these analysis pages is to directly point to problems, large and small, in the design of an original page, and then to compare it to an improved design page. Pinpointing exactly where there are design flaws in these pages will help you understand what professional designers look at as they strive to improve a page design. As appropriate, the design principles are discussed in the page analysis. As you progress through the book, and your understanding of the design principles grow, I encourage you to glance back at these pages, and see if there are any other problems (beyond those listed) and note what you might do to correct those flaws. You'll find that as you study the book, your own critical analysis skills will sharpen.

ADVANCED PAGE ANALYSIS Emphasis

In this advanced page analysis, compare Figure 2–14 (the before page design) with Figure 2–15 (the after page design).

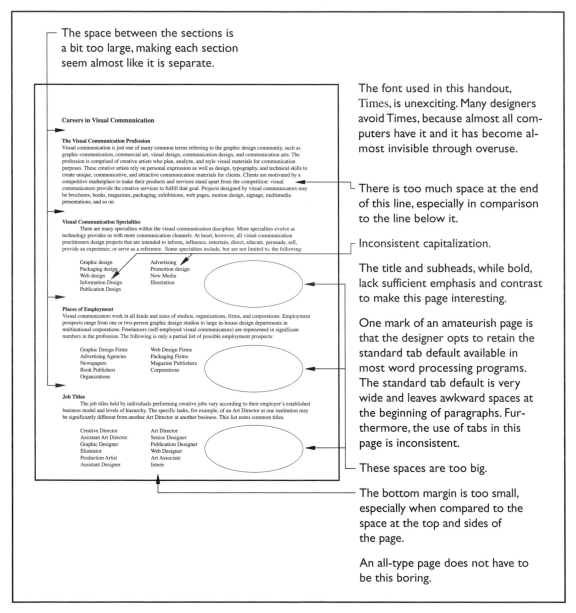

The space between the sections is a bit too large, making each section seem almost like it is separate.

The font used in this handout, Times, is unexciting. Many designers avoid Times, because almost all computers have it and it has become almost invisible through overuse.

There is too much space at the end of this line, especially in comparison to the line below it.

Inconsistent capitalization.

The title and subheads, while bold, lack sufficient emphasis and contrast to make this page interesting.

One mark of an amateurish page is that the designer opts to retain the standard tab default available in most word processing programs. The standard tab default is very wide and leaves awkward spaces at the beginning of paragraphs. Furthermore, the use of tabs in this page is inconsistent.

These spaces are too big.

The bottom margin is too small, especially when compared to the space at the top and sides of the page.

An all-type page does not have to be this boring.

Figure 2-14 The before page design.

The designer chose **Myriad Bold Condensed** for headline and subheads, and Baskerville for headline and body copy. The unfussy, thick letterforms of Myriad Bold Condensed have a modern, friendly look, because they have soft, rounded curves (e.g., in the a, e, and s). The more traditional letterforms of Baskerville (a type classic), also have soft, rounded curves, and are easy to read in body copy. The combination of modern and traditional letterforms implies that a career in visual communications promises both modernity and substance.

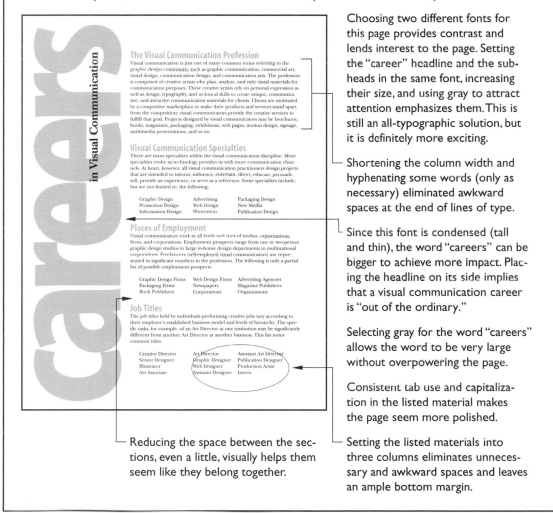

Choosing two different fonts for this page provides contrast and lends interest to the page. Setting the "career" headline and the sub-heads in the same font, increasing their size, and using gray to attract attention emphasizes them. This is still an all-typographic solution, but it is definitely more exciting.

Shortening the column width and hyphenating some words (only as necessary) eliminated awkward spaces at the end of lines of type.

Since this font is condensed (tall and thin), the word "careers" can be bigger to achieve more impact. Placing the headline on its side implies that a visual communication career is "out of the ordinary."

Selecting gray for the word "careers" allows the word to be very large without overpowering the page.

Consistent tab use and capitalization in the listed material makes the page seem more polished.

Reducing the space between the sections, even a little, visually helps them seem like they belong together.

Setting the listed materials into three columns eliminates unnecessary and awkward spaces and leaves an ample bottom margin.

Figure 2-15 The after page design.

SUMMARY

To briefly recap this chapter, the essence of the principle of emphasis is deciding which pieces of information are the most important in your message, and making them most prominent. If you have more than one vital piece of information, you'll need to establish a visual hierarchy plan on your page, determining which element is first in importance, second in importance, third in importance, and so on, and visually emphasizing them to reinforce that order. The advantage of using emphasis in page designs is that critical information is more prominent, which makes it easier for the quickly scanning reader to pick out vital information from the body of the design. The easier you make it for your readers, the more likely they will receive—or at least glance at—your message.

MINI QUIZ #2

The following questions are a mix of short answer and fill-in-the-blank questions. Fill in the blanks with the words in the following list.

accents

emphasis

visual hierarchy

1. Using the principle of _____ simplifies the reader's task and helps him or her pick out the most important points of information in your message.

2. Arranging the headlines and graphics and words in the layout in order of their importance establishes a _____ _____ on the page.

3. What is a focal point and why is it important?

4. Secondary and tertiary focal points are called _____ because they highlight other important information on the page.

5. Which visual elements you emphasize in a design, and how you emphasize them, influence your reader's perceptions about the design. Which of the two type designs in Figure 2–16 has a playful look? Which one looks stodgy and old-fashioned? Why?

Vacation in the
Great Outdoors

Vacation
in the
Great Outdoors

Figure 2–16

EXERCISES

The exercises in this chapter and subsequent principles chapters are intended to sharpen your understanding of the design principles. As you do these exercises, keep in mind that in design there is no right or wrong answer, just better or worse solutions. It's okay to try out different solutions to the exercises and then gather them together so that you can review them with a critical eye. Try to spot their strengths and weaknesses in your solutions. If you find this difficult, ask a friend to review them for a second opinion. They may spot something you don't see. Also, consult the critique guide in Chapter 13 for a list of questions that you can ask while looking at your design solutions.

Exercise 1

Redesign the table of contents in Figure 2–17 on a computer, using the principle of emphasis. All of the type are the same size, which, unfortunately, does not reflect the three different levels of type hierarchy on this page. "Contents" should be most important and the most prominent, chapter headers are second in importance and should be second most prominent, and then the subheads. You can enhance the emphasis of some of the words by making some elements bigger and bolder, or adding color. Other possible ways you can emphasize the importance of the words is to draw in rule lines or place type in rectangles.

Contents	
Introduction	2
Wildflowers	6
Cone Flowers	8
Bluebonnets	12
Rose Bushes	16
Antique Roses	17
Hybrid Roses	24
Decorative Grasses	32
Pampas	33
Fountain Grass	36

Figure 2–17

Exercise 2

Using the same techniques as in exercise 1, redesign the text portion of the newspaper ad in Figure 2–18. This time, write down a listing of which elements are first, second, third, and so on, in the visual hierarchy. Visually emphasize these elements according to their placement in your list.

Figure 2–18

Business Loans Can Help You Succeed!

Funds Available For:
• small business startup
• inventory and equipment
• working capital

Small Business Loan Program
Contact Rey Garcia at 555-5155

Exercise 3

Select one of your own favorite magazines and choose a page that you believe exhibits good use of the principle of emphasis (please don't deface a book). Neatly cut the page out of the magazine (or photocopy it), and with a pen or pencil, circle the items on the page that you think use the principle of emphasis well. Write a sentence or two for each item (or group of items) that explain why you think this is a good use of the principle of emphasis.

Exercise 4

Pick your favorite music artist or group and design a ticket for one of their concerts (Colorplate 2). The venue may be large or small, local or international. Try to express its style through your typographic and/or image choice, emphasizing what you believe is important, whether it is the name, the style, or the venue. Size is of your choice. Don't artificially limit your perception of "ticket" by using a small size. Use whatever medium best expresses your idea, whether it is charcoal, photocopies, paint, or computer imagery.

Figure 3–1

Chapter 3

Contrast

Figure 3–2

OBJECTIVES

- Appreciate the importance of the principle of contrast.

- Understand the effect of contrast in a design.

- Learn key contrast techniques.

- Understand and gain ideas for useful application of the principle of contrast through the study of examples in this chapter.

Imagine what it would be like to eat plain oatmeal for every meal for a week. Really imagine the congealed, lumpy soggy grain taste in your mouth; the slimy feeling as the cereal slides down your throat; the leaden lump resting in your stomach. How would you feel after a week—21 meals—of plain, unsalted, soggy oatmeal (Figure 3-1)? A little bored (perhaps even nauseated)? Ready for something different?

Now imagine how a reader might feel looking at a page where every visual element on the page looks very similar to each other; type is all one size; images are all one size; lines are all one width. True, simply looking at a page may not inspire the same degree of nausea as eating 21 meals of oatmeal, but, as it has been said, variety is the spice of life. Just like you might long for chocolate chip ice cream after a week of slimy, lumpy cereal, so might your reader long for a visual treat (Figure 3-2).

David M. Ceja

WHY USE CONTRAST?

The principle of contrast is one of the easiest, quickest ways to give your reader a visual treat and to draw attention to the page. The principle of contrast is used hand in hand with the principle of emphasis to keep elements on the page from looking too much alike, and to pick up where the principle of emphasis stops on visually organizing the page. When everything on a page looks alike because of a lack of emphasis and contrast, the page seems bland, boring, and lacks a clear organizational scheme. After all, when everything looks about the same in importance, how would the viewer know which element is the most important? How would he know what to look at first?

You can test this out on yourself by looking at the page on the left in Figure 3–3. Do you know which of these squares is the most important square? Do you know which one you should look at first? All of the elements on this page are the same size and look like they are equally important. The page lacks contrast, and there is no one element that serves as its focal point. Without a focal point, viewers lack clues about where they should be looking first, and may miss the full message. In comparison, adding three hollow circles in the middle

 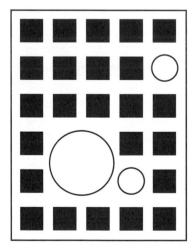

Figure 3–3 The page on the left lacks contrast and, combined with a lack of alignment, consequently seems disorganized and messy. Adding contrast, as seen in the middle and right pages, makes a page more interesting, with the circles becoming the focal point.

image provides contrast, and the circles become the visual focal point of the page. Because they catch the viewer's eye, they seem most important and the page appears planned and organized. Now take a look at the image on the right, where the exaggerated size contrast between the large circle and the small circles increases the page's overall visual interest. Because the large circle is big and white while the squares are black, it draws the viewer's eyes and serves as the primary focal point. To further organize this page, I applied the principle of alignment to the shapes, lining them all up into rows and columns. This cleaned up the page considerably—taking a messy page and making it seem much more clean and organized. Even though this example only shows squares and circles, you can see that applying one design principle to a page improves its appearance; when two or more are applied, the rewards multiply.

Figure 3–4 illustrates how clean and organized a page can appear when contrast is used in conjunction with other principles. The principle of contrast is employed throughout this page: the large headline

Figure 3–4 Using the principle of contrast (the size contrast between the images and the width of the rule lines) with the principles of alignment and flow quickly organizes and unifies a page.

NOTE

Using the principle of emphasis helps you intellectually organize your information and begin to visually differentiate it, whereas using the principle of contrast really stresses the visual difference between visual elements.

Figure 3–5 Flowing script type contrasts harmoniously with bold sans serif type.

Figure 3–6 Contrast thick type with thin type.

Figure 3–7 The texture in the triangle contrasts with the solid black rectangle and bold type and adds visual interest.

contrasts with the smaller subhead and body type, the large turtle with the small hare, the thick rule line with the thinner rule lines. The size contrast between the images naturally leads the viewer's eyes from the turtle down to the smaller hare and therefore into the text (the principle of flow). The visual flow of the page is further enhanced by the stepped size contrast between the rule lines in the head, body, and bottom of the page. The page appears clean and organized because the rules are all the same length and are neatly aligned (the principle of alignment). The combination of the principles of contrast + flow + alignment = a clean, organized, page.

Contrast occurs when two or more elements look dramatically different from one another. Ways to achieve contrast include:

- Placing very small elements on the page with very large elements, such as small type with large type or small images with large images

- ALL CAPITAL LETTERS next to all lowercase letters; elaborate decorative type next to plain sans serif type (Figure 3-5)

- Thick type or lines with thin type or lines (Figure 3-6)

- Warm colors with cool colors; large areas of solid color pierced by geometric, textured shapes (Figure 3-7)

- Vertical columns of text broken by intruding strong horizontal elements (headlines, subheads, or even a solid line)

- Black type and light gray type

Keep in mind that the way to achieve strong contrast is to really stress the difference between visual elements. Do not do things by half-measures. With contrast, it is often all or nothing.

CONTRAST EXAMPLES

The following pages include a number of designs before and after their contrast makeover. In each "after" design, I will point out the different contrast techniques used to improve the design.

Contrast Example 1

Compare the menu in Figure 3–8, below, to the redesigned menu in Figure 3–9, right. Both menus are functional. Customers would have little trouble reading either menu. Both use at least some contrast in their designs. Yet which menu is more interesting to look at and consequently more likely to be read? Which menu conveys a stronger, more sophisticated sense of style? The menu with more contrast and an interesting layout.

Espresso $1.50

Who would have thought? Our espresso is a teensy-tiny shot of pure energy!

Espresso Ristoretto $2.00

Whoa Nelly! An even stronger pick-me-up!

Espresso Macchiato $2.00

The pinnacle of espresso. A shot of espresso with a bit of steamed milk on top.

Cappuccino $2.00

Available in a variety of flavors including amaretto, mocha, and hazelnut. We also have daily specials.

Caffe Americano $2.00

A shot of espresso cut with extremely hot water for a generous serving.

Caffe Latte $1.50

The milk-and-coffee lover's delight. Our best espresso mixed with steamed milk and a topping of foamed milk.

Plain-Jane Joe $1.00

Coffee. Just coffee. Just good coffee. In a variety of flavors including amaretto, mocha, and hazelnut.

Coffee Menu

Espresso: Who would have thought? Our espresso is a teency-tiny shot of pure energy! $1.50

Espresso Ristoretto: Whoa Nelly! An even stronger pick-me-up! $2.00

Espresso Macchiato: The pinnacle of espresso. A shot of espresso with a bit of steamed milk on top. $2.00

Cappuccino: Available in a variety of flavors including amaretto, mocha, and hazelnut. We also have daily specials. $2.00

Caffe Americano: A shot of espresso cut with extremely hot water for a generous serving. $2.00

Caffe Latte: The milk-and-coffee lover's delight. Our best espresso mixed with steamed milk and a topping of foamed milk. $1.50

Plain-Jane Joe: Coffee. Just coffee. Just good coffee. In a variety of flavors including amaretto, mocha, and hazelnut. $1.00

The Coffee Fix 3

Figure 3–8 This menu is relatively easy to read, uses contrast (bold type vs. regular type), but does not really catch the eye. The centered alignment of the type also tends to look formal and even a little dull.

Figure 3–9 The size contrast between the headlines and the text catches the reader's eye. Rule lines under the headlines add emphasis, and the repetition of elements helps to unify the page. The use of the logo as a graphic adds visual interest, and influenced the typeface choice and the overall style of the design.

Contrast Example 2

The report in Figure 3–10 is a pretty standard report. It is clear and legible and gets the job done. Many students, however, are discovering that combining a quality, well-written paper with interesting graphics on a well-designed page conveys a more polished image, which may translate into a better grade.

Now before anyone gets the wrong impression, I need to point out that no amount of pretty graphics will take the place of a good quality, well-written paper. Even the best layouts cannot disguise poor writing. What I am saying is that if you already have a strong paper, then why not use the principles of design you are learning in this book to make it more visually appealing? Why not use your hard-won design skills to help your paper stand out?

Compare the original report in Figure 3–10 with the redesigned report in Figure 3–11. The two reports contain exactly the same text information; however, Figure 3–11 contrasts bold headline type

Animals of the African Savannah:
Will They Survive the Onslaught of Humans?

by Sarah Smith
Assignment 3, English 101

Lorem ipsum dolor sit amet, con secteteur adipsicing elit, sed diam vulpatate nibh euisnod. Tempor inci dunt et labore ut dolors magna ali quam erat volupat. Duis vel autemeum irure dolor in henderit in nonumy velit esse consequat. Vel illum dolor facisci at vero eos. Nam eu feugiat mulla liber tempor, cum solutanobis eligent optius, conquenius nibil impe doming id quod.

Maxim facer possin diet omnis voluptatias. Plecat possin diet omnis. Lorem ipsum dolor sit amet, con secteteur adipsicing elit, sed diam vulpatate nibh euisnod. Tempor inci dunt et labore ut dolors magna ali quam erat volupat. Duis vel autemeum irure.

Dolor in henderit in nonumy velit esse consequat. Vel illum dolor facisci at vero eos. Nam eu feugiat mulla liber tempor, cum solutanobis eligent optius, conquenius nibil impe doming id quod. Maxim facer possin diet omnis voluptatias. Plecat possin diet omnis. Duis vel autemeum irure dolor in henderit in nonumy velit esse consequat. Vel illum dolor facisci at vero eos. Nam eu feugiat mulla liber tempor, cum solutanobis eligent optius,conquenius nibil impe doming id quod. Tempor inci dunt et labore ut dolors magna ali quam erat volupat. Duis vel autemeum irure dolor in henderit in nonumy.Lorem ipsum dolor sit amet, con secteteur adipsicing elit,sed diam

1

Figure 3–10 This standard looking report uses minimal contrast and consequently has minimal eye appeal.

against small body copy, with a graphic added for visual interest. The interesting graphic visually informs the reader even before reading the title that this is a report about wildlife. To continue the wildlife theme, two small giraffes flank the page number with the large giraffe graphic at the top of the page. Even the primitive, angular typeface chosen for the headlines reinforces the wildlife theme.

Compare again the two reports in Figure 3-10 and Figure 3-11. Knowing that both reports have the exact same text information, which report would you prefer to read? Now imagine how the principle of contrast could attract the attention of readers in any kind of page—newsletters, company reports, flyers, direct mail pieces, and so on. Contrast is about making the page visually appealing so the reader wants to spend time looking at it. That is the essence of my point. Why not use design principles to improve the look of your pages and to make your pages more interesting and appealing for your audience?

Figure 3–11 This redesigned report uses contrast and graphics. The increased contrast increases the visual interest.

Contrast Example 3

The flyer in Figure 3–12 already uses a number of visual techniques to organize the information. The headline is big and bold. The type is arranged into groups of information. A graphic provides a focal point. So why does it seem somewhat boring?

While there are a number of items that could be changed in this design, the two biggest problems are the typeface choice and the centered alignment of the type. The typeface is clearly readable but seems too plain and business-like for the topic. Something a little more playful in character would reinforce the "Fun in the Sun" theme. The centered alignment also seems too dull and formal for the topic. Overall, although this design is readable, it is ordinary and boring.

Figure 3–13 shows the redesigned flyer. The headline is considerably larger than the rest of the type, and to make the contrast even more dramatic, it has been placed in a black box and rotated to run along the left side of the page. In this design, rotating the headline adds a playful touch to the page, as does the typeface choice. Be aware, however, that rotating large amounts of text away from the hor-

FUN IN THE SUN!

Preschool Through Preteen
Summer Enrichment Workshops

Workshops Ongoing All Summer

Fresh Air in Outdoor Classrooms

Supervised Environment

Creative Lessons and Activities

**For More Information Contact
Sue @ 555-4FUN**

Figure 3–12 The original flyer design. There is some contrast in the design (size of headline to size of body copy), but it needs to be pushed, to be gutsier.

izontal orientation can make it difficult to read the text (Figure 3-14). If you rotate text, try to limit it to short amounts of information. Another text technique to avoid is stacking letterforms on top of each other. Figure 3-15 is a very short phrase of text, yet it takes a lot longer to read than the same phrase here: Avoid stacking type. Try it out on yourself by reading the previous sentence in this paragraph and comparing it against your reading speed when you look at Figure 3-15. It is a small but significant difference in speed. The longer the sentences and paragraphs, the longer it takes to read, and the more annoyed the reader will become. Just imagine what it would be like to read whole sentences, or worse, paragraphs, of stacked type.

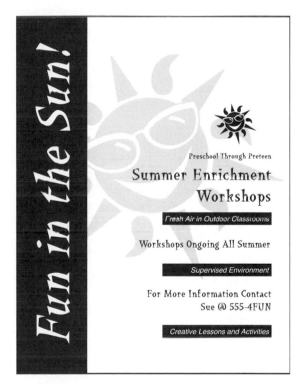

Figure 3–13 This is only one of many different ways to redesign this flyer with the intent of making it a gutsier design. The primary changes to this flyer have been to increase the contrast, select a more playful typeface, repeat the image, and use a flush right alignment. The result is a visually bold flyer that grabs the reader's attention.

Rotating text away from the horizontal makes it very difficult for the reader to read the text, unless they rotate the page momentarily to read the text. Avoid long passages of text, especially those set in small text sizes. Readers are easily annoyed by long passages of rotated text.

Figure 3–14 Rotated type takes longer to read.

A
v
o
i
d

s
t
a
c
k
i
n
g

t
y
p
e

Figure 3–15 Please don't do this. Stacked typography is hard to read and difficult to arrange gracefully.

Because placing the headline text in a big black box in Figure 3-13 made the left side of the page REALLY heavy visually, three smaller black boxes were placed on the right to visually counterbalance the composition. Aligning the rest of the text to the right also helps balance the composition. To connect the two halves of the composition together, the sun image was enlarged (size contrast) and placed in the background. In this position, it forms a visual bridge that leads the viewer's eyes from one half of the page to the other.

Clearly, this flyer has been redesigned using a lot of size contrast. But size contrast is not the only type of contrast used in this design. Figure 3-16 shows how you can use two different typefaces to form type contrast. There are many different ways to develop working type contrasts, and I explain how to do this more in depth in Part 2: Typography Basics. The point to be made here, though, is that *you don't have to use only one typeface in a design*. It is okay to experiment. Many beginners take the safe route, and use only one typeface in their designs. But some of the most beautiful type effects can happen when you contrast two completely different kinds of typefaces (Figure 3-17).

Preschool Through Preteen

Summer Enrichment
Workshops

Fresh Air in Outdoor Classrooms

Workshops Ongoing All Summer

Figure 3-17 Really stress the difference between typefaces. In this example, the beautiful flowing curves of the script typeface contrast with the bold angularity of the sans serif typeface.

Figure 3-16 A portion of Figure 3-13 has been enlarged to show you the type contrast formed by using two different typefaces.

Contrast Example 4

The example in Figure 3-18 is a typical newsletter nameplate design. A **nameplate** is the area, usually at the top of the front page of a newsletter, which contains the newsletter's name in decorative type. This nameplate design could benefit from both size contrast and type contrast. See the redesigned nameplate in Figure 3-19. Figure 3-20 shows the two nameplates placed in the newsletter pages.

Figure 3–18 An ordinary nameplate design from a newsletter that uses one typeface. With only one typeface, everything harmonizes to the point of blandness.

Figure 3–19 To make this nameplate more prominent, I have used quite a number of contrast techniques: big type against small type, serif type against sans serif type, ALL CAPS against upper and lowercase letters, gray type against white type. The nameplate is more playful, attractive, and certainly not bland!

Figure 3–20 The original nameplate and newsletter (left) and the redesigned nameplate and newsletter (right). Liberal use of type contrast results in a visually stronger and more appealing page.

Contrast Example 5

This telephone ad (Figure 3–21) has a nice strong headline typeface and attractive "tile" images, but much of the type is too similar in size. This makes it difficult for the reader to determine which is the most important information.

There are also too many kinds of alignment in the ad. The headline is centered in the space, the "Carpets" type is flush right, and the "Ask About Our..." type is flush left. These many alignments in a design make it difficult to find a visual path through the page. A strong alignment will make the design seem more unified and allow the reader's eye to follow a strong visual path through your page. (And aren't you reading this book because you want to have control over your pages so you can make it easier for the reader to receive your message?)

Figure 3–21 This telephone ad uses way too many types of alignment: flush left, flush right, and centered, which makes it seem visually messy. While there is some contrast, what is there is seriously weakened by the lack of visual organization. Simplifying the alignment will make the contrast more noticeable and strengthen the ad.

Figure 3–22 The redesigned ad benefits from the use of size contrast, type contrast, and texture contrast. The majority of the ad uses a single strong alignment scheme, which significantly improves and organizes the ad.

Figure 3-22 shows the redesigned telephone ad. Because there were a number of attractive features in the original ad, some of these features have been recycled into the new ad. For example, the original typefaces are still in use, but resized, the priority information made the largest to attract attention; the store name is still displayed prominently, as is the telephone number; and the store address, while a necessary part of the ad, is much smaller, but still clearly readable. It is okay to make some information smaller than others—if someone needs it they will still be able to find it easily enough. Of course, you don't want to use type so small that it is a challenge for the reader to see it—Figure 3-23.

The telephone ad in Figure 3-22 also uses a more advanced type of contrast technique—texture contrast. In this design, the original tile patterns inspired the use of a strip of tiles, which when viewed together, form a textural pattern. This texture contrasts with gradient in the small diamond shapes. Drawing on the principle of repetition, the use of the diamond shapes as bullets leads the viewer's eye down the page. To further unify the page, the diamond shapes echo the form of the diamond shapes in the tile pattern. Using the texture in a strip along one side also gives a nice strong edge for the type to align against. Furthermore, the strong flush left alignment of the type and the use of the small diamond shapes lead the reader's eyes naturally through the design.

Figure 3–23 Really small type is difficult to read. Most readers will just ignore small type. Hmm. Maybe that's why contracts use substandard size type.

ADVANCED PAGE ANALYSIS Contrast

This advanced contrast page analysis section points directly to typography, layout, and concept problems in Figure 3-24. Compare the flaws in Figure 3-24 with the improved page design in Figure 3-25. Stressing the contrast between type and image in Figure 3-25, along with rearranging the layout, dramatically improved this page design.

Placement of the text "A special exhibit for Valentine's Day" aligned with the rest of the text is a safe layout solution. It's fine, it functions, but, frankly, it could be gutsier.

This font, *Century Schoolbook Bold Italic*, has pronounced curves in the letterforms (the *v* for example), which implies friendliness and softness: a decent match for the concept of Valentine's Day. It also works fine with the body copy font, Myriad, as well as with the spider image. However, it is a safe choice and does not conceptually enhance the slightly creepy feeling of the copy "Love Bites." Furthermore, the contrast between headline and body copy could be stronger.

The spider image visually informs the viewer that this is an exhibit featuring insects. Works fine, but lacks spunk and contrast.

The punctuation marks (the apostrophe in "Valentine's" and the period after "Day," are a whopping big size in this particular font. They need a bit of optical adjustment to make them look more graceful and less obtrusive.

Love Bites

A special exhibit for
Valentine's Day.

This exhibit explores ancient links between bugs and love. Historic recipes for bug aphrodisiacs are demonstrated and, as a real treat, chocolate-covered crickets will be served by the platter!

City Zoo
For couple reservations call 1-555-555-5555

The text under "City Zoo" seems like an afterthought and lacks unity with the rest of the text, in part because the white space above "City Zoo" serves as a visual wedge to split the composition apart. The text under "City Zoo" is also too close to the bottom of the ad, and seems to belong with the line around the ad, not with the body copy above it.

Figure 3–24 The before version of this page shows multiple type, layout, and conceptual problems.

Increasing the size of the spider increases the contrast and the visual interest of the ad. Positioning it so that its two front legs are reaching out to the "Love Bites" heading makes the viewer wonder if the spider is about to hug and kiss, or to grab and chomp. This ambiguity of purpose enhances the concept behind the headline text.

The outspread spider legs suggest a new placement solution for where to put this text. The left edge of the "A" and "V" align with the left edge of the "B" in "Bites," drawing on the power of the principle of alignment to make the words seem anchored and to strengthen the composition.

Reducing the size of the apostrophe and the period de-emphasizes them and makes them less obtrusive.

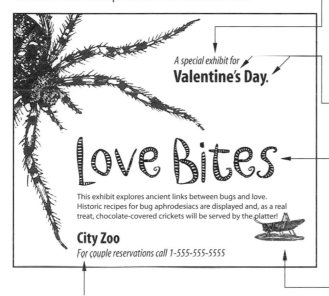

A special exhibit for
Valentine's Day.

Love Bites

This exhibit explores ancient links between bugs and love. Historic recipes for bug aphrodisiacs are displayed and, as a real treat, chocolate-covered crickets will be served by the platter!

City Zoo
For couple reservations call 1-555-555-5555

This font, Caterpillar, is eye-catching and the stripes in the font echo the stripes in the spider's legs (principle of repetition). The larger size contrasts better with the body copy. The quirky nature of the font also conceptually enhances the creepy copy "Love Bites."

The addition of the small cricket image, in the same illustration style as the spider, enhances the principle of contrast on the page because of the size variation between the spider and the cricket. The deliberate placement of the cricket, with its antennae gently touching the "p" in "platter" serves to conceptually underscore the last line of body copy. The image in this position also reduces the white space at the bottom of the ad, eliminating a problem present in the before version of the ad.

Changing the font of the body copy under City Zoo to the same font as used in "A special exhibit for" strengthens the visual unity on the page. Using the same italic type to start and end the text on the page forms a subtle visual bracket on the page, making it seem more sophisticated. This is a fine nuance of advanced typographic control. Moving the type up a little bit on the page helps tie it in with the rest of the body copy.

Figure 3–25 The after version of this page resolves the problems shown in Figure 3–24. Application of the principle of contrast improved the page design.

SUMMARY

Don't be afraid to use strong contrasts in your pages. Using strong contrast is one of the quickest and most effective ways to attract attention to your page and to visually organize the information. Designs with little contrast often lack variety and are visually boring. Try using size contrast, color contrast, typeface contrast, weight contrast (bold vs. regular type), and even texture contrast in your pages. Remember, if two elements are not supposed to look identical, then make them look extremely different.

MINI QUIZ #3

Fill in the blanks with the words in the following list.

color	organization
contrast	size
nameplate	

1. Pages where everything is the same size, typeface, and color lack _____, and look bland and boring.

2. Adding contrast to a page can dramatically improve the _____ of the page.

3. A newsletter's _____ design contains the newsletter's name in decorative type and is usually placed at the top or run along the side of the front page.

4. You can use different types of contrast: texture contrast, _____contrast, _____contrast, weight contrast (bold vs. regular type), and even typeface contrast to improve your pages.

5. Redesign the list in Figure 3-26 using the principle of contrast. Improve the organization of this list by applying the principle of contrast to the subheads. Let me suggest several working methods to solve this problem; choose the one most comfortable for you. If this is your book then you can go ahead and draw directly on the page; or you could take a piece of tracing paper and a pencil and retrace the elements on the list; or you could retype the list in the computer using a similar (it doesn't have to be

exact) font. Whichever method you choose, modify the elements on the list to increase the contrast by using some or all of these visual techniques:

- Make some of the type bigger.

- Make some of the type bolder.

- Draw rule lines under category head type.

- Add color.

- Place some type in boxes.

Drawing Tools
Pencils
Pens
Chalk

Painting Tools
Brushes
Palette
Palette Knives

Figure 3–26

You're invited

Hello

health

Rocks

newsletter

Sticks & Stones

Party

HEALTH

Baking Contest

You're invited

attic

newsletter

Rocks

HEALTH

Sticks & Stones

Hello

Baking Contest

Party

attic

Figure 3–27

EXERCISES

Exercise 1

Mix and match the phrases in Figure 3–27 by tracing them with a piece of tracing paper and a pencil or fine-tipped marker; or by photocopying them and cutting and pasting them into new combinations; or, if you're really industrious, scan this page and rescale them in an image-manipulation program such as Photoshop. Figure 3–28 shows a couple of solutions to this problem. This designer chose to enlarge the page on a photocopier and then traced the text with a fine-tipped black marker. Try to contrast typefaces, weight, and size and develop at least six variations. It doesn't matter if the word combinations make sense, just retrace them with an eye toward contrast. Which combinations have the most contrast? Why?

Figure 3–28 Two ways out of many to solve Exercise 1. This designer deliberately traced just the outline of the word "Party" to experiment with contrast.

Exercise 2

Find interesting examples of text in magazines and newspapers, and stressing the principles of contrast, cut and paste them into a ransom note style page. Use your found typography to construct a short phrase or sentence that tells a story. Do not use trademarked logos, logotypes, or slogans for this project; target headlines, subheads, and body copy for this exercise.

Figure 3–29 shows one possible solution to this problem. In this figure, the designer chose to explore the principle of contrast, not only through varying the size of the type and through font choice, but also by pasting the cut paper onto a grey background, forming another level of contrast between the background, cut paper, and letters. The grey background, furthermore, accentuates the irregular, cut edges of the pages, and adds to the ransom note look of the page.

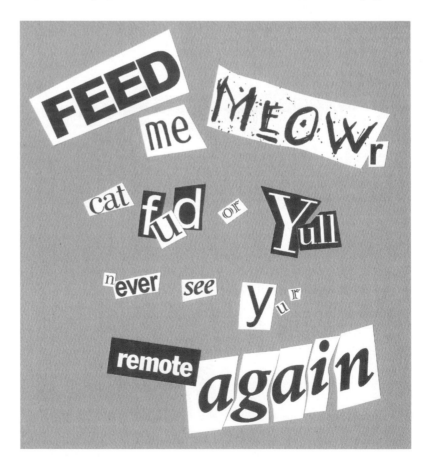

Figure 3–29 The note Fluffy Kat might leave you if only he had thumbs. In this example, the designer (who was born equipped with opposable thumbs) cut, with a pair of scissors, type out of a variety of magazines and experimented with the principle of contrast to form this ransom note style of message.

Exercise 3

Pick two or three letters and, through font choice, size, texture, pattern, or color, show the principle of contrast. You may use found letters clipped from newspapers or magazines; you may paint or draw the letters; or you may computer generate the letters. Constrain your composition within a square, focusing on arranging the contrasting letterforms within the format: it's never too early to focus on improving your layout skills. Figure 3–30 shows one solution to this problem.

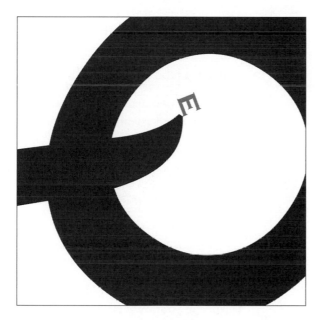

Figure 3–30 This figure shows one possible solution to Exercise 3. Extreme contrast between the Q and the E, along with an asymmetrical layout, lends a dynamic flair to this composition. *Credit, University of Texas at Arlington student Brandon Nielsen, 2004.*

Chapter 4

Balance

Visualize walking into a new acquaintance's apartment and noticing that all of the living room furniture is clumped against one wall. Chairs are stacked on chairs, the TV and VCR are on the sofa along with five plants, a throw rug is draped over a bookcase stacked on a coffee table, and a cat resentfully glares at you from his high perch on top of a stack of teetering videotapes (Figure 4–1). Quickly discerning (with swift logic, you think) that the acquaintance has recently moved into the apartment, you say, "This place is great! It'll be a wonderful place when you finish decorating. When did you move in?"

Figure 4–1

"I've been here for five years," the acquaintance replies, giving you a strange look.

Puzzled, you query, "Are you redecorating, or are you going to clean the carpets?"

"No, this is how my living room always looks. Why do you ask?" the acquaintance says suspiciously.

With a flash of insight you realize that this person is just a little… odd. Perhaps it is time to leave.

Now visualize what it would be like to read a page in which the headline, text, and pictures are clumped tightly into one small corner. Trying to figure out the page's message when everything is jammed into one little corner might be difficult. It might even make you a little uncomfortable—after all, the page is definitely odd. Perhaps you might even want to put the page down without reading it, right?

What both the acquaintance's living room and the page lack is good balance. Spreading things around a bit to achieve a better balance would greatly improve both situations.

WHY USE BALANCE?

Just like in a living room, a page layout needs good balance in order to be comfortable and functional. People are more comfortable with balanced designs and are more likely to stick around to read the page. A balanced design seems more thought out and complete than an unbalanced design.

A balanced design is one in which the visual weights of all of the elements are equally dispersed throughout the layout. **Visual weight** is the illusion of physical weight of a visual element on the page. A bold headline, for example, will have more visual weight than the author's much smaller byline. A bright red graphic will have more visual weight than the same graphic in gray. An interesting photo will have more visual weight than body copy because people tend to look at pictures before looking at text. The size, color, and texture of a visual element all contribute to its perceived visual weight (Figure 4–2). The four lines of type in Figure 4-2 depict different visual weights. All of the lines of type are set at 26 point: the top two lines are Gill Sans Regular, the bottom two lines are Gill Sans Extra Bold. Notice how quickly your eye is drawn to the extra bold line second from the bottom. This line, because of its dense black color and boldness, carries the most visual weight and attracts the viewer's eye faster than the other, less visually heavy lines. The two lines of gray type carry much less visual weight despite being the same point size and boldness as the middle two lines of type. All of these attributes that contribute to visual weight must be considered: each visual element has its own visual weight that must be carefully balanced and counterbalanced by other visual elements on the page.

Most beginners either clump all of the words and graphics tightly together (perhaps for safety?) or spread the words and graphics evenly all over the layout as if to fill in all of the corners. In both cases these page layouts lack clear organization, which makes it more difficult for the reader to figure out each page's message. What is required is the thoughtful, balanced arrangement of visual elements on the page to avoid either leaving large areas of the page completely blank or completely overloading other areas.

Before attempting to achieve a good balance, you need to have decided which words and phrases and graphics you should emphasize and which elements belong together. Logically group related

Visual Weight

Visual Weight

Visual Weight

Visual Weight

Figure 4–2 Four variations in visual weight.

items and place them together on the page: pictures with their captions, maps with their legends, and so on. Once you start to group information together, you will need to counterbalance it on another part of the page with another element or group of information.

SYMMETRICAL VERSUS ASYMMETRICAL BALANCE

Page designers can achieve balance through either symmetrical or asymmetrical layouts. A **symmetrically balanced** layout is one in which visual elements are mirrored from side to side or from top to bottom. You can create a symmetrical layout very simply: draw an imaginary line down the middle of the page and arrange identical or similar visual elements so that they are equally distributed on either side of the axis (Figure 4-3). This is a quick and easy way to create a page design. Because they are easy to create, many beginning designers depend heavily on centered, symmetrical layouts. There is nothing inherently wrong with centered or symmetrical layouts, but centered pages often appear formal, dignified, and static. In other words, they lack a strong sense of movement and visual energy. Symmetrical layouts are safe. Using a symmetrically balanced layout works just fine when you are trying to convey a sense of dignity, history, or formality. On the other hand, if you want a more dynamic design, then you might want to try an asymmetrical layout.

In an **asymmetrically balanced** layout, the words and phrases and graphics are arranged unequally on either side of the imaginary axis, yet the focus is still on achieving a harmonious balance (Figure 4-4). In a symmetrical layout, if there was an image of an animal on the lower left side of the page, it would be balanced out by a same size image of an animal on the lower right. In an asymmetrical layout, the animal could be bal-

Figure 4–3 A symmetrical layout is essentially the same on both the left and right sides.

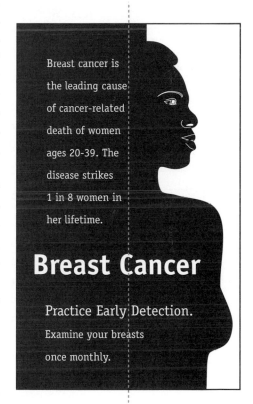

Figure 4–4 In an asymmetrical layout the left and right sides are different and have varying visual elements that a good designer will strive to balance.

anced out by one or more pieces of type, photos, shapes, color gradation, textures, or by grouping of smaller animals (Figure 4–5). This open-ended variety of choices makes creating an asymmetrical layout more challenging because the size, color, and proportion of each individual element must be considered and weighed against the visual weight of every other individual element on the page. The reward, however, is that asymmetrical layouts tend to seem more unpredictable and dynamic.

 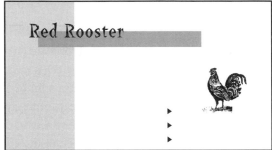

Figure 4–5 The illustration on the left is symmetrically balanced. The illustration on the right is asymmetrically balanced, with the visual weight of the varying elements weighed carefully against one another to achieve a dynamic asymmetrical layout.

A WORD ABOUT PROPORTION

Striking a working balance in a page depends a great deal on finding the right sizes for all the visual elements—the words, phrases, and graphics—you need to shoehorn into the space. Finding the right size, or the proportion, of elements on the page means you will need to decide which elements should be emphasized to indicate that they are most important. But how do you decide when a headline is big enough? Or when a rule line is thick enough? Or when a picture is big enough? These details are hard to determine because the overall success of a page layout depends on the relationship between the format's size and shape and the visual elements on the page. Unfortunately, there is no good replacement for practice. In order to strike a working balance on a page you will need to carefully consider the placement, size, and proportion of all the visual elements on the

page. Shuffling visual elements around on the page looking for a working balance takes time and practice.

There are no absolute right or wrong answers in designing a page. There are just better or worse solutions. Experiment. Try to have fun. Look at what other people are doing in their pages and try out some of their ideas on your next page. Of course you don't want to copy them, but take the best of their ideas and try it out in your own way. Don't despair if your pages aren't as attractive as they could be—you can always do better on the next page.

BALANCE EXAMPLES

The next few pages highlight some of the important issues to consider when striving for a balanced design. Keep in mind as you are reviewing the following examples that pages with balance problems often have other visual problems such as problems with contrast, flow, emphasis, and the other design principles. Fixing a balance problem, although essential, often requires the page designer to rework at least some of the design.

Balance Example 1

The page in Figure 4-6 has multiple flaws, including problems with alignment, type size, and balance. Solving this particular page's problems will require the resizing and rearranging of the type in accordance with the design principles of balance, alignment, and contrast.

One of the major problems with the page in Figure 4-6 is the lack of a single strong alignment scheme. The page uses centered and flush left type on the same page, which ends up looking awkward. The awkward spacing of the headline and graphic leaves areas of excess white space. **White space** is the space

ANCIENT ARTWORK STUNS WORLD!

Experts believe cave painting is a self-portrait! View it yourself and wonder.

Gallery open 8-5 daily.

Figure 4–6 This page has too many alignment schemes. The title is flush left but pushed to the right, the picture is pushed to the left, and the rest of the copy is centered.

TIP

Until you get more practice, stick with a single strong alignment scheme.

in the page that doesn't contain visual elements such as text or images or lines. It looks like the designer was aiming at funky and energetic but ended up with an unbalanced mess. Some designers feel that using several alignment schemes in a single page adds a sense of energy and contemporary "edginess," but getting several alignment schemes to work in the same page is difficult. For the most part, using more than one type of text alignment on a page simply makes the page designer look as if she couldn't decide where to put the type. Picking a single strong text alignment, such as flush left, centered, or flush right, and sticking to it dramatically improves the look of a page and makes it look like the page designer is in control.

Another major problem with the page is that the type is about all the same size and consequently, seems about the same in importance. Headline type should be bigger or more prominent than body copy type so the viewer can quickly scan the page and quickly grasp the essence of the message from the headline. The viewer then decides if the headline is interesting enough to continue reading. When type is all about the same size on the page, the viewer has to work to figure out the main message of the page. If your design forces the viewer to do too much work, your message may be ignored. Many viewers simply turn away from a page that lacks a clear typographic hierarchy.

The page in Figure 4-7 corrects the problems with alignment and with type size contrast. The strong sense of alignment improves the overall impression of the page, yet the page still seems unbalanced because of the wide expanse of white space on the left. Totally rearranging all the type and the graphic on the page into a centered and symmetrical layout would solve the alignment problem and eliminate the white space but make the page seem dull and formal. In addition, the dynamic off-center curvilinear movement of the lizard graphic, which suggests an asymmetrical layout such as the one in Figure 4-7, is more suitable and reinforces the visual energy of the graphic. Furthermore, a centered alignment scheme would clash with the strong curves of the lizard and suppress its strong visual movement. So an asymmetrically balanced layout works better with the image than a symmetrically balanced one.

In keeping with the decision to stick to an asymmetrical layout, Figure 4-8 shows essentially the same layout as in Figure 4-7 but with one additional visual element that resolves the problem of excess

TIP

The images you choose should reinforce the message. Don't let the images you have available dictate or twist the message.

white space on the left—the black jagged bar. The bar runs the length of the left side of the page, occupying excess white space and counterbalancing the visual heaviness of the right side of the page. The jagged bar was made by simply copying and repeating the jagged bar inside the graphic. Repeating a visual element helps make the page seem more unified. The jagged edge is also reminiscent of the irregularities in a cave wall, which ties in conceptually with the cave painting artwork.

An additional benefit to using this jagged bar is that it visually directs the viewer's eyes back toward the headline: the viewer's eyes follow the curve of the lizard's back down along the sweep of the tail, slide across to the jagged black bar, and bounce back up to the headline. This is a "trick of the trade" that professional designers use: iden-

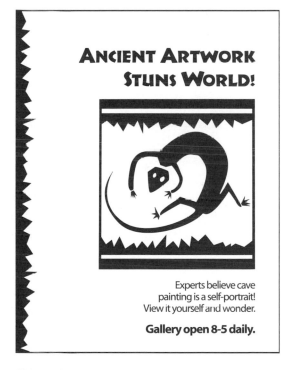

Figure 4–7 The reworked page. Picking a flush right alignment scheme and resizing the type dramatically improves this page, yet because of the excess white space on the left side it still isn't balanced.

Figure 4–8 Adding in the black jagged edge helps balance this asymmetrical composition.

tifying a strong visual path of movement in a picture and deliberately placing the picture in the composition to direct the viewer's eyes around the page. It doesn't work with all pictures, only those with a strong directional movement. In this case, the curve of the lizard's back presents a rich opportunity to direct the viewer's eyes across the page.

Balance Example 2

In Balance Example 1, the strong visual path of movement already present in the graphic played a pivotal role in the decision on whether to build either a symmetrical or an asymmetrical layout. This is a valid approach to picking a balance scheme, but you should primarily base your decision on whether to use a symmetrical or asymmetrical layout on the topic and message of the page. If your topic or message is formal, then the more formal impression of a symmetrical layout works in your favor. If the meat of your message were more informal, quirky, or gutsy, then the dynamic visual energy of an asymmetrical layout would reinforce that message. If the page's message is neither formal nor gutsy, then either balance scheme is suitable—you choose.

The message of the page in Figure 4-9 is decidedly quirky, and the designer has chosen to go with an asymmetrically balanced layout. The asymmetrical balance of the page works well, but there is room for improvement because the page still seems somewhat stilted, despite the energetic feeling of an asymmetrical layout. This design has the potential to be really gutsy and fun if the asymmetrical balance and type were pushed a little more. After all, why be wimpy? It's just a page, and as long as the information is readable, why not have a little fun with it?

The first thing to throw out in Figure 4-9 is the plain, ordinary, functional, readable, but extremely boring typeface. A gutsy or unusual-looking typeface with some distinctive letterform features would add much more personality to this message than this plain typeface. Furthermore, the calm and orderly look of the typeface seems weird when compared to the frightening size of the insects. Those are some big bugs. From a purely design standpoint, the size of the bug graphic visually conflicts with the size of the headlines, which makes them seem as if they are about the same in importance. This conflict is visu-

ally awkward and the similar size of the graphics and the headline clutters up the page. Reducing the size of one of these elements will resolve this conflict and have the additional benefit of relieving the page's cramped feeling.

Figure 4–10 shows the redesigned page. Shrinking the bug graphics opens up some much needed white space on the page, which makes the page seem less crowded, and eliminates the visual conflict between the headline and the graphics. The body copy was reduced slightly in size, again to allow more white space into the design. The new typeface adds an edgy, excited feeling to the page. Varying the size of the words in the headlines helps place additional emphasis on key words and is a contemporary, playful touch. Running the headline type diagonally on the page pushes the asymmetrical balance of the page a little further, enhancing the overall energetic feeling of the page.

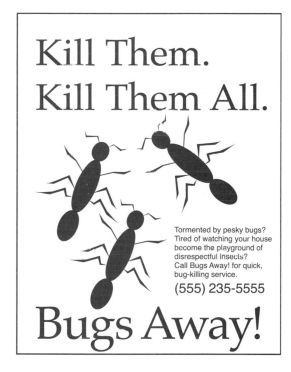

Figure 4–9 The original asymmetrical design. It has contrast, but pushing the type choice further, experimenting more with the type, will increase visual interest.

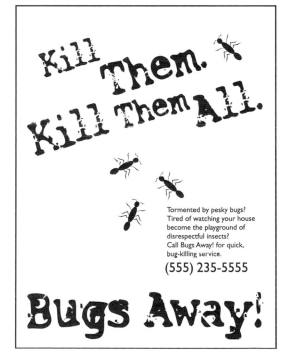

Figure 4–10 Changing the typeface, shrinking the bug graphics, increasing the contrast between the headline and the bugs, and experimentally running the type on a diagonal improves this design over the original as seen in Figure 4–9.

Figure 4–11 Positioning type so that it runs uphill has a positive, energetic connotation. The type seems dynamic, as if it is moving with energy into the future.

Figure 4–12 Don't stagger type. It looks awkward and is difficult to arrange gracefully on the page.

Asymmetrical layouts often, but not always, have one or more strong diagonal elements in them, with type, graphics, lines, photos, or other visual elements placed at an angle on the page. Skewing visual elements diagonally away from the horizontal and the vertical adds a sense of energy and movement to a page (Figure 4-11 and Figure 4-12). Horizontal and vertical lines seem stable because they remind us of our everyday physical orientation of walking upright across flat floors. Diagonal lines seem energetic because they give us the perception that they are about to fall toward the more stable horizontal or flip up to the vertical. You can take advantage of this quirk of human psychology by using diagonal visual elements on your pages to make them seem more exciting and energetic. A single element can be placed at an angle or you can skew the whole layout on the page. Adding a drop shadow behind a whole skewed layout design gives the viewer the impression that the design is about to lift off the page's surface (Figure 4-13).

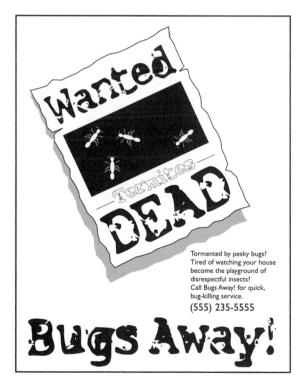

Figure 4–13 Drop shadows create the illusion that objects are "lifting" off the page.

Balance Example 3

Designing a well-balanced page layout means the designer must juggle the visual weights of all of the visual elements on the page. Ignoring the visual weight of elements results in awkward, unbalanced layouts. Visual elements on the page seem to have visual weight because of their texture, size, tonal values, or color. Headlines seem to have a lot of visual weight because they are often in color or in black, are typically bigger than the body copy, and are often bolded and even italicized. Photos, illustrations, and graphics have areas of light and dark that attract the viewer's eyes. The mass of the lines of text in a column form lighter areas of gray that must be balanced against headlines and graphics (Figure 4–14). Areas without any visual elements form white space. Even these "empty" areas of white space must be taken into account and balanced against other areas with visual weight.

The sequence in which readers will look at the page follows the density of the visual weight on the page. If the page is in black and white, the readers will see dense areas of black first, lighter gray areas

Figure 4–14 This figure has three main areas of differing visual weight: the headline, graphic, and body copy. The sweeping curves, large size, and bold italic letters of this headline draw the reader's attention first and carry a lot of visual weight. The lights and darks in the illustration are visually interesting and contribute to its visual weight. The columns of body copy, with their line after line of type, form an area of gray (squint to see the gray better).

second, and white space last. If there is color on the page, the readers will see color first, dense black areas second, gray areas third, and white space last. Too much color in one spot can unbalance the page. Too much black on a page, and the page will seem busy. Too many grays on the page will make the page seem drab. Too much white space in the wrong areas can throw the balance of a page out of whack as surely as too much color, black, or gray.

If possible, try to avoid having pages with only body copy on them. Columns of body copy form a gray tone that to many readers signifies "work." The drab dullness of an exclusively gray tone page is formed by line after line of body copy: reading body copy requires effort and takes longer for the reader to wade her way through. To break the monotony and make the page more visually welcoming, sprinkle the page with pictures, graphics, or at a minimum, some sort of visual element such as rule lines. Visual elements can be individual lines, shapes, images, headlines, body copy, or other objects, or a group of objects that are close enough together that they are perceived as a single element, such as a grouping of body copy. Adding visual elements helps attract and retain the reader's interest.

NOTE

Paragraph after paragraph of all-text pages signify "work" to many readers. While there is nothing wrong with making your reader do a little work, if you can make your pages more appealing with a few simple changes, such as adding an interesting visual element, why not?

Sometimes, because of the content of the page, the designer has few options in adding visual elements. In this case, adding even small visual elements, such as a rule line or a chart box, can help improve a largely all-text copy page. Figure 4–15 shows how quickly a boring page shapes up when just a few simple visual elements are added. Compare the all-text page on the left in Figure 4–15 to the page on the right. The insertion of rule lines, small giraffe graphic, and text columns make the page on the right more visually appealing than the solid lines of text in the left page. Breaking the type into columns and widening the page margins increase the amount of white space, providing a welcome resting place for the reader's eye. The overall impression is of a more dignified and refined page.

Pages with lots of graphics, photos, and illustrations catch the reader's eyes faster than all-text pages. After all, a picture is worth a thousand words. Furthermore, words alone don't always clearly carry your message. Well-chosen and informative graphics, illustrations, and photos can help create another channel of information that reinforces and further explains complicated portions of the text message, helping the reader grasp the message better.

It's easy to test this out for yourself, on yourself. Find a daily newspaper, and scan through the front-page section. What do you see first? Most people look at headlines and pictures first, then the gray body of the text. Pick a story with a photo, illustration, or chart. Read the text, then look at the picture. Does the story seem clearer in your mind after digesting both the text and the picture? What would the front page of a newspaper be like without any pictures or illustrations? Would it be as clear without these visuals? Now look at the stock quote sections. Notice how the page appears a gray tone and the page is almost uniform in overall visual weight. Try to read the stock quotes. They *are* readable, but they take more work to decipher than a page with photos, graphics, or illustrations on it. Pages with varying visual weight are more interesting to look at than pages with even visual weight, such as the stock quotes page.

Lorem ipsum dolor sit amet, con sec teteur adipsicing elit, sed diam vulpatate nibh euisnod. Tempor inci dunt et labore ut dolors magna ali quam erat volupat. Duis vel aute me um irure dolor in hendent innonumy velit esse consequat. Vel illum dolor facisti at vero eos. Nam eu feugiat mulla liber tempor, cum solutanobis eligent optius, conquenius nibil impe doming id quod. Maxim facer possin diet omnis voluptatias. Plecat possin diet omnis. Lorem ipsum dolor sit amet, con secteteur adipsicing elit, sed diam vulpatate nibh euisnod.

Tempor inci dunt et labore ut dolors magna ali quam erat volupat. Duis vel autemeum irure dolor in henderit in nonumy velit esse consequat. Vel illum dolor facisti at vero eos. Nam eu feugiat mulla liber tempor, cum solutanobis eligent optius, conq uen ius nibil impe doming id quod.

Maxim facer possin diet omnis vol uptatias. Plecat possin diet omnis. Duis vel autemeum irure dolor in henderit in nonumy velit esse conseq uat. Vel illum dolor facisti at vero eos. Nam eu feugiat mulla liber tempor, cum solutanobis eligent optius, conquenius nibil impe doming id quod. Tempor inci dunt et labore ut dolors magna ali quam erat volupat. Duis vel autemeum irure dolor intu hend erit in nonumy. Lorem ipsum dolor sit amet, con secteteur adip sicing elit, sed diam vulpatate nibh euisnod. Plecat possin diet omnis. Maxim facer possin diet omnis volup tatias.

Vel illum dolor facisti at vero eos. Lorem ipsum dolor sit amet, con secteteur adipsicing elit, sed diam vul patate nibh euisnod. Tempor inci dunt et labore ut dolors magna ali quam erat volupat. Duis vel aute meum irure dolor in henderit in nonumy velit esse consequat. Vel illum dolor facisti at vero eos, Nam eu feugiat mulla liber tempor, cum solutanobis eligent optius, conquen ius nibil impe doming id quod.

Maxim facer possin diet omnis voluptatias. Plecat possin diet omnis. Lorem ipsum dolor sit amet, con secteteur adipsicing elit, sed diam vulpatate nibh euisnod. Tempor inci dunt et labore ut dolors magna ali quam erat volupat. Duis vel aute meum irure dolor in henderit in nonumy velit esse consequat. Vel illum

Lorem ipsum dolor sit amet, con sec teteur adipsicing elit, sed diam vul patate nibh euisnod. Tempor inci dunt et labore ut dolors magna ali quam erat volupat. Duis vel aute me um irure dolor in henderit innonumy velit esse consequat. Vel illum dolor facisti at vero eos. Nam eu feugiat mulla liber tempor, cum solutanobis eligent optius, conquenius nibil impe doming id quod. Maxim facer possin diet omnis voluptatias. Plecat possin diet omnis. Lorem ipsum dolor sit amet, con secteteur adipsicing elit, sed diam vulpatate nibh euisnod.

Tempor inci dunt et labore ut dolors magna ali quam erat volupat. Duis vel autemeum irure dolor in henderit in nonumy velit esse consequat. Vel illum dolor facisti at vero eos. Nam eu feugiat mulla liber tempor, cum solutanobis eligent optius, conq uen ius nibil impe doming id quod.

Maxim facer possin diet omnis vol uptatias. Plecat possin diet omnis. Duis vel autemeum irure dolor in henderit in nonumy velit esse conseq uat. Vel illum dolor facisti at vero eos. Nam eu feugiat mulla liber tempor, cum solutanobis eligent opt

ius, conquenius nibil impe doming id quod. Tempor inci dunt et labore ut dolors magna ali quam erat volupat. Duis vel autemeum irure dolor intu hend erit in nonumy. Lorem ipsum dolor sit amet, con secteteur adip sicing elit, sed diam vulpatate nibh euisnod. Plecat possin diet omnis. Maxim facer possin diet omnis volup tatias.

Vel illum dolor facisti at vero eos. Lorem ipsum dolor sit amet, con secteteur adipsicing elit, sed diam vul patate nibh euisnod. Tempor inci du nt et labore ut dolors magna aliquam erat volupat. Duis vel aute me um irure dolor in henderit in nonumy vel it esse consequat. Vel illum dolor fa cis cti at vero eos. Nam eu feugiat mulla liber tempor, cum solutanobis eligent optius, conquen ius nibil im pe doming id quod.

Maxim facer possin diet omnis voluptatias. Plecat possin diet omnis. Lorem ipsum dolor sit amet, con secteteur adipsicing elit, sed diam vulpatate nibh euisnod. Tempor inci dunt et labore ut dolors magna ali quam erat volupat. Duis vel aute me um irure dolor in henderit innonumy

Figure 4–15 The boring page on the left quickly shaped up with the addition of a few rule lines and small graphics (right page).

Making the Most of Black and White

The most economical way of producing a page is to have it printed or reproduced in black and white. Don't despair, there are many ways to use these "colors" to your advantage and liven up your page. Try these techniques to vary these "colors":

- Use black shapes, solid backgrounds, or rectangles with white type reversed out.

- Try thick rule lines in gray, thin rules lines in black or vice versa. Contrast thick rule lines with thin.

- Use gradations from white to black in rule lines, in type, in shapes, in the background.

- Try photographs and illustrations with a wide range of gray tones.

- Use plenty of white space.

Balance Example 4

When using color on your page, consider the strong visual impact of color. Color attracts attention, makes items seem more prominent, can help organize and unify your pages, and adds visual excitement. Choosing the right color for your message is essential, as is achieving a color-balanced layout. A major mistake that novices often make is using isolated spots of color in a page or clumping several spots of color together in one area. This is a tendency that is pretty easy to recognize once it has been pointed out and easy to avoid repeating. Just spread the color around instead of clumping it into one area.

Take a look at Figure 4–16. I'm going to ask you to do a little work with a marker or crayon for this study because this section of the book is in black and white. If this isn't your book, or you plan to resell it, then photocopy Figure 4–16 (and 4–17 while you're at it) and color the figure for this study. Color in the leaf graphics and the words "Fall Festival" with a red or orange marker. Adding color to one area of this figure suddenly makes the bottom part of the page very visually dominant and visually heavy, doesn't it? Too dominant and heavy. The grouping of colored graphics and type on the bottom needs counterbalancing with another touch of color somewhere else on the page.

Calendar of Events

Pick a Pumpkin

Lorem ipsum dolor sit amet, con secteteur adipsicing elit, sed diam vulpatate nibh euisnod. Tempor inci dunt et labore ut dolors magna.

Corn Husking and Beer Brewing

Vel illum dolor faciscti at vero eos. Nam eu feugiat mulla liber tempor, cum solutanobis eligent optius, conquenius nibil impe doming id quod.

Apple Harvest

Plecat possin diet omnis. Lorem ipsum dolor sit amet, con secteteur adipsicing elit, sed diam vulpatate nibh euisnod. Tempor inci dunt et labore ut dolors magna ali quam erat volupat. Duis vel autemeum irure dolor in henderit in nonumy velitt.

Fall Colors Scavenger Hunt

Duis vel autemeum irure dolor in henderit in nonumy velit esse consequat. Vel illum dolor faciscti at vero eos. Nam eu feugiat mulla liber tempor, cum solutanobis.

Figure 4–16 Coloring in the leaves and the "Fall Festival" headline in red or orange will make the bottom part of the page visually heavy.

Calendar of Events

Pick a Pumpkin

Lorem ipsum dolor sit amet, con secteteur adipsicing elit, sed diam vulpatate nibh euisnod. Tempor inci dunt et labore ut dolors magna.

Corn Husking and Beer Brewing

Vel illum dolor faciscti at vero eos. Nam eu feugiat mulla liber tempor, cum solutanobis eligent optius, conquenius nibil impe doming id quod.

Apple Harvest

Plecat possin diet omnis. Lorem ipsum dolor sit amet, con secteteur adipsicing elit, sed diam vulpatate nibh euisnod. Tempor inci dunt et labore ut dolors magna ali quam erat volupat. Duis vel autemeum irure dolor in henderit in nonumy velitt.

Fall Colors Scavenger Hunt

Duis vel autemeum irure dolor in henderit in nonumy velit esse consequat. Vel illum dolor faciscti at vero eos. Nam eu feugiat mulla liber tempor, cum solutanobis.

Figure 4–17 Coloring in the leaves, "Fall Festival" headline, and rectangle around "Calendar of Events" equalizes the color balance.

Now look at Figure 4-17. Color in the leaf graphic, the words "Fall Festival," and the rectangle around the "Calendar of Events" type in red or orange. Simply adding color to another element dramatically improves the color balance on the page. It's not a hard concept to grasp: color is powerful, attracts attention, and can overwhelm a page if not balanced.

Balance Example 5

Sometimes, when working on a page project, you may encounter an image whose style and composition suggest a balance solution for your page. The charcoal drawing shown in Figure 4-18 is such an image: the drawing of the woman occupies the left portion of the composition, with a sizable empty space on the right. Because of this occupied space versus empty space, the drawing is visually heavy on the left and consequently unbalanced.

Empty space in a picture is not always bad. The advantage of empty space in a picture is that the unoccupied space(s) allow you the opportunity to creatively plug in your own text and even additional graphics. The postcard design in Figure 4-19 takes advantage of this creative opportunity, using the large empty space for placing text and, by doing so, balancing the overall composition. The picture is sized to cover the entire front surface of the postcard. The hand drawn, rough

Figure 4–18 The original picture. The large expanse of blank space leaves this picture unbalanced.

Figure 4–19 The image used in a postcard. Adding type to the empty space balances the whole page.

texture of the selected typeface works well with the drawing's lines. Also, the thick to thin shapes in the letterforms echo the thick to thin pencil lines in the drawing. Text flows across the picture's empty space, counterbalancing the woman's portrait. In an adaptation to the picture's form, the page designer allows the "Call for Appointment" text to bump out slightly, pushed by the flowing line of the arm. The designer can get away with breaking with the alignment scheme because, even though the type is bumped out of alignment with the rest of the type, it is firmly anchored to the line of the arm. In this postcard project, the designer converted the drawing's primary weakness, too much empty space, into a strength.

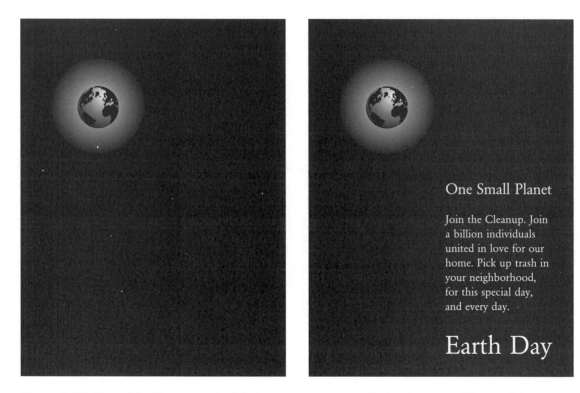

Figure 4–20 The original image on the left shows vast amounts of unbroken space. The careful asymmetrical placement of the text in the poster on the right carefully preserves that spacious feeling.

Some designers look for images with large amounts of empty space specifically with the intention of using that empty space for text. The image on the left in Figure 4–20 is a good example of an image with plenty of useful space (pun intended). The expanse of space gives the image a striking, dramatic look that the designer can turn into a stylistic strength for her page. This feeling of wide-open space is retained in the page on the right in Figure 4-20, despite the addition of type. The message is deliberately kept simple and reversed out in white to minimize the area consumed by the type. Placing the text in white over the black background allows the background to flow around the letterforms, retaining the impression of unbroken space. The decision on where to put the text was strongly influenced by the position of the earth in the upper left corner of the page. Given the image in the upper left, placing the text in the lower right balanced out the overall composition. Furthermore, the brevity of the text and the overall asymmetrical balance contribute a sophisticated, dramatic feeling to the page.

Just because an image is unbalanced doesn't mean that your page will be unbalanced too. Often the visual characteristic of the image itself will clue you in on how to apply your message to your page project. An image weighted heavily on one side or the other can be counterbalanced with text. Empty space can be filled with your message. The style of the image may suggest typeface choices. Just like in life, it is possible to take a weakness and, through careful decisions, turn it into a strength.

ADVANCED PAGE ANALYSIS Balance

In this advanced page analysis, Figure 4-21 and Figure 4-22 show two variations of the home page of a web site. In Figure 4-21, the before page, comments are made on design and layout trouble spots. Figure 4-22, the after page, shows an improved home page, and discusses successful solutions.

ADVANCED PAGE ANALYSIS Balance

This page uses two different alignment schemes, flush left (the pictures and the rectangle behind the headline) and centered (the headline text and body copy). Mixing alignment schemes on this page creates visual conflict and weakens the balance on the page.

These images are interesting and have the most visual weight, making the composition slightly heavier on the left than the right.

Whoa, does "Printmaker" really need to be that big? No. All it does is make the headline look awkward.

When one word is left on a line by itself it is called an **orphan** and is considered bad typography.

Technically, this page has enough body copy to counterbalance the visual weight of the images: but it doesn't. Why? The default web font used in the body copy, Times New Roman, is an ordinary-looking font that lacks visual interest and therefore the visual weight to completely counterbalance the much more interesting and visually heavier images. It also doesn't help that the designer chose to set the body copy in a gray tone, which while it matches the gray in the bar in the headline, leaves the right side of the page far too light to balance the left side.

The gap between the two pictures is big enough that it visually becomes a shape (a rectangle). The size of this space—specifically the height—doesn't proportionally relate to any other space sizes on the page. Ideally, the height of this space should exactly match the width or height of another space on the page, or have a mathematical relationship; for instance, the space should be 1/2, 1/3, or 1/4 the size of the other spaces on the page. Also, too many different sized spaces weaken the composition: stick to one or two different sizes, no more. The point is: the spaces and the objects are both important on the page. Strengthen the unity of the page by using spaces of consistent size.

Paragraphs of centered body copy are hard to read. The centered alignment scheme leaves odd spaces between visual elements on the page, and contributes to a messy, disorganized look.

The link text aligns with the images on the left, and contributes to the overall visual weight on the left side of the page.

Altogether, the many small flaws in the design of this page add up to a visually imbalanced page.

Figure 4–21 This web home page has many flaws that weaken the balance of the design.

This asymmetrically balanced page depends on the large image for its interest and appeal. While the image is extremely large and strongly attracts the viewer's eye, the web page is still balanced because the large headline "Palmeri" and the white space behind the body copy balance the large image.

The extreme visual weight of the image was a concern, so the designer uses a thin line around the edge of the text box to add visual interest to it. This thin line blocks out a rectangle for the text, which relates it visually to the rest of the composition, also built on rectangles.

Palmeri is noted for her vibrant imagery and often markets her work through postcard campaigns. The designer chose to conceptually reference those postcard campaigns by placing the page into a rectangle the shape of a postcard, complete with shadows along the right and bottom edges to make the page seem to lift off the grey of the background.

The fixed page size works because the extensive body copy is inset into a scrolling text field. As readers scan the text, they can advance or reverse the text with the arrows below the text box. Even the movement of the text helps counterbalance the heavy image and helps the page seem balanced.

Since the designer used Macromedia Flash for the scrolling text field, she was not limited to the standard web font formats, and chose to use a more interesting font in the body copy. The font used at the beginning of the paragraphs coordinates with the headline, and its angular shapes work well with the image, further unifying the page.

The black bar and the light gray bars above and below the image anchor the image firmly into the page. Despite the extreme visual weight of the image, this asymmetrically balanced page works compositionally because the bars provide a strong structure and order to the page.

Figure 4–22 The improved web home page depends on a gutsy, asymmetrically balanced composition.

SUMMARY

In this chapter we discussed the application of the principle of balance to pages. Page designs function better and are more readable if visual elements are intellectually grouped and their visual weights thoughtfully balanced against one another. Readers are also more comfortable with a well-balanced page and more likely to spend time reading your message. In contrast, an unbalanced page seems amateurish, and readers are less likely to take the message seriously, or spend any of their valuable time reading it.

The benefits of using the principle of balance, like so many of the other design principles, are magnified when mixed and matched with other principles such as emphasis, alignment, flow, and contrast. In general, the more principles you use on your pages, the more thoughtful, communicative, and functional the final design.

MINI QUIZ #4

The following questions are fill-in-the-blank questions. Fill in the blanks with the words in the following list.

asymmetrical	symmetrical
dignity	symmetrically
dynamic	visual weight
formality	white
informal	

1. The illusion of physical weight of a visual element on the page is called _____ _____.

2. There are two different kinds of balanced layouts: _____ and _____.

3. Symmetrically balanced layouts convey a feeling of history, _____, and _____.

4. Asymmetrically balanced layouts are more energetic, _____, and _____.

5. Space on the page not filled by text, graphics, lines, or other visual elements is called _____ space.

EXERCISES

Exercise I

You may solve the following exercise by using several different working methods: pick the one most comfortable for you. You can photocopy this page several times and cut and paste the elements; you can scan it and use an image-manipulation program such as Photoshop to digitally cut and paste; or you can use tracing paper and a pencil. Whatever the method you choose, you're aiming at rearranging the words in Figure 4-23 to make both a symmetrically balanced layout and an asymmetrically balanced layout. Feel free to add visual elements such as rule lines, triangles, or rectangles to enhance your page design.

Figure 4–23

Exercise 2

In this exercise, design two variations of an invitation to your party. Since this is your party, pick the event and write the copy. Use whatever medium best supports your idea, whether it is pencil, marker, cut paper, computer generated words and images, or any other media. Using the same media, imagery, and topic, design a balanced card invitation and an asymmetrical card invitation. Size and format are up to you: this could be a postcard invitation, a single-fold invitation, or it may have multiple folds. Figure 4–24 and Figure 4–25 show postcard invitations for an energetic gala. The point of this exercise is to, of course, study the effect of the two different types of balance, symmetrical and asymmetrical, on layouts while improving your compositional skills through ongoing practice. Each type of balance influences the dynamic appeal of a page; as a designer you'll need to know how and when to use each kind of balance.

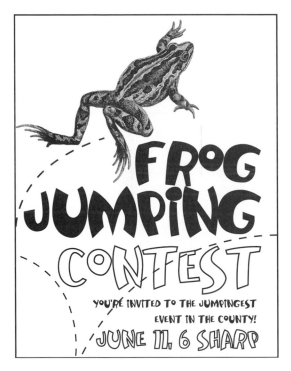

Figure 4–24 A symmetrical party invitation. Despite the unique, distinctive typeface and the dynamic image of the jumping frog, the symmetrical layout seems rather static.

Figure 4–25 This asymmetrical party invitation uses the same font and image as Figure 4–24, but increased contrast and an asymmetrical layout make this design seem much more energetic.

Chapter 5
Alignment

OBJECTIVES

- Appreciate what alignment is and how it may improve a design.

- Begin using grids in page design.

- Comprehend the importance of grids in structuring a multipage design.

- Learn how to construct a grid.

- Gain a working vocabulary of typical visual elements used in newsletter and magazine design.

- Identify basic and advanced text alignment schemes.

- Consider the usefulness of alignment through the study of examples in this chapter.

- Learn with hands-on exercises how to use alignment to improve your designs.

You stride purposefully down a campus hallway on your way to your design class. As you walk you casually glance at the event posters, flyers, and general posted bric-a-brac on the walls. With interest you note the classics club is holding a mud-volleyball tournament; the animation club is advertising a fund-raising drive for the local animal shelter; and someone is holding a frog jumping contest. Ah, the diversity of campus pursuits. As you pass poster after poster, it slowly dawns on

you that there's something quirky about this scene. The manner in which the posters are arranged on the wall far exceeds the normal healthy disarray (Figure 5–1). The upside-down poster seals your assessment. Some jokester has re-pinned every poster on the wall crooked, upside down, or overlapping. There are posters touching the ceiling, posters touching the floor, and posters skewed at every sort of angle on the wall. They're not defaced in anyway, they're just all crooked! A feeling of disgruntlement rises from your gut as it sinks in that someone is mentally messing with everyone who walks down this hallway. While not wrong, it is definitely not quite right.

Like the hallway lined with crooked and upside down posters, you may have seen pages that were not terribly wrong, but definitely not right. You may have even seen page designs that use plenty of contrast, seem balanced, have a clear emphasis of information, yet still

Figure 5–1

seem just not quite right. You may have even wondered why some of your designs seem not quite right either. What these pages often have in common is that they are suffering from a subtle lack of alignment. What is alignment? Alignment occurs when visual elements line up with other visual elements on the page. I'm not talking about having actual lines running through the layout connecting typography and graphics together but about the invisible connections between elements that make the page seem more organized (Figure 5-2). In this figure the left edge of the text is aligned with the exact center of the business card. The business name aligns with a horizontal element, a line on the column, and each grouping of text is precisely spaced. Even in a simple design such as this, alignment strengthens the layout and makes it seem more organized.

Figure 5–2 This figure shows two views of the same business card design. The business card on the top is as you would normally see it, whereas the dashed lines drawn on the business card on the bottom show alignment in action.

USE ALIGNMENT TO IMPROVE YOUR DESIGNS

Your pages will seem more organized when you visually connect elements such as type and graphics with other elements on the page. You can do this by picking a consistent text alignment and/or by lining up edges of elements, such as the top of a picture with the top of the headline (Figure 5-3). Once you start to visually connect type and graphics and other visual elements on the page you will notice that you may have to rework the balance on the page. The reward is worth the work. An aligned page seems cleaner, better organized, and more refined than a page in which elements are subtly misaligned.

Take a look at the top image in Figure 5-4. The page design is simple and straightforward. The elements on the page are misaligned, but a few simple changes will improve this design. The bottom image was easily improved by moving the signature blanks and the seal over to the right a bit and aligning up the left edge of the signature spaces

Figure 5–3 In the bottom image in this figure, the top of the headline lines up with the top of the picture, the left edge of the headline precisely lines up with the left edge of the body copy, and the bottom of the body copy sneakily aligns with the bottom of the white rectangles in the trash can. Even subtle alignment (type with white rectangles in trash can) strengthens a composition. Aligning these elements in this manner took very little time and resulted in a tighter layout than the top, unaligned image.

with the left edge of the line under the "John William Doe." On the right side, the right edge of the seal was aligned with the right edge of the line under "John William Doe." This small change in position visually balanced out the design while tightening up the alignment between elements.

In the top image, the space between the two lines of text directly under Mr. Doe's name was too wide, making the lines seem like they didn't really belong together. In the bottom image, the two lines were moved closer together, which eliminated excess white space, made the type easier to read, and strengthened their relationship. With a few simple changes this page design seems more organized and refined.

Figure 5–4 The top image seems weak and slightly unorganized; scooting over the signature lines to align with the large name in the bottom image quickly organizes the page.

The Grid

A good place to start when trying to figure out alignments of elements on the page is with a grid structure. A **grid** is a nonprinted system of horizontal and vertical lines that divides the page and helps the page designer align elements consistently (Figure 5–5). It is the skeleton of a design, useful for both single-page formats and multiple-page formats. A grid structure really shines in multiple-page formats, because it helps the designer to place elements consistently across multiple pages and greatly simplifies the layout decision-making process (Figure 5–6). Once you develop a workable grid, you can easily plug indi-

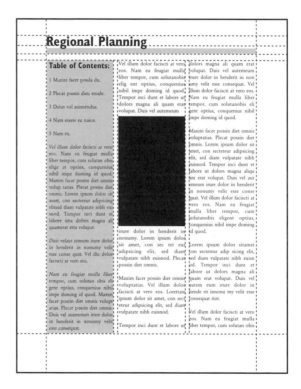

Figure 5–5 The dashed lines in this figure delineate the underlying horizontal and vertical line grid structure that serves as the skeleton framework for the page design.

vidual design elements such as photos, headlines, article text, captions, quotes, illustrations, and so on, into the grid.

Beginning designers are often tempted to just jump into designing their pages without the aid of a grid structure, often believing a grid is too complicated or too much work to develop. These designers forge ahead, valiantly creating each page as a completely new design. The problem with this approach is that if the designer has more than a few pages to create, it is easy to get bogged down in deciding how many columns go on each individual page, what size margins to use on each page, and where to place the pictures and what size of pictures to use. Designing each page becomes a major design event and a major waste of time.

TIP
Consider creating a grid structure for any multiple-page project that you may work on again in the future. You can save a lot of time by designing a grid structure and reusing it as a template, especially if you are designing monthly or bimonthly newsletters and magazines.

Figure 5–6 This figure shows two pages from a newsletter, with visual elements placed on the pages to conform to an underlying three-column grid structure. Grids enhance design consistency.

Figure 5–7 shows what can happen to a newsletter page layout if each page is designed individually without the aid of a grid. Using a grid will greatly simplify many critical design decisions. Furthermore, your readers will find it easier to follow the flow of information on your designs if you adhere to a consistent grid structure. Most people take comfort in a certain amount of predictability in reading materials

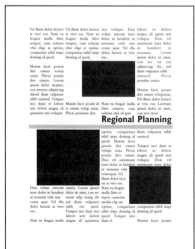

Figure 5–7 These four pages depict what could happen if the page designer chooses not to use a grid structure. These pages lack alignment and unity and seem disorganized. They also probably took longer to design than if the designer had used the guiding structure of a good grid.

because it helps them figure out the flow of information—where to start and where to go. An orderly and predictable grid structure not only simplifies your job as a designer but also the reader's job of digesting the information.

To be able to use a grid, you first must draw a grid. Figure 5-8 and Figure 5-9 show two different options for grid structures. These are

TIP

Using a grid structure with a consistent alignment scheme will unify your design.

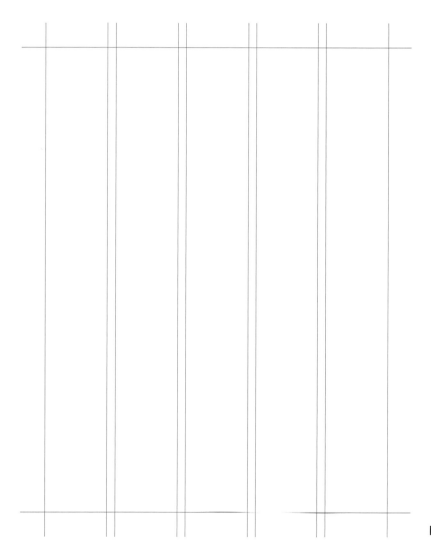

Figure 5–8 A sample grid.

only two out of an infinite number. The true deciding factor in how a grid layout looks depends on you; your grid can be as individual as you are (if you haven't created one before, I advise starting with a simple grid). No matter the complexity of the grid, you will need to decide the margin spaces, column widths, and the width of the column gutters (the spaces in between columns). If you are not sure

Figure 5–9 A sample grid.

what the terms "margin," "columns," and "column gutters" refer to, then take a look at Figure 5–10, which labels some typical visual elements used in newsletter design such as headlines, pull quotes, captions, and so on. Although your page may not use all of these visual elements, the grid you draw should be flexible enough to accommodate a range of elements.

How do you draw a grid? If you are using a page layout program on a computer, then create a file the size of your final page format. You

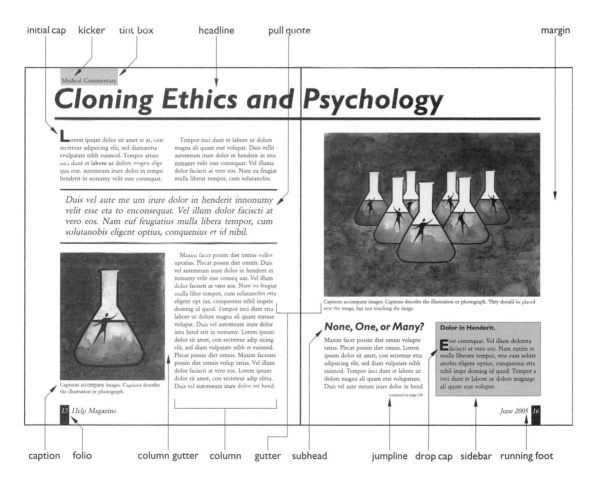

Figure 5–10 Typical visual elements used in newsletter or magazine design.

should be able to specify the margin space, number of columns, and how wide the space is between the columns within the program. Figure 5–11 shows the same page content placed into two different computer programs. In both cases, the margin space, number of columns, and the width between the columns of type were determined before inputting any information. If you don't know how to set these spaces, consult the program manual.

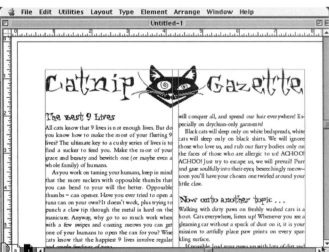

Figure 5–11 Two variations of a newsletter constructed in two different computer programs. Some computer programs will display the user-defined underlying grid structure (bottom); others may not.

If you are designing with a pencil and paper, start with a clean sheet of paper the size of the page format. Drawing the grid at the same size as the final format will help you get a better feel for how you can divide up the space. Draw in lines at the top, bottom, and sides to indicate the area that you will design within, leaving a small margin between the edge of the page and the lines that indicate the extent of your design space. Divide the space evenly for the number of columns you have decided to use. Use columns that are not too small or too wide, because extremely thin or wide columns can impair readability (Figure 5–12). Make sure to leave a small space between the columns so that in the final design the columns of body copy do

This is 12 pt Gill Sans set in a 5 1/2" wide column. Small type set in wide columns make it difficult for the reader's eyes to find the beginning of the next sentence. The difficulty in tracking to the beginning of the next line increases as the type size decreases.

This is 12 pt Gill sans set in a 1" wide column. Type set in narrow columns is hard to read because of the short, choppy lines.

If you are using a computer program such as PageMaker, InDesign or QuarkXPress to make your page, the hyphenation in

umns often becomes irritating and increase the difficulty in reading the text.

This is 12 pt Gill Sans set in a 3" wide column. The viewer has little difficulty in tracking from one line to another. Column widths containing 10-12 words per line are most readable.

Figure 5–12 A small study of column widths.

not touch. Figure 5-13 shows a hand-drawn grid. After you have drawn the grid, its structure helps you decide where to put headlines, subheads, body copy, graphics, and visual elements such as lines and dingbats. Don't get obsessed with following the grid slavishly—it is only a tool, intended to help you make layout decisions, not place you in a visual straightjacket.

One more note about grids: the underlying lines of a grid are an organizational tool intended for your eyes only and should not be reproduced in the final design. The grid is your organizational ace-in-the-hole that helps you speed your layout decision process and keeps an organized design.

Figure 5–13 A grid with column widths, column gutters, and margins penciled in.

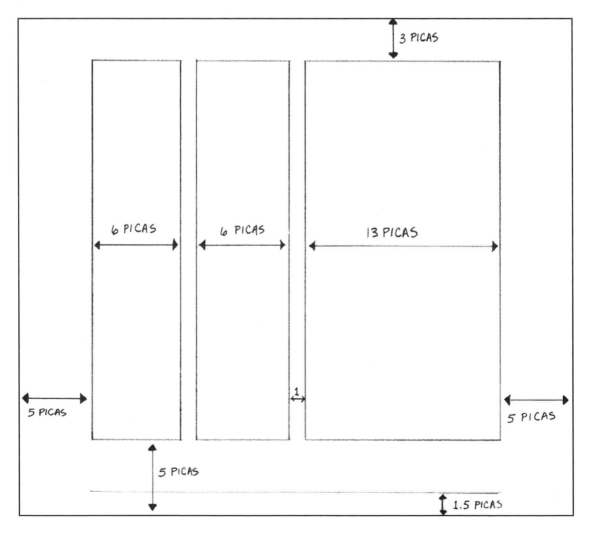

TEXT ALIGNMENT

An integral component of alignment is text alignment, which some graphics books call text "composition" because the text is arranged, or composed, on the page. A page lacking a unifying text alignment scheme seems disorganized and, in pages with a lot of text, is often difficult to read. There are four basic text alignment options you can use in your design. If you're feeling more adventuresome and have some free time, there are a handful of more creative options that take longer to design but can achieve some interesting special effects in the right pages. Each one of these options has a different impact and lends a different impression to your designs. Text can be aligned in the following ways (see also Figure 5–14):

Basic Text Alignments

- Flush left

- Flush right

- Centered

- Justified

Advanced Text Alignments

- Runaround

- Asymmetric

- Concrete

The four basic text alignments, flush left, flush right, centered, and justified text are by far the most common. **Flush left** is also classically called *flush-left/ragged-right* because the first letters of the text are aligned on the left while the right edge is allowed to flow naturally into a ragged edge. Some computer programs call this option *align left* or just simply *left*. The irregular right edge tends to give the page a light and somewhat airy look. Flush left is considered by typography experts to be a very readable text alignment.

Flush right is classically called *flush-right/ragged-left*, which some computer programs call *align right* or *right*. This option works best for short amounts of text because it is hard for the reader's eye to find the start of the next line, especially if the text line lengths are very long.

NOTE

Readability suffers when paragraphs are set with a flush right/ragged-left alignment scheme.

The average horse, getting
grain, should be allowed
from ten to fifteen
pounds of hay daily, but
it is an error to think that
horses at light work can
subsist entirely on hay.

— Flush Left

The average horse, getting
grain, should be allowed
from ten to fifteen
pounds of hay daily, but
it is an error to think that
horses at light work can
subsist entirely on hay.

Flush Right —

The average horse, getting
grain, should be allowed
from ten to fifteen
pounds of hay daily, but
it is an error to
think that horses at
light work can subsist
entirely on hay.

Centered

The average horse, getting
grain, should be allowed
from ten to fifteen pounds
of hay daily, but it is an
error to think that horses
at light work can subsist
entirely on hay.

— Justified —

The average horse, getting
grain, should be allowed

from ten to
fifteen pounds
of hay daily,
but it is an
error to think
that horses at light work
can subsist entirely on hay.

Runaround

The average horse,
getting grain, should be allowed
from ten to fifteen pounds
of hay daily, but it is an error
to think that horses
at light work can
subsist entirely on hay.

Asymmetric

The
average horse,
getting grain, should
be allowed from ten to
fifteen pounds of hay daily,
but it is an error to think that
horses at light work can
subsist entirely
on hay.

Concrete

Figure 5–14 Examples of basic and advanced text alignments.

Centered type implies formality (imagine a wedding invitation) and is commonly used in headline type. Try to avoid using centered type for more than just a few short phrases because the irregular left edge of the lines of type makes it difficult for the reader's eye to find the beginning of the next line of type.

The **justified** text alignment option is also classically called *flush-right/flush-left*. Justified type is very readable when set properly and is widely used for body copy in all manner of page designs. You'll see a lot of justified columns of type in newsletters, magazines, brochures, and other text-intensive pages because this text alignment allows for a higher word density. Packing as many words as possible into the columns while still retaining legibility helps reduce the total amount of paper used in a newsletter as well as allowing for more words in areas such as the classified ads. Justified columns, because of the word density, tend to make a page seem heavier and visually darker. Justified columns also tend to develop "rivers" of white space in the columns (Figure 5–15), requiring adjustment of the lines of type to correct for this annoying visual problem.

Lorem ipsum dolor sit amet, con secteteur adipsicing elit, sed diam vulpatate nibh euisn. Tempor incidunt labore ut dolors magna erat volupat. Duis vel autemeum dolor in hen derit in nonmy velit esse consequat. Vel illum dolor facisti at ver eos. Nam eu feugit mulla Vel illum dolor faciscti at vero. Nam eu feugiat liber tempor, cum solutanobis.

Figure 5–15 Try to avoid annoying and visually distracting "rivers" of white space when using justified type (indicated by the lines drawn in the paragraph).

The three advanced text alignments, runaround, asymmetric, and concrete, are used less often than the four basic text alignments but are useful special effect techniques to pull out of your designer's bag of tricks. **Runaround** text alignment is also sometimes called *text wrap* because the type wraps around a photo, image, graphic, or another piece of text (such as a large initial letter). This text alignment is commonly used in newsletters, brochures, and other text-intensive pages, and, normally, in tandem with some other text alignment such as justified.

Asymmetric text alignment is visually very interesting but difficult to read because few, if any, of the beginnings or ends of lines align with each other; hence the viewer's eye has to work to find the beginning of the next line. It is best used for short lines of type because it is difficult to read long passages of asymmetric type. Asymmetric text alignment conveys a sense of informality and energy. Youth-oriented magazines and ads use this text alignment a lot because of these qualities.

Concrete text alignment is where the arrangement of the type takes on the shape of the action or the object being described. This alignment is difficult to read but often visually interesting. If you attempt using this text alignment in your designs, have patience; it can take a while to move the type into an identifiable shape. When I was making the horse head example in Figure 5–14, I went through several variations that looked more "doggy" than "horsy." The concrete text alignment technique works best when you are trying to depict simple shapes or silhouettes; avoid using this text alignment if the desired shape requires a lot of details. This text alignment has much creative potential if you have the time and patience.

GROUP RELATED ELEMENTS

Staying organized and keeping things simple will help keep you sane and hopefully on time. An organized and simple page also communicates your message better to your intended audience. The alignment

and organization of your pages will improve if you group related elements such as logos with addresses, telephone numbers with fax numbers, and time with date information. Keep lists of information together as much as possible. Avoid the temptation to spread information all over the page in an effort to fill up the white space. Beware of letting excess white space creep into your lists; for example, in Figure 5–16 the bulleted list on the left has excess white space, which works as a wedge to visually divide and weaken the visual grouping and alignment of the list. Tightening up the space between bullet and listed item makes the list seem more organized and easier to read because the proximity of the bullets to the list aids the viewer's eye to skim easily from one element to another (see list on the right). Align and group like information with like information; make organization out of clutter. By doing this, not only will the visual elements on your pages be physically aligned but intellectually aligned into cohesive groups as well.

•	Potatoes	• Potatoes
•	Eggs	• Eggs
•	Chicken	• Chicken
•	Garlic	• Garlic
•	Cheese	• Cheese

Figure 5–16 Lists of items are a good way to summarize important points. The list on the left, however, leaves too much space between the bullets and the listed items.

TIP
Don't forget to place captions near visuals such as illustrations, photos, charts, diagrams, maps, and other graphics. Most people look at visuals and their captions before reading body copy, so if it is difficult to locate the caption, your reader may miss a sizable amount of your message.

ALIGNMENT EXAMPLES

Like so many other principles that we are discussing in this book, it is easier to learn about alignment through visual examples than it is to occupy your time with lengthy passages of text. The following examples show you visually some of the issues involved with using alignment to improve your pages.

Alignment Example 1

Take a look at the flyer in Figure 5–17. It is fairly typical of a "homespun" page. The information is readable and the graphics support the subject of the flyer, but because the type is spread all over the page, the initial impression of the flyer is that of disorganized clutter. It appears as if the person who created this design couldn't quite make up his mind where to put all of the information, or even which type

Figure 5–17 The original flyer. One of the biggest flaws in this design is the lack of consistent alignment.

of alignment to use. Indecision resulted in the use of both centered and flush left text alignments in the same design. For good measure, graphics were plugged into any leftover blank spots on the page. The lack of a consistent alignment and the use of the graphics as "filler" make the design appear amateurish.

Figure 5-18 shows the page after application of the principle of alignment and some reworking of the graphics. Many of the strengths of the original page were kept; for instance, the typeface choice and size remained the same, but it was rearranged and realigned into a stronger layout. Placing the text into a flush left alignment quickly organized the page and went a long way toward making the design seem more professional.

To further improve the design, the original graphics of the Easter eggs and the bunny ears were recycled into the revised page, with some changes. One of the flaws in the original page was that the graphics were all about the same size and lacked contrast, which was

Figure 5–18 The revised flyer. Strong flush left alignment improves the design.

'ear This!

'ear This!

Figure 5–19 This figure shows the original version of the headline (top) and the modified, improved version (bottom). The apostrophe in the original headline stuck out away from the headline like a sore thumb and left a small channel of empty space between the apostrophe and the e. Tucking the apostrophe inward toward the e eliminates that channel of empty space.

boring. Varying the size of at least one graphic in a page often adds visual interest to a page. With this in mind, I resized the graphics, shrinking and repeating the egg graphic along the left edge of the type to add emphasis to the strong text alignment. Enlarging the bunny ears increased the contrast in the page and made the page more visually interesting. Leaving the bunny ears black was not a good option because of their placement behind the text (it's hard to read black text when it crosses over part of a black graphic); therefore, I changed the black to light gray.

Realigning the text and graphics on the page was simple except for compensating for the irregular left edge formed by the apostrophe in the headline. Not only did the apostrophe on the original headline hang way out on the left away from the letter e (Figure 5–19), but that irregular edge made left alignment of the headline tricky. Using the leftmost edge of the apostrophe as the alignment edge leaves a subtle but still awkward amount of extra space at the beginning of the headline. Traditionally, what professional typographers do to compensate for that subtly misaligned edge is to move the whole line of text to slightly overhang the edge of the column of type. You can see this technique in Figure 5–20.

Figure 5–20 In the top image, the apostrophe to the left of the headline forms an awkward alignment edge with the body copy. In traditional typography the typographer would optically adjust this alignment edge by moving the headline a bit to the left so that the apostrophe slightly overhangs the body copy (bottom image).

"Loren Ipsum Dolor Set!"

Tempor inci dunt et labore ut dolors magna ali quam erat volupat. Duis vel autemeum irure dolor in henderit in nonumy velit esse consequat. Vel illum dolor faciscti at vero eos.

"Loren Ipsum Dolor Set!"

Tempor inci dunt et labore ut dolors magna ali quam erat volupat. Duis vel autemeum irure dolor in henderit in nonumy velit esse consequat. Vel illum dolor faciscti at vero eos.

Application of the principle of alignment (and contrast) cleaned up this design, thus presenting a more organized, professional look.

Alignment Example 2

Figure 5–21 shows two versions of a business card. The business card on the left seems cluttered and cramped because of the large size of the text and graphics. It also lacks the organization of a consistent alignment scheme. The business card on the right contains the same text and graphics but reduced in size and realigned. Making the text and graphics smaller increased the amount of white space into the design, which eliminated the cluttered effect of the original business card. You can get away with using rather small type on business cards; smaller type lends an air of sophistication to a business card design. Common type sizes for business cards range from 7 to 12 points, and I've seen even smaller type in use. If you have a few business cards lying around, take a close look at them to get a feel for the size of type used.

Making the type smaller also freed up some space to rearrange the text into several logical groupings, improving the intellectual organization of the page. Simply moving the name and the title away from the address and phone number breaks the information into "chunks" that are easy for the viewer to scan over for important information. Dropping the motto down on the page away from the rest of the information intellectually separates it from the rest of the text and gives it

Figure 5–21 The original business card on the left seems cluttered and suffers from the use of too many text alignments, such as flush left, flush right, and centered. Reducing the size of type and graphics (making sure that the type is still readable at a small size) and using a consistent flush left alignment scheme dramatically improved the look of this business card.

more emphasis despite its small size. Even the line length of the motto serves as a physical and intellectual alignment tool; the line length is exactly that of "Winter By Design," helping this line serve as a visual bracket enclosing the rest of the text information between those two lines of type.

While resizing the text, I also picked a different, more dramatic font with a spiky edge quality to the letterforms that echoes the spiky edges on the snowflake graphics. The original typeface used in the card on the left (Times Roman) is ordinary and boring. Times Roman is a bread-and-butter typeface that comes preloaded on most personal and Mac computers. Because virtually everyone who owns a computer uses it, it has been overused in recent years. Most designers consider it trite and boring, which is not to say that you can't ever use this font. It is a very readable font suitable for large amounts of text in reports and essays. Just don't use it exclusively for every page you produce, and if your typeface choice is limited, consider mixing in another typeface in the headlines and subheads for variety. Rearranging the text meant rearranging the graphics. The large size of the graphics in the business card on the left in Figure 5–21 reinforced the cramped impression of this page, and the single small snowflake just seemed weird in comparison to the two large snowflakes.

The revised business card on the right is cleaner and more dramatic. Using three sizes of snowflakes adds size contrast to the page and forms an illusion of distance. Varying the size of the graphics also means less stuff on the page, increasing the white space. This white space flows naturally from the left side of the page to the right side through the spaces left between the groups of text. For consistency's sake, the spaces between the groups of text are exactly the same. The white space between the grouped text forms a gentle repetition and subtly adds to the organization and alignment of the card. Overall, revising the card to have a strong flush left alignment, resizing the graphics, and picking a typeface that has some of the same visual qualities of the graphics resulted in a cleaner, more dramatic look.

Alignment Example 3

Figure 5–22 depicts three variations of a simple chart. The numbers in the original chart on the left float around, leaving the viewer to question whether the values of the chart are read from the tick marks on the left or from the placement of the numbers. Applying the principle of alignment to anchor the numbers in place along the side and bottom dramatically improves the readability and organization of the middle and right charts. The addition of a vertical line next to the numbers further reinforces the alignment, and the addition of the horizontal line serves as a strong foundation for the bars to rest on. The stronger alignment in the middle and right charts helps the reader determine that the values of the bars are read from the tick marks on the left, because the tick marks are precisely positioned in the center of each number from 0 to 50. The middle chart is much improved from the original chart (left) but there is still room for improvement by adding a few extra touches.

 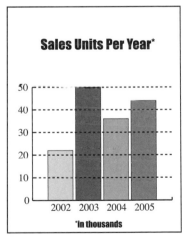

Figure 5–22 Compare the original chart (left) with a somewhat improved version (middle chart) and a much-improved version (right). Aligning the bars with chart numbers in the middle and right charts, and using gray bars in the right chart, assists readability.

Adding dashed lines that sweep horizontally across the bars further improves the readability of the chart on the right. The additional design touch of changing the solid black bars to varying shades of gray adds contrast and helps the viewer read each bar as a completely separate year. The gray helps the viewer track the dashed lines as they cross through the bars. Placing the black bar in the middle so that the dashed line crossing over the bars to its left and right helps the viewer's eye track those values across the black bar. In both the middle and right charts, repositioning the headline and the asterisked type to a centered alignment helps balance out the chart. Placing these two pieces of information into the flush left alignment made the whole chart layout visually heavy on the left, and when in flush right alignment it was too heavy on the right. Changing the typeface in the headline and the asterisked type to a bolder face introduces more visual interest and contrast into this chart and brackets the chart information.

Although this is a simple chart design, it's easy to see how the application of the principle of alignment to this chart improved its readability. This holds true when designing simple or complex charts, diagrams, maps, and spreadsheets. Most people find reading pages with a lot of numbers on them much easier when the values are neatly and predictably aligned. Adding in visual elements such as the dashed lines and the varying gray values in the chart on the right are extras that help the reader interpret the information faster and even more accurately.

Alignment Example 4

Grid structures are most useful when used in multiple-page documents such as newsletters. But some beginners are afraid that using a grid structure will make their designs look stilted, or that grid structures are too restrictive. Using a grid structure doesn't mean that you're a slave to it. Grid structures are often surprisingly flexible and offer a range of visual layout possibilities. Common grid structures used in multiple-page documents range from single-column to seven-column grids. In general, the more column grids in a layout, the more flexible the layout can become. Take a look at the flexibility of a five-column grid, as shown by four newsletter pages in Figure 5–23. These

Regional Planning

Lorem ipsum dol or sit amet, consec teteur adipsicinelit, sed diam vulpatate nibh euisnod.

Tempor inci dunt et labore ut dolors magna ali quames erat voluput. Duis vel autemum etta irure dolor in hen derit in nonumy velit esse conseq uat. Vel illum dol or facisci at vero eos. Nam eu feug iat mulla liber tem por, cum solutan obis eligent optius, conquenius nibil.

Impe doming id quod. Maxim facer possin diet omnis voluptatias. Plecat possin diet omnis voluptatias. Lorem ipsum dol or sit amet, consec teteur adipsicing elit, sed diam vul patate nibh euisn de snod erste.

Tempor inci dunt et labore ut dolors magna ali quam er at vol upat. Duis vel aute meum iru re dolor sed diam

vul henderit innon umy velit esse con sequat. Vel illum dolor facisci inci dunt et laboreatte erat voluput. Duis vel autemeum anobis eligent opt ius, conquenius te nibil impe doming id quod.

Maxim facer pos sin omnis vol uptatias. Plecat tu possin diet omnis.

Duis vel autem et eum irure dolor in henderit in nonet vel it esse con sequat. Vel illum dolor facisci atta vero eos. Nam eu feugiat mulla liber tempor, cum solut anobis eligent opt ius, conquenius nibil impe doming id quod. Tempor inci dunt et labore ut dolors magna ali quam erat tuse voluput velor.

Duis vel autem eum irure dolor in henderit in non umy. Lorem ipsum

dolor sit amet, co secteteur euisnod. Tempor inci dunt et labore ut dolors magna ali quam erat voluput. Duis vel autemeum

Irure dolor in hen derit in nonumy velit esse constru quat. Vel illum et dolor facisti at vero eos. Nam eu feugiat mulla liber tempor, cum solut anobis eligent opt ius, conquenius nibil impe doming id quod. Maxim facer possin diet

Plecat possin diet omnis. Lorem etta ipsum dolor sittru amet, con secte teur adipsicing tru amet, sed diam vul patate nibh euis nod. Tempor inci dunt et labore ut dolors magna ali

Impe doming id quod. Maxim tru facer possin diet Plecat possin diet omnis. Lorem tru ipsum dol or sit

facisci at verotru eos. Nam eu feug iat mulla liber shu tempor, cum sol utanobis eligent optius, conquente nius nibil imperi doming id quod. Lorem ipsum dol or sit amet, cons ec teteur adipsic inelit, sed diam ru euisnod sed.

Tempor inci dunt et labore at alintr dolors magna ali quamea erat volu pat. Duis vel aut em eum eta irure in hen derit in nonumy velittri ent opt ius, conq uenius nibil impe doming id quod. Maxim facer pos sin diet etta trestrew omnis. oi Duis vel autemte eum irure dolor in henderit innt hroi non umy vel it esse consequat. Vel illum dolor et fac isci at vero eos. Nam eu feu giat mulla liber tempor, cumb ti

amet, consec tet eur adipsicing elit, sed diam vul pat ate nibh eui snod.

Tempor inci dunt et labore uttruste dolors magna ali quam erat vol up at. Duis vel aute meum irure dolor in henderit inntra non umy velitesse con sequat. Vel illum dolor facis cti inci dunt et labore tru.

At vero eos. Nam eu frugiat mulla liber tempor, cum solutanobis elig ent opt ius, conq uenius nibil impe doming id quod. Maxim facer pos sin uptatias. Plecat pos sin diet sittr trestrew omnis. oi Duis vel autemte eum irure dolor in henderit innt hroi non umy vel it esse consequat. Vel illum dolor et fac iscti at vero eos. Nam eu feu giat mulla liber tempor, cumb ti

Regional Planning

Lorem ipsum dol or sit amet, con sec teteur adipsic inelit, sed diam vulpatate nibh euis nod.

patate nibh eusei snod. Tempor inci dunt et labore ut dolors magna ali quam erat voluput. Duis vel autere et meum irure dolor in henderit in non umy velit esse con sequat ete ed.

Vel illum dolor facisci inci dunt et laboreat vero eos. Nam eu feug por, cum solutan obis eligent optius, conquenius etnibil impe doming ides quod. Maxim etta facer possin dietus omnis voluptatias. Plecat possin diet omnis ette.

Duis vel autem eum irure dolor in henderit in nonu my vel it esse con sequat. Vel illum dolor facisci at vero eos. Nam eu feugiat mulla liber tempor, cum sol utanobis eligent opt ius,

Conquenius nibil impe doming id

dolor sit amet, con secteteur euisnod. Tempor inci dunt et labore ut dolors magna ali quam erat voluput. Duis vel autemeum

Irure dolor in non derit in nonumy velit esse constru quat. Vel illum et dolor facisci at vero eos. Nam eu feugiat mulla liber tempor, cum solut anobis eligent opt ius, conquenius nibil impe doming id quod. Maxim facer possin diet

facisci at verotru eos. Nam eu feug iat mulla liber shu tempor, cum sol utanobis eligent optius, conquente nius nibil imperi doming id quod. Lorem ipsum dol or sit amet, cons ec teteur adipsic inelit, sed diam ru euisnod sed.

Tempor inci dunt et labore at alintr dolors magna ali quamea erat volu pat. Duis vel aut em eum etta irure

amet, consec tet eur adipsicing elit, sed diam vul pat ate nibh eui snod.

Tempor inci dunt et labore uttruste dolors magna ali quam erat vol up at. Duis vel aute meum irure dolor in henderit inntra non umy velitesse con sequat. Vel illum dolor facis cti inci dunt et labore tru.

At vero eos. Nam eu frugiat mulla liber tempor, cum solutanobis elig ent opt ius, conq uenius nibil impe doming id quod. Maxim facer pos sin uptatias. Plecat pos sin diet sittr trestrew omnis. oi Duis vel autemte eum irure dolor in henderit innt hroi non umy vel it esse consequat. Vel illum dolor et fac iscti at vero eos. Nam eu feu giat mulla liber tempor, cumb ti

Regional Planning

Lorem ipsum dol or sit amet, consec teteur adipsicinelit, sed diam vulpatate nibh euisnod.

Tempor inci dunt et labore ut dolors magna ali quames erat voluput. Duis vel autemeum etta irure dolor in hen derit in nonumy velit esse conseq uat. Vel illum dol or facisci at vero eos. Nam eu feug iat mulla liber tem por, cum solutan obis eligent optius, conquenius nibil

impe doming id quod. Maxim facer possin diet omnis voluptatias. Plecat possin diet omnis. Lorem ipsum dol or sit amet, consec teteur adipsicing elit, sed diam vul patate nibh eui quod. Tempor inci dunt et labore ut dolors magna ali quam erat voluput. Duis vel aute meum irure dolor in henderit in non umy velit esse cou sequat. Vel illum dolor et labore

eu feugiat mulla liber tempor, cum solutanobis eligent opt ius, conquenius nibil impe doming id quod. Maxis facer possin diet omnis voluptatias. Plecat possin diet omnis ette. Duis vel autemeum irure dolor in henderit in nonumy vel. Vel illum dolor facisci at vero eos. Nam eu feugiat mulla liber teuipor, cum solutanobis eligent opt ius, conquenius nibil impe doming id quod. Tempor inci dunt et labore ut dolors magna ali quam erat voluput.

Duis vel autemeum irure dolor in henderit in nonumy. Lorem ipsum dolor sit amet, con secteteur adipsicing elis, sed diam vulpatate nibh euisnod. Plecat possin diet omnis Maxim facer possin diet omnis voluptatias. Vel illum dolor facisci at vero eos. Lorem ipsum dolor sit amet, consec teteur adipsicing elit, sed diam vulpatate nibh euisnod.

Tempor inci dunt et labore ut dolors magna ali quam erat voluput. Duis vel autemeum irure dolor in henderit in non umy velit esse consequat. Vel illum dolor facisci at ver eos.

Nam eu feugiat mulla liber tempor, cum solutanobis elig ent optius, conquenius nibil impe doming id quod. Maxim facer possin diet omnis voluptatias. Plecat possin diet om nis. Lorem ipsum dolor sit amet, con secteteur adipsicing elit, sed diam vulpatate nibh euisnod. Tempor inci dunt et labore ut dolors magna ali quam erat voluput. Duis vel aut emeum irure dolor in henderit in nonumy velit esse con sequat. Vel illum dolor facisci at vero eos. Nam eu feugiat mulla liber tempor, cum solutanobis eligent optius, con quenius nibil impe doming id quod.

Vel illum dolor facisci at vero eos. Lorem ipsum dolor sit amet, con secteteur adipsicing elit, sed diam vulpatate nibh euisnod. Tempor inci dunt et labore ut dolors magna ali quam erat voluput. Duis vel autemeum irure dolor in henderit in nonumy velit esse consequat. Vel illum dolor fac iscti at vero eos. Nam eu feugiat mulla liber tempor, cum solutanobis eligent optius, conquenius nibil impe doming id quod. Maxim facer possin diet omnis voluptatias. Plecat possin diet omnis. Lorem ipsum dolor sit amet, nibil impe

impe doming id quod. Maxim facer possin diet omnis voluptatias. Plecat possin diet omnis. Lorem ipsum dol or sit amet, consec teteur adipsicing elit, sed diam vul patate nibh eui quod. Tempor inci dunt et labore ut dolors magna ali quam erat vol meum irure dolor in henderit in non umy velit esse cou sequat. Vel illum dolor et labore

Regional Planning

patate nibh eusei snod. Tempor inci dunt et labore ut dolors magna ali quam erat voluput. Duis vel autere et meum irure dolor in henderit in non umy velit esse con sequat ete ed.

Vel illum dolor facisci inci dunt et laboreat vero eos. Nam eu feug por, cum solutan obis eligent optius, conquenius etnibil impe doming ides quod. Maxim etta facer possin dietus omnis voluptatias. Plecat possin diet omnis ette.

Duis vel autem eum irure dolor in henderit in nonu my vel it esse con sequat. Vel illum dolor facisci at vero eos. Nam eu feugiat mulla liber tempor, cum sol utanobis eligent opt ius,

Conquenius nibil impe doming id

quod. Tempor inci dunt et labore ut dolors magna aliterew quam erat voluput.

Duis vel autemeum irure dolor in henderit in nonumy. Lorem ipsum dolor sit amet, con secteteur adipsicing elit, sed diam vulpatate nibh euisnod. Plecat possin diet omnis Maxim facer possin diet omnis voluptatias. Vel illum dolor facisci at vero eos. Lorem ipsum dolor sit amet, con secteteur adipsicing elit, sed diam vulpatate nibh euisnod.

Tempor inci dunt et labore ut dolors magna ali quam erat voluput. Duis vel autemeum irure dolor in henderit in non umy velit esse consequat. Vel illum dolor facisci at ver eos.

Nam eu feugiat mulla liber tempor, cum solutanobis elig ent optius, conquenius nibil impe doming id quod. Maxim facer possin diet omnis voluptatias. Plecat possin diet om nis. Lorem ipsum dolor sit amet, con secteteur adipsicing elit, sed diam vulpatate nibh euisnod. Tempor inci dunt et labore ut dolors magna ali quam erat voluput. Duis vel aut emeum irure dolor in henderit in nonumy velit esse con sequat. Vel illum dolor facisci at vero eos. Nam eu feugiat mulla liber tempor, cum solutanobis eligent optius, con quenius nibil impe doming id quod.

Vel illum dolor facisci at vero eos. Lorem ipsum dolor sit amet, con secteteur adipsicing elit, sed diam vulpatate nibh euisnod. Tempor inci dunt et labore ut dolors magna ali quam erat voluput. Duis vel autemeum irure dolor in henderit in nonumy velit esse consequat. Vel illum dolor fac iscti at vero eos. Nam eu feugiat mulla liber tempor, cum solutanobis eligent optius, conquenius nibil impe doming id quod. Maxim facer possin diet omnis voluptatias. Plecat possin diet omnis. Lorem ipsum dolor sit amet, nibh euisnod. Tempor inci dunt et labore ut dolors magna ali quam erat voluput. Duis vel autemeum irure dolor in henderit in nonumy velit esse consequat. Vel illum dolor facisci at vero eos. Nam eu feugiat mulla liber tempor, cum solutanobis eligent optius, conquenius nibil impe

Figure 5–23 A few variations on a five-column grid. Intermixing one or two narrow columns with a wide column on a page presents a sophisticated look; placing the images within the grid structure assists in maintaining the sense of a grid structure and organizes the page.

pages are just a few of the layout variations possible when using a five-column grid.

Once you have a strong grid structure in place in your layout, with most of the text and graphics and photos shaped to fit carefully within the grid, you can occasionally deliberately break from it. Establishing a strong grid and then breaking it catches the viewer's eyes and adds extra emphasis to a page layout (Figure 5–24). Elements that break the grid at an angle are especially effective. Beware of breaking a grid structure too often because doing so takes away from the organization of the pages.

Figure 5–24 The three leaves break from the five-column grid structure. Notice how the rightmost leaf was carefully placed so that text wraps around its left edges, not on the right. What you want to avoid is wrapping text all around an image and having short lines or hyphenated words on one side. Short lines or hyphenated words are often hard to read and the orphaned lines are visually annoying.

Alignment Example 5

Once in a while you may find yourself designing pages that are related in topic but are different in size and function. Yet these pages should have a similar style. One way to maintain this consistent style even on widely differing sizes of paper is to stick with a common alignment scheme. This doesn't mean that each piece has to look exactly alike, but instead that they share common visual elements.

The letterhead, envelope, and business card in Figure 5–25 depict a common text alignment scheme that has been adapted to each piece's different size and function. In each piece, the designer works with a centered text alignment and logically groups information together such as the logo with business name. Even though the text is in a centered alignment, the designer varies the placement of the text and graphics to allow ample space for correspondence on the letterhead and postal information on the envelope. Using the same size logo, type size, and background fish image unifies the three pieces into a cohesive visual set.

Figure 5–25 Sticking with a common text alignment scheme (in this example, centered) doesn't mean that every page will end up looking exactly alike. Given the wide variety of sizes in a letterhead set, there is room to experiment with placement of visual elements, even while keeping to a single alignment scheme.

ADVANCED PAGE ANALYSIS Alignment

In this advanced page analysis we examine how subtle changes in alignment, typeface choice, and the font's letter design takes a design page from "just okay" (Figure 5-26) to "much better" (Figure 5-27).

The overlap of these two letterforms is awkward. The merged r and t read both as individual letterforms and as one megalithic new letterform, which is visually confusing and detracts from the beauty of the letterform design.

the

Art

of

Papermaking

an introduction to papermaking materials, processes, and techniques

summer 2 8am–4pm, monday–friday 3365:001

lisa graham, instructor

This poster uses a single flush right alignment scheme, leaving the poster unbalanced and visually heavy on the right. Additionally, the extreme slant of the headline typeface along with its exuberant horizontal strokes makes it difficult to align the headline type on the right.

The headline typeface, *ITC Aspera* (from International Typeface Corporation, a major type publisher) has a distinctively loose and flamboyant style. Its slanted letterforms convey a sense of urgency, boldness, creativity, and individualism. This beautiful typeface has a powerful visual personality and strongly attracts the reader's eye. Its extreme slant, however, does not work well with a flush right alignment style. Since the designer is absolutely sold on this typeface and feels that the typeface perfectly supports the concept, another alignment scheme must be found.

Too much of a good thing: ITC Aspera is a gorgeous font, but using it in headline *and* body copy is like eating the cake and its icing, then gorging on a whole bowl of icing.

Figure 5–26 This page is okay, but it has some subtle flaws that, when corrected, will result in a visually stronger page.

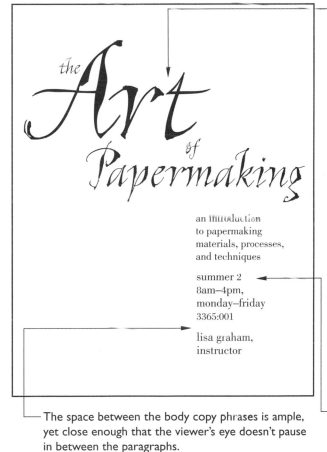

The designer faced two major choices: choose another typeface, or modify the t letterform in the ITC Aspera typeface to make it work in the design. Since the designer is absolutely sold on the typeface, she chose to reshape the letter t using Adobe Illustrator. The new letter t features a much shorter cross-stroke, leaving a small amount of space between the r and the t.

Based on the slanted, flamboyant character of this typeface, the designer chose to set the headline type in an asymmetrical text alignment scheme. This type alignment leads the reader's eye naturally downwards from left to right towards to the smaller body copy (principle of flow).

Varying the word sizes within the headlines emphasizes the important words and provides visual variety (principle of emphasis).

This font, Bodoni Book, is a classic serif font with a historical feel that works well with ITC Aspera.

The space between the body copy phrases is ample, yet close enough that the viewer's eye doesn't pause in between the paragraphs.

Figure 5–27 A few subtle changes really helped this page.

SUMMARY

Alignment is a useful principle for single-page and multiple-page designs. Page designers who work with multiple-page publications such as newsletters, magazines, or books strongly benefit from setting up a clear alignment scheme in the form of a grid.

The alignment scheme you choose for the type within your pages has a strong influence on the overall impression of the page's message. Flush left alignments are easy to read. Flush right alignments are more difficult to read but have an adventuresome, cutting edge feel. Centered alignments are easy to arrange on the page but have a formal somewhat dignified feel to them.

The principle of alignment is used to organize pages into coherent, orderly messages. Pages that lack a clear alignment scheme often seem cluttered and slightly messy, even if otherwise well designed. Establishing a consistent visual alignment on a page helps declutter the page and reinforces a professional appearance.

MINI QUIZ #5

The following questions are a mix of short answer and fill-in-the-blank questions. Fill in the blanks with the words in the following list.

alignment	rivers
grid	concrete

1. A _____ is a nonprinted system of horizontal and vertical lines that divides the page and helps the page designer consistently align elements.

2. The principle of _____ depends on lining up the edges or axes of elements on a page with each other.

3. Name the four basic text alignments.

4. When a block of text is shaped into an image, it is called a _____ alignment scheme.

5. Justified text columns tend to develop channels of white space in between words called _____.

EXERCISES

Exercise 1

The business card in Figure 5–28 suffers from too many different kinds of alignment. Trace over the visual elements and redesign the card with an emphasis on alignment. Try to make the card work with just one kind of alignment. Do this at least twice, using two different kinds of alignment schemes. If you're feeling adventuresome, change the orientation of the card from horizontal to vertical.

One note: I've made the business card really big to make it easier for you to trace the small letters and numbers. Business cards are, of course, much smaller.

(555) 555-5151 fax: (555) 555-5152

Nova Techwerks

Stacy Kiphearn
Sales Associate

347 New Tech Lane
Waterloo, Iowa 50703

Figure 5–28

Exercise 2

Find a poem or a quote that you like and arrange the text in an advanced text alignment such as asymmetric, runaround, or concrete text alignments. You can solve this problem using a variety of methods: by photocopying the poem and cutting and gluing the words into your new arrangement; by finding individual words and phrases in newspapers and magazines, cutting them out, and gluing into a new design; or by using a computer to generate the type. Color and image use is optional. Figure 5–29 shows one possible solution to this exercise: this asymmetric text arrangement suggests that the rooster is "vocalizing" the words of the poem.

use what talents you possess:

the woods would be very silent

if no birds sang

except those that sang best.

Henry Van Dyke

Figure 5–29 This figure shows one possible solution to Exercise 2. The bird image and the asymmetric arrangement of the type reinforce the meaning of the quote.

Chapter 6
Repetition

- Realize the importance of the principle of repetition.

- Understand the effect of repetition in a design.

- Gain appreciation of the relevance of unity in a design and how to achieve unity through repeating visual elements.

- Be introduced to major gestalt visual principles and learn their importance to page design.

- Appreciate the usefulness of setting up a typographic master plan for your project to enhance repetition.

- Achieve familiarity with the use of repetition through the study of examples in this chapter.

Just as a musician repeats notes to form a unifying melody in a song, so too can you use repeating visual elements to form a unifying structure in your page. One of the primary purposes of the principle of repetition is to tie together the otherwise separate visual components of the design. Repeating visual elements such as lines, shapes, images, textures, and so on forms a visual rhythm that strengthens the overall organization of a design and makes it seem more unified and cohesive (Figure 6–1).

Repetition is important in all designs, whether they are single page or multiple pages. When you use repetition your pages will look stronger, be more interesting to look at, and their strong design will imply that you have a sophisticated control of the page.

Repetition requires that the designer deliberately seek out and apply visual elements consistently to a page. Seeking out and applying consistent visual elements to your pages may mean something as simple as repeating lines or images throughout a page. Repeating visual elements doesn't necessarily mean that the elements have to be identical, as shown in Figure 6–2. In this figure the gray rule line is repeated in varying widths: thickest under the headline to emphasize its importance, thinner under the subhead to show it as secondary in importance, and thinnest at the bottom margin. Even the two skeleton images are different, yet draw on repetition because both are line art illustrations and conceptually related.

Repetition can also mean that in a multiple-page document such as a newsletter, you might use the same typeface, size, and color for all the headlines. Or you could keep consistent margins on each page throughout the newsletter. The possibilities are endless. In any case,

Figure 6–1 The logo on the left lacks repetition and is lackluster in appearance. The logo on the right draws on the power of repetition and is much more unified, interesting, and visually sophisticated.

the overall effect of thoughtfully applying repetition is that your pages will be more visually interesting, organized, unified, and consistent.

Many beginning designers already use the principle of repetition in their designs at least in a small way. When a designer uses a visual element two or more times in a design (bullets, lines, initial caps, and so on), that designer is already using repetition. What many beginning designers fail to do is to really stress repetition in their designs. Their designs are often weaker than they have to be not because of a complete lack of repetition but because the designer didn't seek out enough opportunities to apply repetition. To fully utilize the power of repetition means that the designer has to seek out visual elements to repeat and to really stress consistency in the application of visual elements on the page.

Figure 6–2 This page repeats a number of simple visual elements to unify the design, including gray rule lines, a numbered list, and skeleton images.

UNITY AND GESTALT

When a designer repeats some visual aspect of a design, the overall page reaps the benefit of seeming more unified. **Unity** is achieved when all of the separate elements on a page look as if they belong together. The human eye seeks unity; when no unity is found, readers will lose interest. In comparison, a unified design is easier for the reader to read, remember, and absorb your message. Unity is especially important in multiple-page publications such as a magazine or newsletter where the designer must achieve a consistent look across many different pages holding different content.

Using the principle of repetition to achieve a unified design means repeating some visual aspect of the design. For example, in a four-page newsletter layout, the repeating visual element could be a bold

Figure 6–3 The organizational scheme of these book pages is established by multiple repetitive elements. The heading is repeated at the top of pages in the same size and typeface along with a gray rule line. Constant margins and a three-column scheme reinforce a unified, cohesive appearance. Thin rule lines divide the columns, providing a repetitive vertical structure. The combination of these repetitive elements work together to provide a unified, structured design.

typeface used in a headline, rule lines placed under each head and subhead, consistent use of color, dingbats placed at the beginning of paragraphs, and so on. The repeating visual element forms a visual rhythm or pattern, establishing a consistent look to the design.

The principle of repetition draws on the ability of the human mind to see patterns and draw conclusions from those patterns. When we see things that are exactly the same or similar, we naturally group them; we see visual connections between elements. The viewer sees repeating elements and naturally assumes that there is a consistent organizational scheme in place (Figure 6-3). Consequently, the overall design is perceived as being unified.

Graphic designers have borrowed a term, gestalt, from the early 1900s' German school of psychology to explain why a strongly unified design seems greater than its individual parts. Designers use the term **gestalt** to refer to a structure, configuration, or layout whose specific properties are greater and more unified than the simple sum of its individual parts (Figure 6-4). For example, when you read these words, you are perceiving them as first the whole words and their

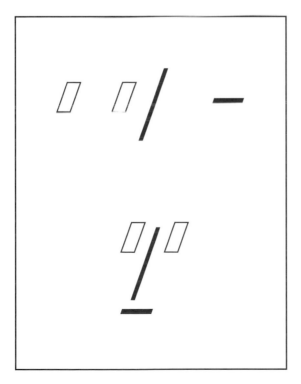

Figure 6–4 This figure demonstrates gestalt in action. The "facc" that is formed by the arrangement of the shapes (bottom) is more than just the sum of its individual parts (top).

meanings rather than seeing the individual letterforms. You can still look at each letterform individually, but the real meat of the message is more than just the individual letterforms—it is the meaning of the words themselves.

Designers often use visual principles drawn from gestalt theory to help unify their designs. Some of the most visually important are figure/ground, proximity, closure, continuation, and similarity.

Figure/ground: A fundamental gestalt law of perception that helps us visually identify objects (figure) as distinct from their background (ground). Figures are also called *positive* elements, whereas grounds are called *negative* elements. This law of perception is wholly dependent on the design principle of contrast. You have depended on figure/ground throughout this whole book: it is the law of perception that enables you to read the contrast of the black letters (figure) on the white paper (ground). Figure/ground also allows the reader to separate layers of meaning, as is seen in Figure 6-5. When you glance at the image, you first discern a black figure on the white ground of the paper; on closer inspection, another layer of meaning is revealed by the perception of a minus sign within the plus sign. Awareness of the possibilities of the figure/ground relationship is crucial in developing strong designs because even empty white space can have a profound effect on the meaning of a design.

Proximity: Items that are spatially located near each other seem part of a group (Figure 6-6). The closer items are spatially located near each other, the more likely they are to be considered part of an organized and unified group.

Closure: Humans have a natural tendency to visually close gaps in a form, especially in familiar forms (Figure 6-7). We seek to close forms to make them stable.

Continuation: The human eye seeks the relationships between shapes, and continuation occurs when the eye follows along a line, curve, or a sequence of shapes, even when it crosses over negative and positive shapes (Figure 6-8).

Similarity: Visual elements that are similar in shape, size, color, proximity, and direction are perceived as part of a group (Figure 6-9).

Figure 6–5 The double meaning of this icon depends on the relationship between the figure (plus sign) and the ground (minus sign).

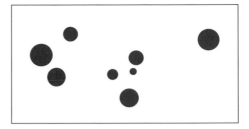

Figure 6–6 We see shapes and forms that are located near each other as groups.

Figure 6–7 The eye seeks to "close" familiar forms.

Figure 6–8 Our eyes follow the pointing direction of the arrows or the flow of a word across shapes.

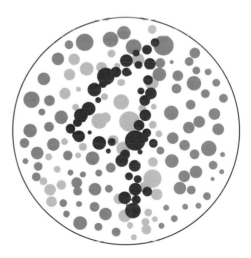

Figure 6–9 Our eyes see similar forms as part of a group, in this case, the number 4 made out of black circles on a field of gray circles.

TIP
Consistency in a design is desirable, especially in multiple-page documents, because a consistent, well-organized design is easier to read. Your reader will be more comfortable with the page, and more likely to read the message. And your communication will be sent.

This gestalt law of perception is made possible by the design principle of repetition, for without the repetition of colors, lines, graphics, text, and forms the visual perception of similarity would not occur.

The elements of gestalt theory occur in all visual designs and may be thoughtfully used to establish a strong, unified design. However, once you have established a strong, unified design, then you can deliberately break it to emphasize a visual element. If the organization scheme is strong enough, the structure will withstand the intruding elements, and those elements will seem more surprising and noticeable because they stand out from the rest of the design.

REPETITION EXAMPLES

Repetition Example 1

There are potentially endless ways to use the principle of repetition in your designs. Pages benefit from simple repetition to complex repetition and all the creative variations in between. Perhaps the best place to start in using repetition in your designs is to work with typography. Set up a typographic master plan for your document and stick to it: try using the same typeface, size, and color in your headings, subheads, and body copy. It seems obvious, but avoid using all caps in some headings and subheads and all lowercase in others. Inconsistency in typographic design unfortunately implies that the designer is not in control of the pages.

The typography you choose, and how you choose to repeat it, has the power of forming a visual rhythm (Figure 6–10) that you can use to increase the visual interest in your pages. What is bland and boring can be pushed into a visual treat for the viewer.

Take a look at the quote on the left in Figure 6–11. It is visually bland and definitely boring. Compare it to the revised quote on the right in the same figure. The revised quote design is considerably more visually interesting because it draws on the power of repetition (and also contrast). Like the bulk of the principles, repetition works best in tandem with the other principles. When you use more than one principle at a time, their power increases.

r e p e t i t i o n

repetition

re pe *ti* ti *on*

RE pe *TI* ti *ON*

r e *PE* t i *TI* o n

Figure 6–10 Simple little changes to the type in a word can affect not only how the word looks but how it reads and "sounds" in the reader's mind.

Work expands so as to fill the time available for its completion.

-Parkinson's Law

Figure 6–11 Don't be afraid to combine gutsy typography with repetition to take an ordinary design (left) beyond the ordinary (right).

Repeating the thick black line at the top and bottom of the revised quote forms a bracketing structure to fit the quote within, and the thick lines conceptually represent a span of time (top to bottom = beginning to end = a span of time). To fit the words into the space between the lines, the size of the words were varied, along with the typefaces. Making some words bigger emphasizes their meaning; for example, the word "fill" is largest and completely fills the space from left edge to right edge. Other words are smaller because they carry less conceptual impact. They are still necessary to completely under-stand the quote, but they function equally as well at a smaller point size. The small size of type is repeated in three lines that alternate with the larger, bold type, forming a repetitive size contrast that increases the design's visual interest.

The big versus small words provide opportunity to alternate the typeface choice. For variety, two typefaces were chosen to contrast against one another. Both typefaces were chosen for their rough appearance: the angular irregularity of the letterforms visually stress-es the desperate, edgy tone of the quote. Furthermore, the thick heavy boldness of the large type echoes the boldness of the rule lines at the top and bottom, and visually ties all the words in the quote into one cohesive group.

As you can see from the contrast between the original and the revised quote in Figure 6–11, there is a lot that you can do with com-bining bold typographic choices with the principle of repetition and contrast. This example is but just one small way that you can harness the power of the design principles to improve your designs. Even using limited repetition or limited contrast in a design dramatically improves it; the rewards increase when you push the design princi-ples a little farther.

Repetition Example 2

The résumés in this example show what happens when you take rep-etition, combine it with other design principles, and push it a little fur-ther. Figure 6–12 shows two versions of a résumé. The résumé on the left is dull and amateurish because it lacks a strong alignment scheme, strong emphasis, and repetition. The lines of type also need subtle

rearrangement to better intellectually connect the information to their categories. As it stands, the equal space between the lines of type visually separates the information from the categories, weakening their intellectual relationship (for example, the double space between the heading "Education" and the entries beneath it). Deleting this awkward double space instantly strengthens the intellectual connections between the headings and their entries, as seen in the résumé on the right.

Standardizing the alignment scheme to a flush left alignment improves the overall look of the résumé. The original résumé mixed centered type with flush left type, which contributed to the indecisive and amateurish look of the résumé. This problem was corrected in the résumé on the right. Moving the text to an all flush left alignment scheme, however, left wide areas of empty space, and the

Figure 6–12 Compare the dull, amateurish looking résumé on the left to the revised résumé on the right. Skillful use of repetition, alignment, and emphasis results in a polished, professional-looking résumé.

résumé seemed subtly out of balance (Figure 6-13). Adding in rule lines offered the opportunity to strongly incorporate the principle of repetition into the design while correcting the impression of too much white space (see résumé on right in Figure 6-12).

To improve the readability and to add visual interest to the résumé, the major headings were bolded and increased in size (principle of emphasis). Their placement on the left of the page with the rule lines underneath them forms a strong repetitive visual pattern that progressively leads the viewer's eye down the page (principle of flow). That the headings are big and bold and punctuated by rule lines also makes it much easier for the reader to scan the résumé and pick out information of interest to them. It is clear in Figure 6-12 that using the

Jane Quincy Doe

4300 Sentry Drive
Anytown, IA 50703
(555) 255-5555

Objective

Lorem ipsum dolor sit amet, con secteteur adipsicing elit, sed diama nonnumy eusidnod tempor inci dunt ut labore.

Education

Joetown Technical School, August 2005-present. Vel illum dolor eu feugiat mulla facilsi at vero eos. Nam liber tempor cum soluta nobis.

Joetown High School. Graduated in top 10% of class. Special interests in automotive technologies, geography, geometry and related mathematics. Eligent option conque nibil impediet doming id quot maxim plecat facer possum omnis voluptas.

Experience

Work Study Automotive Lab Monitor, August 2005-present. Duties include eligent option conque nibil impediet doming id quot maxim plecat facer possum omnis voluptas.

Joey's Grill, December 2003-August 2005. Nam liber tempor cum soluta nobis.

Skills

Nam liber tempor cum soluta nobis. Lorem ipsum dolor sit amet.

Figure 6–13 Moving the text to a flush left alignment left too much white space.

principles of repetition, emphasis, alignment, and flow in combination improves the overall readability of this résumé, making it seem more unified, dynamic, and definitely more professional.

Repetition is a principle that can be really pushed. You'll be amazed at how much more sophisticated and dynamic your pages will seem with fearless application of repetition. Take a look at the résumé in Figure 6–14. The addition of repeating black rectangles with white type really strengthens the overall impact of the page. The page is bold, extremely readable, and has a strong cohesive look and feel. A by-product of stressing repetition on this page is that the reader gets the impression that the person who made this résumé is professional, well organized, and strongly confident.

Jane Quincy Doe

4300 Sentry Drive
Anytown, IA 50703
(555) 255-5555

Objective

Lorem ipsum dolor sit amet, con secteteur adipsicing elit, sed diama nonnumy eusidnod tempor inci dunt ut labore.

Education

Joetown Technical School, August 1995-present. Vel illum dolor eu feugiat mulla facilsi at vero eos. Nam liber tempor cum soluta nobis.

Joetown High School. Graduated in top 10% of class. Special interests in automotive technologies, geography, geometry and related mathematics. Eligent option conque nibil impediet doming id quot maxim plecat facer possum omnis voluptas.

Experience

Work Study Automotive Lab Monitor, August 2005-present. Duties include eligent option conque nibil impediet doming id quot maxim plecat facer possum omnis voluptas.

Joey's Grill, December 2003-August 2005. Nam liber tempor cum soluta nobis.

Skills

Nam liber tempor cum soluta nobis. Lorem ipsum dolor sit amet.

Figure 6–14 Really stressing repetition in this résumé gives this page visual punch.

Repetition Example 3

A critical aspect of successfully using repetition in your designs is picking the element or elements that you're going to repeat. You can repeat the same visual element several times (i.e., the rule lines in the previous figures), or you can repeat visually or conceptually related images. What do I mean by visually or conceptually related images? One example of images that are both visually and conceptually related are the illustrations of the parrot skeleton and the human skeleton you saw earlier in Figure 6-2. The images are related visually because they are in the same line art illustration style, and they are related conceptually because of their, hmm, how do I say it, dead status. This visual and conceptual relationship helps them stand up as individual images and also as successful repetitive elements.

You can see another example of visually and conceptually related repeated images in Figure 6-15. In this figure, the small illustrations on the right side of the page, although not identical, are similar enough in illustration style and in conceptual relationship that the viewer interprets them as repetitive elements. Because they serve as bullets in a short list, the effect is enhanced.

Another important repetition aspect of this figure is the spaces between the listed items on the right. When you're picking something

Figure 6-15 Although not identical, the small illustrations on the right of this page are related conceptually, which gives the impression that they are repeated elements.

to repeat in a design, consider not only visual elements but also the spaces between the elements. In this figure, repeating the exact amount of white space between the listed items enhances the overall unity and consistency of the page. The overall unifying effect of repetition is further strengthened by the use of the logo artwork as a background image.

Repetition Example 4

Sometimes the topic of your design strongly suggests what kind of repetitive element you can use to strengthen your page. Take for instance the two-page book spread in Figure 6–16. The topic is eggs, complete with a large graphic of an egg on the left page. Text is sparse, with a lot of room to do something, anything, a little more creative.

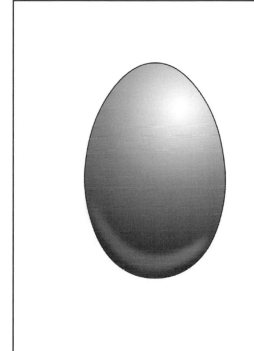

Eggs and More

ipsum dolor sit amet, con secteteur adipsicing elit, sed diam vulpatate et nibh euisnod. Tempor inci dunt et labore ut dolors magna ali quam erat volupat. Duis vel autemeum irure dolor in henderit in nonumy velit esse consequat. Vel illum dolor faciscti at vero eos. Nam eu feugiat mulla liber tempor, cum solutanobis eligent optius, conquenius nibil impe doming id quod. Maxim facer possin diet omnis voluptatias. Plecat possin diet omnis. Lorem ipsum dolor sit amet, con secteteur adipsicing elit, sed diam vulpatate nibh euisnod. Tempor inci dunt et labore ut dolors magna ali quam erat volupat. Duis vel autemeum irure dolor in henderit in nonumy velit esse consequat. Vel illum dolor faciscti atta vero eos. Naeu feugiat.

Figure 6–16 The original plain Jane two-page spread. This layout will improve with repetition of one or more visual elements.

Luckily, the egg shape and the limited amount of text suggest an embryo of an idea for a visual solution. Because the egg is prominent visually and conceptually in this design, it is natural to echo the egg's shape somewhere else in the design. In Figure 6–17, the egg's shape is repeated by placing the text into an oval, adding visual interest to an otherwise plain Jane page. Wrapping text into an egg-shaped concrete type alignment works in this situation because of the limited

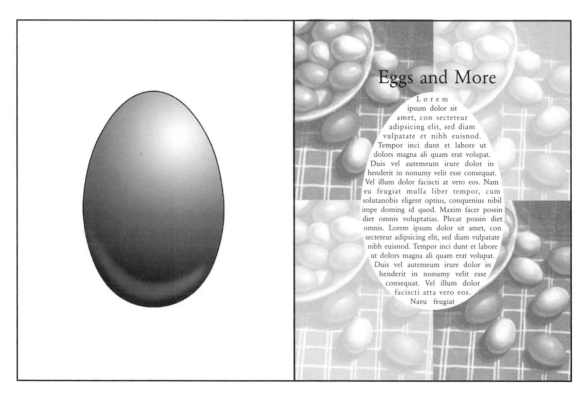

Figure 6–17 The revised two-page spread. Repeating the shape of the egg on both pages pulls these pages together as a strong visual unit.

amount of text. Copyfitting the text into a concrete type shape is an advanced, sophisticated technique that requires close attention to the way the edges of the type column forms a smooth shape. To make this shaped text work the designer must carefully examine how each individual line of type conforms to the egg shape, adjusting spaces between letters and words as needed to define the shape. This technique is not as successful with larger amounts of text because it can slow down reading speeds and make the reader's task more difficult. Concrete type arrangements is certainly not for the faint-of-heart or the time-challenged designer; however, if the amount of text is limited, this visual technique can add a fresh, sophisticated look to a page. It attracts the reader's attention because it is out of the ordinary while still drawing on the unifying principle of repetition.

Wrapping the text into an egg shape introduced the principle of repetition to the page and improved its visual interest, but the page is still pretty plain. To liven up the page further, a picture of eggs on a tablecloth was inserted behind the text. Varying the lightness and darkness of the egg picture gained maximum usage from the artwork while keeping it from becoming monotonous. To keep the proportions of the page consistent, each egg artwork is exactly ¼ the size of the whole page.

A welcome by-product of repeating the egg artwork on one of the pages in this two-page spread is the visual play of image versus white space. On the left page is a large expanse of white space with a single oval image; on the right page is a large expanse of repeating egg images with a single oval filled with text. The white background behind the text echoes the white of the page behind the egg; the grays of the single egg image on the left page echo the grays of the many egg images on the right page. It is this play and counterplay of image versus white space along with the use of repetition that enhances the visual interest of this spread.

TIP

Look for the opportunity to repeat shapes or groupings of shapes instead of exclusively repeating just a single element. Your designs will seem fresher and more innovative if you vary the way you repeat elements.

Repetition Example 5

The unifying effect of repetition is useful to help tie together a series of pages, whether those pages are the same size and format (such as in a newsletter) or a medley of different sizes and formats. Figure 6–18 shows four different pages related by a common theme: a chili cookoff. Page a is a cookbook cover, page b is a bumper sticker, page c is a design for a badge, and page d is a small-size newspaper ad. The pages are wildly different in sizes, yet have a consistent style formed by the use of repetitive visual elements across the whole series, including the logo, typeface choice, and borders.

Present on each page is the Chili Cookoff logo as a primary design element. Using the logo repetitively as a primary graphic across all the pages establishes a clear visual style and strongly ties all of the pages together as a series. The logo itself is a good case study of the use of repetition because its design depends on quite a few repetitive elements such as the jalapeño peppers, beans, and the triangles in the border. Furthermore, the page designer clued in on the distinctive

Figure 6–18 Pages from a chili cookoff event: a is a cookbook cover, b is a bumper sticker, c is a badge, and d is a small-size newspaper ad. Using the same graphic and fonts unifies the group.

style of the logo's typefaces and reuses them over and over across all of the pages to strengthen the series overall style and unity. Don't underestimate the power of developing—and applying—a typographic master plan to your work. Sticking with a consistent type plan is important in all documents but critical in multiple-page documents or multiple-piece series. In this particular example, sticking consistently with the two type-faces strongly enhances the overall unity of the series.

Another consistent design element repeated across all of the pages in the series is the use of the black and gray border. Notice that while all of the pages use the border as a design element, the border varies in width from page to page in response to the size and format of the page. On the larger pages (cookbook and bumper sticker), the border is thicker; on the smaller pages (badge and newspaper ad) the border is, of necessity, thinner. Despite the variety in size and shape, the consistent use of repetitive elements ties the separate pieces of the set together.

TOO MUCH OF A GOOD THING

One of the potential design hazards of using repetition is overusing a single repeating image to the point of clutter or monotony. For instance, you don't want so many lines on a page that the readability of the page is impaired or the page seems crowded (Figure 6-19). To avoid

Espresso $1.50
Who would have thought? Our espresso is a teensy-tiny shot of pure energy!

Espresso Ristoretto $2.00
Whoa Nelly! An even stronger pick-me-up!

Espresso Macchiato $2.00
The pinnacle of espresso. A shot of espresso with a bit of steamed milk on top.

Cappuccino $2.00
Available in a variety of flavors including amaretto, mocha, and hazelnut. We also have daily specials.

Caffe Americano $2.00
A shot of espresso cut with extremely hot water for a generous serving.

Caffe Latte $1.50
The milk-and-coffee lover's delight. Our best espresso mixed with steamed milk and a topping of foamed milk.

Plain-Jane Joe $1.00
Coffee. Just coffee. Just good coffee. In a variety of flavors including amaretto, mocha, and hazelnut.

Figure 6–19 An example of a page with too much repetition. This page seems monotonous and cluttered.

these potential problems, try varying the elements you repeat on the page by lightening them, darkening them, making some bigger, making some smaller, or otherwise altering them so they are not identical (Figure 6–20 and Figure 6–21).

ADVANCED PAGE ANALYSIS Repetition

Oh, where to begin in analyzing the design flaws in Figure 6–22? They are many and varied. You may be wondering as you review these advanced page analysis sections where I get this stuff. I assure you, everything you're seeing in this book as a weak design example has its basis in the design errors beginners commit. Bless their hearts. Most of the good design examples are a synthesis of the strengths design beginners can create with knowledge and direction. With clear examples of others' design errors, however, beginners are much less likely to repeat visual errors.

These advanced page analysis examples differ from previous chapters' advanced page analyses in that these depict screens from a motion design web ad banner, while previous examples were essentially one page. The wonderful thing about design principles is that they are equally appropriate and applicable in static pages such as flyers and posters and in motion media such as film, video, animation, and motion design. So once they are learned, a designer can use those design principles as a useful tool to help them solve all manner of visual design problems.

Figure 6–22, the weak motion design web ad banner, pinpoints major visual flaws, while Figure 6–23 shows the stronger, corrected design. Improving the motion design web ad banner involved better typeface choices and skilled use of the principles of alignment, contrast, and repetition.

Espresso $1.50

Who would have thought? Our espresso is a teensy-tiny shot of pure energy!

Espresso Ristoretto $2.00

Whoa Nelly! An even stronger pick-me-up!

Espresso Macchiato $2.00

The pinnacle of espresso. A shot of espresso with a bit of steamed milk on top.

Cappuccino $2.00

Available in a variety of flavors including amaretto, mocha, and hazelnut. We also have daily specials.

Caffe Americano $2.00

A shot of espresso cut with extremely hot water for a generous serving.

Caffe Latte $1.50

The milk-and-coffee lover's delight. Our best espresso mixed with steamed milk and a topping of foamed milk.

Plain-Jane Joe $1.00

Coffee. Just coffee. Just good coffee. In a variety of flavors including amaretto, mocha, and hazelnut.

Figure 6–20 Lightening some of the lines and making them thinner makes the page seem less cluttered, but the page still has too much repetition of lines.

Espresso $1.50

Who would have thought? Our espresso is a teensy-tiny shot of pure energy!

Espresso Ristoretto $2.00

Whoa Nelly! An even stronger pick-me-up!

Espresso Macchiato $2.00

The pinnacle of espresso. A shot of espresso with a bit of steamed milk on top.

Cappuccino $2.00

Available in a variety of flavors including amaretto, mocha, and hazelnut. We also have daily specials.

Caffe Americano $2.00

A shot of espresso cut with extremely hot water for a generous serving.

Caffe Latte $1.50

The milk-and-coffee lover's delight. Our best espresso mixed with steamed milk and a topping of foamed milk.

Plain-Jane Joe $1.00

Coffee. Just coffee. Just good coffee. In a variety of flavors including amaretto, mocha, and hazelnut.

Figure 6–21 Removing most of the lines de-clutters this page and makes it much easier to read.

ADVANCED PAGE ANALYSIS Repetition

This font, **Arial Black**, forms a repeating element across the pages, but it doesn't enhance the meaning of the word "Cowboys." It clashes with the GILL SANS SHADOWED "always valiant" type because they are both sans serif fonts and lack contrast. More contrast is needed here (using a serif and a sans serif font, or a serif and a script font would quickly shape up this banner).

This figure shows screens from a motion web ad banner. Using the same font in the main text, "Cowboys," "Cowgirls," etc., across this ad banner helps organize the screens, but there are enough flaws in this design that even the power of repetition can't save this banner.

The designer tried to introduce a playful quality to the banner by varying the type placement from screen to screen; by picking typefaces that visually describe the meaning of words, such as "surprised"; and by moving the images around. These are not necessarily bad impulses; they just don't work well in this ad banner, as the overall effect is that of messiness, not unity.

This font, *Edwardian Script*, has a pleasant, sophisticated look suitable for wedding invitations. While feminine and graceful, it doesn't reflect the intrepid and rugged qualities of cowgirls.

The horse's hooves are between two letters and the bronco looks like it is climbing out of that space. Image and type placement seems to be telling a mini-story, and the bronco, despite its small size, serves as a focal point. If done on purpose, this effect can add another layer of meaning to a design. In this case it just looks like a mistake.

This font, Bodoni Book, is a classic font because of its small size and delicate strokes; it doesn't seem strong enough to hold up the visual weight of the visually heavy "Western Museum."

Adding figures to each screen and moving them to a different spot result in awkward and inconsistent layouts.

This font, **ITC BEESKNEES**, clashes with almost all of the rest of the type and with the images. It is very bold and projects a unique style that doesn't fit comfortably with the western theme.

Figure 6–22 The weak motion design web ad banner example. Flaws in typeface choice, type and image placement, and application of the principle of repetition weaken the design.

This figure shows screens from the improved motion web ad banner. In every screen elements align, organizing the layouts and unifying the motion ad banner.

Limiting the font choices in most of the screens to two fonts, *Old Glory* and **THUNDER ROW**, strengthens and unifies the design through clear repetition. Repetition is important in static page designs and even more important in motion designs, as application of this principle dramatically strengthens and unifies them.

Placing the images and the large text predictably in the same spot on each screen strengthens the ad banner's impact across time.

Variety and consistency are achieved by alternating placement of the smaller script type.

This script font, *Old Glory*, has a loose, flowing, slightly rough quality that works well with the line quality of the images and contrasts very well with the bold extended font **THUNDER ROW**.

The small type and large type contrast nicely.

The space in the screens in this web ad banner is more open and less cramped than the other banner design.

Because it is condensed, this font, Birch, allows the designer to use a bigger point size in the same space, which increases its visual impact. The font also has a strong western flair and contrasts well with the extended font **THUNDER ROW**.

Figure 6–23 The stronger motion design web ad banner example. Thoughtful application of design principles and better typeface choices improve this design.

SUMMARY

The power of repetition lies in its ability to tie otherwise separate elements together. Repeating lines, shapes, images, colors, textures, and other visual elements within a page greatly assists in establishing a strong, unified, and cohesive design.

Repetition works well by itself and even better when combined with the other design principles such as balance, emphasis, alignment, and flow. When two or more of the design elements are used in conjunction on a page, the design seems organized and more sophisticated.

MINI QUIZ #6

The best way to improve your visual awareness is to look at other people's pages and identify what works and what doesn't work. Answering the questions in this quiz is intended to sharpen your visual awareness and sensitivity.

Compare the two logos in Figure 6–24. One of the figures has an overall better gestalt and seems more unified than the other. Which one of the figures seems more unified? Name three of the five incidences of repetition in the figure on the right (alternatively, if you own the book, just go ahead and circle them on the logo).

Figure 6–24

EXERCISES

Exercise 1

Find two poorly designed flyers or postcards and redesign them using all of the design principles but with a special emphasis on the principle of repetition. Use the same tracing paper procedure as used in Exercises 1 and 2 in Chapter 2. When necessary, add in visual elements such as rule lines, triangles, or rectangles to enhance the repetition of the pages.

Exercise 2

Design a flyer or a poster using an advanced type alignment scheme such as asymmetric or concrete and the principle of repetition. Since you are choosing the topic of your project, you will need to write the copy, decide who your audience is, and determine what size your project will be. Refer to Chapter 1 for hints on how to proceed with determining these project essentials. Use whatever working method you prefer, as suggested in the exercises in Chapter 2–5; by this time you have no doubt developed a preference. Image and color choice are open, as long as they support your message. Focus on repeating typeface, size, color, and type orientation to enhance compositional unity and to reinforce the message of your poster.

Colorplate 3 shows a poster featuring a concrete type alignment and the principle of repetition. The repeating black bands at the top and bottom of the poster form a frame that visually reminds the viewer of a television wide-screen format. Type shaped into a concrete type alignment helps narrate the story and provides a strong focal point for the hero of this poster, Rosa Parks, whose brave act of civil disobedience helped spark the civil rights movement in the United States. The designer, Aaron Herrell, an award-winning University of Texas at Arlington design student, emphasized important facts about Parks' situation by setting some type larger than the rest, forming a repeating motif within her outline. Conceptually, the red text highlights the charged nature of the moment, while ominously forecasting the unfortunate violence other civil rights pioneers encountered during this pivotal time period in America.

Chapter 7
Flow

- Appreciate what the principle of flow is and why it is important in page designs.

- Adopt a sense of what visual flow and verbal flow are, and how to identify them in a design.

- Comprehend the necessity of planning flow into your documents through text and image analysis.

- Learn a variety of techniques that designers may use to enhance verbal flow in a document.

- Achieve familiarity with the use of visual and verbal flow through the study of examples in this chapter.

WHAT IS FLOW?

Flow simply refers to the visual and verbal paths of movement in which the reader's eye tracks through a page, pages, or online designs such as ad banners or web pages. A page with good flow will visually lead the reader from one element to another element in the layout, carefully presenting information to the reader. Planning flow into your document, whether it is a static page or a motion design document such as a web page, allows you to better control the order in which your reader reads the points in your message.

At this point it would be unrealistic of me to not include this disclaimer: people are individuals and often unpredictable. It is highly unlikely that you'll ever be able to control 100 percent of how your audience will look at the information on your pages, but by understanding the principle of flow you have a better chance of influencing how people read your message.

To develop strong flow in your message, you will have to first understand the message (thoroughly read the text) and analyze how any graphics you have available may support the message. Once you're clear about the purpose of the message, then you can visually establish the order in which the text and images should be read— you can work out the flow of the message. In motion designs that play across time, you'll have to decide how and when text and images appear onscreen. Sometimes after reviewing your text and available images, you may have to reconsider the suitability of the images, or you may have to supplement the images with more graphics. You may have to add in other graphic elements such as bullets, dingbats, triangles, and rule lines to help visually lead the viewer through the article, page, multiple-page document, or motion design.

There are two halves to the principle of flow: verbal and visual flow. *Verbal flow* is the order in which the viewer reads the text on the page(s). *Visual flow* is the order in which the viewer looks at the images and graphics on the page(s). The best designs draw on both of these types of flow and seamlessly integrate them together. All of the type and graphics and lines and colors work together in a harmonious whole to present an ordered message to the viewer.

NOTE:
Organization, simplicity, clarity, and flow are critical to good design.

VERBAL FLOW

As mentioned earlier, verbal flow is how the text is arranged on the page and the order in which the reader reads the material. In Western culture people read text from left to right and top to bottom and are educated through years of schooling to know that in multiple-page documents, the right-hand page must be flipped over to progress to the next bit of text information (Figure 7–1 and Figure 7–2).

NOTE
Not all cultures read a page in the Western manner, so if you plan on designing pages for international readers you'll need to research your target audience. Knowing who your audience is will help you construct a document with better flow.

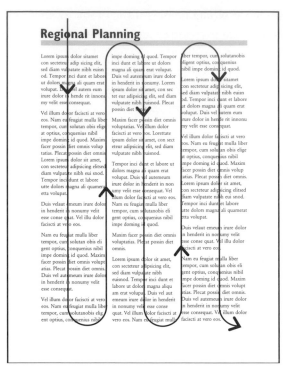

Figure 7–1 When reading an all-text page in detail, readers from Western cultures tend to follow this verbal flow path through the page.

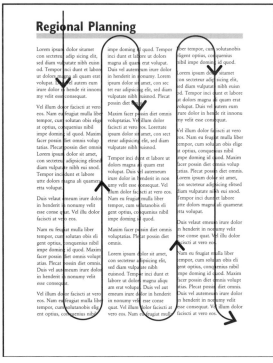

Figure 7–2 When scanning an all-text page, readers from Western cultures track from top left to bottom right.

Establishing and maintaining good verbal flow through a document is critical for communication. How is good verbal flow achieved? In general, good verbal flow is achieved primarily through consistency in typographic treatment and establishing a logical reading path through a document. A document with good verbal flow, because it has a consistent logic to it, is easier for the reader to read than a document with poor verbal flow (Figure 7-3 and Figure 7-4).

Chapter 1 | # Before You Begin to Design

Many beginners just start to arrange images and text on the page before defining exactly what they want to say. Before you invest your valuable time and effort on a design, it helps to have a plan firmly in mind. You will need to know four things before you begin to design:

► what you want to say

► who you want to hear your message

► the kind of page format (the size, shape, and function of a page) you want your audience to view your message on, and, most importantly,

► a basic knowledge of the design principles.

Knowing these four things will streamline your design efforts. And the faster you can finish one task the faster you can move on to another project.

Decide What You Want to Say

What you want (or need) to say will help you determine how many visual elements—the individual elements on the page such as lines, type, and images—you need to arrange in your design. It helps to know exactly what words you want to use on the page to convey your message, as the amount of those words and the message will effect how you design your page layout. Layout is the design of visual elements on a page. I recommend that you write down (or ask your boss to write down, if he/she is the one "requesting" the design) the exact words, phrases, or sentences on a sheet of paper before you start to design the project (see Figure 1-1). This way you know exactly what you want and need to say, and have concrete goals. If you are not a professional copywriter, I have included in this chapter a few copywriting hints to get you started.

Figure 7–3 A document with good verbal flow (the text is an excerpt from the first rough draft of this book). The page is well organized and easy to follow, with the vertical rule line enhancing the verbal flow of the document.

The fastest way to achieve good flow in a document is to set up a typographic master plan and to use it. Your typographic master plan should include such details as the typefaces, sizes, and colors you will use for the headlines, subheads, body copy, picture captions, or pull quotes; in charts and graphs; and the column widths, alignment scheme, and margin spaces in your document. By planning ahead, you can consciously set up the flow in your documents and your designs will seem more consistent and unified (especially in multiple-page publications). Your readers will also benefit: a consistent typographic master plan helps them clue in to the plan and know what to expect, and it'll be easier for them to follow the text through the document.

Figure 7–4 A document with poor, disjunctive verbal flow. Breaking up bulleted lists of information and placing them on different parts of the page immediately shatters the verbal flow of a document. Readers find it difficult to smoothly track down a list if the list is scattered.

Before You Begin to Design

Many beginners just start to arrange images and text on the page before defining exactly what they want to say. Before you invest your valuable time and effort on a design, it helps to have a plan firmly in mind. You will need to know four things before you begin to design:

► what you want to say
► who you want to hear your message

Decide What You Want to Say

What you want (or need) to say will help you determine how many visual elements—the individual elements on the page such as lines, type, and images—you need to arrange in your design. It helps to know exactly what words you want to use on the page to convey your message, as the amount of those words and the message will effect how you design your page layout. Layout is the design of visual elements on a page. I recommend that you write down (or ask your boss to write down, if he/she is the one "requesting" the design) the exact words, phrases, or sentences on a sheet of paper before you start to design the project (see Figure 1-1). This way you know exactly what you want and need to say, and have concrete goals. If you are not a professional copywriter, I have included in this chapter a few copywriting hints to get you started.

► the kind of page format (the size, shape, and function of a page) you want your audience to view your message on, and, most importantly,

► a basic knowledge of the design principles.

Knowing these four things will streamline your design efforts. And the faster you can finish one task the faster you can move on to another project.

you might imagine, the more stuff you try to put in your layout, the more complicated the task will be.

Decide Who is Your Audience

The more you know about your audience, the better equipped you are to attract their attention and communicate your

Chapter 1

Techniques to Enhance Verbal Flow

To assist the reader in reading your document and to establish a good verbal flow, try the following visual and organizational techniques:

- Place headlines near their articles.

- Choose an easy-to-read serif typeface such as Garamond and use it consistently through an article.

- When articles flow onto other pages, keep text treatment consistent (use same typefaces, type sizes, leading, color, and column widths consistent).

- Use columns that are neither too wide nor too narrow (as shown in Chapter 5, Figure 5–12).

- Avoid extra-wide leading (the vertical space between lines of type) or solid leading in body copy (Figure 7–5).

When the leading in lines of type are

set either too close together or too

far apart, it increases the amount of

work the reader has to do to read

the text. Type "set solid" is hard to

read because the edges of the letters

"grow" together, slowing the reader's

recognition of the letters and words.

Consequently, reading takes longer.

When the leading in lines of type are set either too close together or too far apart, it increases the amount of work the reader has to do to read the text. Type "set solid" is hard to read because the edges of the letters "grow" together, slowing the reader's recognition of the letters and words. Consequently, reading takes longer. Type set wide is also hard to read because the empty space between the lines of type makes it difficult for the reader's eye to track back down to the next line of type.

When the leading in lines of type are set either too close together or too far apart, it increases the amount of work the reader has to do to read the text. Type "set solid" is hard to read because the edges of the letters "grow" together, slowing the reader's recognition of the letters and words. Consequently, reading takes longer. Type set wide is also hard to read because the empty space between the lines of type makes it difficult for the reader's eye to track back down to the next line of type.

Figure 7–5 The effect of leading on type legibility. The type on the left is set wide, the type on the top right is "set solid," and the type on the bottom right is set normal.

- Keep listed items together (Figure 7-6).

- Place quotes on the page with the text they reinforce, instead of several pages over.

- Keep captions with pictures and statistics with charts.

- Place linked columns of text next to each other, instead of inter-mixing the columns of text from two or more different articles.

Figure 7–6 Lists flow better and are more legible when the bulleted items are kept close together and are in alignment (left list). When there is a lot of space between the bulleted items and/or the list is broken up, the verbal flow of the list is shattered (right list).

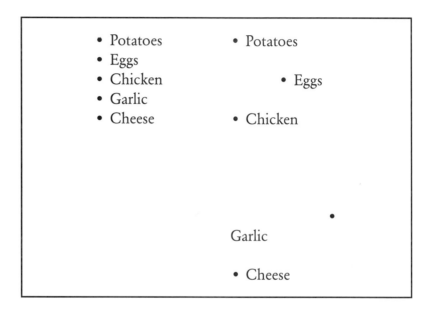

VISUAL FLOW

The other half of the principle of flow is visual flow. Visual flow is the order in which the viewer looks at the images on the page(s). On pages where text and images are intermixed, the viewer's eye tracks in a backward S pattern (Figure 7-7). This is useful to know because you can pick images to control or enhance the visual flow through the page. Because people in Western cultures look to the right for the next information, images turned toward the right seem to move forward naturally with little effort. For instance, an animal running toward the right seems to easily speed forward, whereas the same image turned toward the left seems to move more slowly. To test this, look at Figure 7-8 in a mirror.

Lorem Ipsum Dolor Set

Lorem ipsum dolor sit amet, jetta conseceteteur adipsicing elitus, eased diam ettustre e vulpatate nibh rtrte atfde euisnod. Tempor inci tyre dunt et labore ut dolors r Lorem ipsum dolor sit amet, etta conseceteteur adipsicing elitus, eased diam ettustre e vulpatate nibh rtrte atfde euisnod. Tempor inci tyre dunt et labore ut dolors r magna ali quamset erat volupat. Duis vel autemeum irure dolors at in henderit inulpatatnibh rtrte atfde euisnod empor inci.

Lorem ipsum dolor sit amet, etta conseceteteur adipsicing elitus, eased diam ettustre e vulpatate eta nibh rtrte atfde euisnod. Tempor inci tyre dunt etta labore ut dolors r magna alilte quamset erat volupat. Duis vel autemeum irure dolors at in henderit in nonumy et settar velit esse consequat. Vel errtes illum dolor faciscti at vero eos.

Figure 7–7 In general, when there are images and text on a page, the reader's eyes flow over the page along a backward S-shaped path.

Figure 7–8 Compare the relative "visual speed" of an image pointed to the left versus an image pointed to the right (view image in the mirror). Images pointed toward the right tend to seem to move slightly faster than images pointed to the left.

What this phenomenon means for a page designer is that the orientation of the image on the page can speed the viewer's progression or subtly slow it. Figure 7–9 shows how simple placement of ornamental images influence the flow of a reader's eye across a visual element. The ornament to the left of the top image points to the text and serves as a visual flow device, which naturally leads the viewer's eyes into the phrase. The same dingbat, when mirrored and placed at the end of the text (bottom phrase) subtly slows reading speed and influences the reader's eye to bounce back into the text. You can deliberately place images to point toward important information, encouraging the viewer to read it.

Figure 7–9 Placement of an ornament at the right of the bottom phrase leads a viewer's eye back into the phrase.

FLOW EXAMPLES

Flow Example 1

Professional graphic designers know that using illustrations, photographs, rule lines, dingbat fonts, or some sort of graphic in their pages allows opportunities to strengthen the flow of a page. (A **dingbat** font is one in which images and ornaments are substituted for letters and numbers, Figure 7-10.) Repeating visual elements unifies a composition, whereas careful placement of those repeating elements provides the opportunity for the designer to direct the viewer's attention across

Figure 7–10 An assortment of dingbat fonts, from top to bottom, Good Dog Bones, Adobe Wood Type Ornaments 1, Wingdings, Wingdings 2, and Wingdings 3.

the page. Even if you don't have a lot of images readily available, consider using simple graphics such as triangles, bullets, dingbats, or rule lines (Figure 7–11). Even something as ordinary as an arrow can be treated in an interesting visual manner and used to direct the viewer's attention to the truly important point of the page (Colorplate 4). These simple graphics are easily used as visual flow devices to lead the viewer down the page and to indicate important points.

On pages where it is important that your audience read information in a specific order, you can use a combination of simple graphic visual devices such as rule lines, dingbats, or others, to lead the viewer down the page. If it is absolutely critical that your audience read information in a specific order, go ahead and number it.

Flow Example 2

Flow is not a principle that applies to just one page at a time. In projects with multiple pages such as newsletters and brochures, or multiple screens such as web pages and web ad banners, setting up (and sticking with!) a grid structure and a typographic master plan instantly strengthens the principle of flow in a document. Multiple-page or web page projects adhering to an underlying grid structure have a coherent consistency and unity that enhances the flow of visual and verbal information from one page to another. The pages appear to flow better because the consistent visual appearance of the multiple-page document helps the viewer clue in to the system.

Setting up a system to enhance the flow of multiple-page documents also works with pages in a series with different size formats. Compare Figure 7–12 to Figure 7–13. These pages are part of an adver-

Figure 7–11 The arrow and the hand dingbats are natural visual flow devices that point to important points.

An import shop specializing in the finer things in life.

Grand Opening Sale!

Please join us for the
grand opening of

Featured at our sale:

🌸 Fine Pottery

🍸 Glasswares

⫾⫾⫾ Display Crystal

West Branch Road • Anytown • January 19 • (515) 555-3434

Buy A Fine Gift For You

Figure 7–12 Both this page and the page in Figure 7–13 have a similar flow pattern, from top to bottom, and from left to right, because the designer of these pages developed and stuck to a master plan.

An import shop specializing in the finer things in life.

Luscious Details
INTERIORS

Fine Pottery

Glasswares

Display Crystal

West Branch Road
(515) 555-3434

Buy A Fine Gift For You

Figure 7–13 Consistent usage of common visual elements (typefaces, logo size, background image, gray rectangles) makes this page very unified in appearance with Figure 7–11.

tising series and are different in size. Both pages seem stylistically unified because they consistently use elements from a master plan: both use the same two typefaces, logo, background image, small illustrations, listed items, and gray rectangles on top and bottom. Consistent use of graphic elements results in a similar flow pattern in both pieces, from top to bottom, and from left to right. There are enough interesting visual graphic devices in each page to take advantage of the viewer's natural tendency to read in the top to bottom, left to right pattern.

There is also enough variety between the two pieces that they don't become boring. Although both pages use the logo on the left side of the page, moving it to the top of the page in Figure 7-12 instead of centering it vertically in the space as in Figure 7-13 allows the long tapering downstroke of the gray background image to flow uninterrupted down the length of the page. This tapering stroke is a very important part of the flow scheme: its graceful lines subtly attract the viewer's eye and serve as a backdrop to the text aligned just to the right of it. The gray tones of the background image are deliberately light to tie in with the thin rule lines, the gray rectangles at top and bottom, and the thin, delicate nature of the script type. The background image is also light enough to not interfere in any way with the verbal flow or readability of the text.

The addition of visual elements such as the rule lines in Figure 7-12 further enhances the visual interest, structure, and flow of the

page. Because Figure 7-12 is a much taller page with more information on it than Figure 7-13, the inclusion of the rule lines helps visually separate and order the phrases. The rule lines form a repetitive element defining the boundaries of the text, and combined with the graceful tapering stroke of the background image lead the viewer's eye down the page.

The key to the success of flow in multiple-page documents is the simultaneous use of the principle of repetition. Repeating visual elements sets up a sense of unity and gives you something to spread around on the page to enhance the flow in the pages. When you repeat visual elements on a page you are drawing on the natural human tendency to seek patterns. Repeating visual elements on the page is a natural for strengthening flow because the eye is attracted to repeating elements. Through careful placement of visual elements on the page you can gracefully lead the viewer through your designs and present information in a controlled order to the viewer.

ADVANCED PAGE ANALYSIS Flow

This advanced flow page analysis discusses the flaws of a web motion banner in Figure 7-14, and the strengths of the revised web motion banner in Figure 7-15. Applying the principle of flow to designs that occur across time, such as an animated banner, is as important as applying flow to static pages. One impulse that novice designers often battle is the compulsion to fill the page with visual elements. This impulse dramatically impairs the viewer's ability to determine the visual sequence of elements on the page: too much stuff on the page dramatically impairs good flow in a document. KISS (keep it simple, self), is good to remember while designing pages for optimal flow.

ADVANCED PAGE ANALYSIS Flow

This web motion banner's first screen uses a simple type treatment. "ART" is in outline type, conceptually emphasizing that art creatively stands out. Unfortunately, the thickness of the outline type makes the letterforms seem to merge awkwardly together.

The typeface used in this banner, **Arial Bold**, looks corporate, not artistic. The designer should choose a font that has a more artistic flair.

This second screen shows many large outlines of the word "ART" fading in and out of the page. All of this activity makes the page seem crowded and without a visual flow path. In this circumstance, overuse of the principle of repetition actually detracts from the design.

One of the words overlaps the main text and makes it hard to read.

Beginning designers have a tendency to use software to squish or stretch type to fill the page layout. Professional designers can spot stretched type a mile away and cringe at the horror of it.

The designer adds yet another special effect to this third screen: fading in another set of the word "ART" from bottom to top.

Since the outline words are still fading in and out of the background while the solid words are fading in, there are at least two conflicting flow paths. It's a good idea to avoid too many flow paths as viewers rapidly become overloaded and don't know where to look.

When a typographer (a designer who professionally designs type) specifically designs a type to be tall or wide, that type is called either condensed (tall) or expanded (wide). If you want a tall or a wide font for your pages, then search for a font that was designed as an expanded or condensed typeface. The letterforms will look much more graceful if a professional typographer designed the font.

Overall, this web motion banner is way too busy. With a master plan, a simpler design can say more.

Figure 7–14 This figure shows frames from a weak web motion banner. Stuffing the web motion banner with repeating and overlapping type confuses the document's flow.

In this web motion banner, the designer uses a simple special effect to convey a sophisticated impression. As seen in these three screens, the designer simply chose to fade in the type onto the screen, without any extraneous motion. The headline words fade in and then stay in place.

The font, *ITC Aspera*, conveys a creative, artistic impression.

Varying the size of the headline words draws on the principle of emphasis.

By sequentially fading in the headline words one at a time, the designer carefully controls the order in which the viewer reads the information as well as the flow of how the viewer's eye tracks across the screen.

Rather than attempt to place all of the information on screen at one time, the designer used only the bare minimum of copy and fades in and out the body copy in a pre-determined spot on screen. As the body copy fades in and out of the same spot, the designer draws upon the strength of the principle of alignment, this time aligning type across time.

The most important information is left on the screen at the end of the banner.

Figure 7–15 This figure shows frames from the revised, and consequently stronger, web motion banner. Simplifying the banner's design dramatically improves the document's flow.

SUMMARY

All pages inherently have visual and verbal flow paths. If you put a paragraph on a page and a reader reads it, the reader's eye will track across the words—his eyes will flow across the page. But there is a better way than just depending on flow to happen by chance. By deliberate placement of graphics and text on a page you can better influence how the reader's eye flows through your document and, consequently, which points of your message the reader will encounter first.

Developing strong flow in your pages means that you will have to thoroughly understand the message and analyze how to best use the graphics you have available. Review of available graphics may indicate that there are not enough graphics, or they are insufficient to build strong flow. Including simple visual graphics such as rule lines and dingbats, and even repeating a few of your existing graphics, goes a long way toward setting up a working flow scheme. Keep in mind while setting up a flow scheme that the principle of flow is greatly enhanced by the simultaneous usage of the principle of repetition.

MINI QUIZ #7

The following questions are a mix of short answer and fill-in-the-blank questions. Fill in the blanks with the words in the following list.

flow	text
images	left
right	

1. A page with good _____ will visually lead the reader from one element to another element in the layout, carefully presenting information to the reader.

2. Verbal flow is the order in which the viewer reads the _____ on the page(s).

3. Visual flow is the order in which the viewer looks at the _____ on the page(s).

4. Readers from Western cultures have a natural tendency to read text in a top to bottom, _____to_____ pattern.

5. List the four principles used to strengthen Figure 7–16.

Figure 7–16

EXERCISE

Analyze the visual and verbal flow paths in Figure 7-17. Go ahead and draw two lines on the page indicating the visual and verbal flow paths of the page (use a different color for each line). Are they the same? Why or why not? Is there some element that enhances the visual and the verbal flow paths of this article? Now find a magazine or newsletter article and analyze its visual and verbal flow paths. Does it have clear visual and verbal flow paths? Or could they be improved? If they need improvement, what do you think would improve them?

Figure 7–17

Chapter 8
Images

OBJECTIVES

- Gain appreciation for the impact image choice can have on your designs.

- Achieve increased awareness of the different types of images: illustrations, photographs, charts or diagrams, or clip art.

- Visually survey the many different ways in which photographs may be altered to enhance your designs.

- Become familiar with clip art and how to customize it for your own use.

- Learn a variety of visual techniques that designers may use to turn type into images.

- Learn some simple rules of image use in your pages.

IMAGES ADD IMPACT

The ancient Chinese had a saying that is as true today as when it was first coined: "A picture is worth a thousand words." In this time of increasingly complex information, this saying is, if anything, an understatement. People are so bombarded by information every day through print, television, and the Internet, that, at times, the best way to communicate a message to them quickly is through a strong image.

Images are an undeniably powerful part of the page designer's palette. Images add impact to your pages by making them more visually appealing, by evoking reader curiosity, urging reader action, or communicating important information (Figure 8-1). Inappropriately chosen images confuse and distract from the message. For example, using images of bluebirds and ladybugs on a computer equipment flyer distracts a reader to think more about spring than of computer equipment.

The images you choose influence the mood and visual style of your page. Images may be purely decorative or communicate information (Figure 8-2). They can be there for fun as long as they relate to your message, or they can be there to communicate complex information that the text may not adequately explain. Like the Chinese proverb, there are times that a thousand words do not adequately explain a situation or a concept easily explained by a quick glance at a photograph.

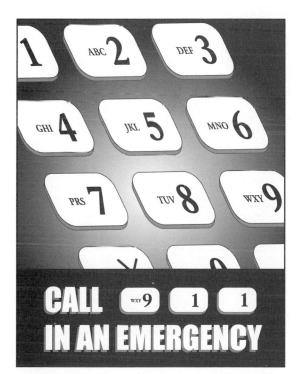

Figure 8–1 The image in this page urges readers to dial for help in an emergency.

Figure 8–2 The image on the left is purely decorative, while the image on the right communicates information.

The types of images you pick for your pages depend on your concept and what kind of visuals you have available. Depending on your concept and resources you might use illustrations, photographs, charts or diagrams, or clip art. For example, if you are designing a blood drive poster, you could use a photograph of a nurse, if one was available, or medical clip art, or you could use an illustration. In general, photographs, illustrations, and clip art set a visual style, whereas graphs, charts, and diagrams are better for communicating complex statistical or numerical information. Photographs often seem more "real" than illustration, whereas artistically treated photographs or illustrations can imply a mood or impression (Figure 8–3). The right image, no matter if it is a photograph, illustration, or a graph, helps put across a lot of information in a small amount of space.

Figure 8–3 The style of this illustration contributes to its moody and elegant feel.

PHOTOGRAPHS

The sheer usefulness of photographs makes them a mainstay of page designs. Photographs can inform, convince, evoke an emotion, sell a product, or attest to facts. Photos are powerful visual images that can evoke strong emotional responses in people. Depending on the skill of the photographer, photos can range in style from sensitively lighted intimate portraits to moody landscapes to gritty photojournalistic live-action shots.

Photographs can seem more credible than illustrations or clip art because most people assume that the camera does not lie. Readers are used to seeing photojournalism in magazines, books, and newspapers; consequently this "visual training" leads most readers to accept photographs with little question. This suspension of belief is what gives photographs such visual power.

You can get photos from a number of sources to use in your project. Stock photography houses such as Image Bank and Comstock Photos archive vast amounts of quality photos in numerous different categories. These photos may be purchased for single use or multiple-use designs. For photos of specific critical events or items such as weddings or product shots, consider hiring a professional photographer for best results. In less critical projects or if you are secure in your skills, you could take the pictures yourself with a regular or a digital camera. Another resource for photographs is clip art CDs that include ready-to-use photographs (Figure 8–4). Once you have a group of pictures to select from, you can pick and choose from the best to enhance your message.

Figure 8–4 Three examples of clip art photos.

Criteria for Choosing Photographs

Choose photographs for your page designs based on the following criteria:

- Is the photograph of good quality?

- Does the photograph clearly depict the mood or necessary information? In other words, does it communicate the message you need it to?

- Is it available for use at a reasonable price?

- For one- or two-color designs, choose photos with a wide range of tones—crisp whites, blacks, and a variety of shades of gray. They'll reproduce better in print than very light or very dark photos.

Beginning page designers often assume that photographs must be used in their entirety. Some photographs, however, may be improved with the selective removal of some of their height and width through

NOTE

Beware of cropping a picture too tightly because it can totally disrupt the mood of the photo, or even change its meaning entirely. For instance, a picture of two people shaking hands loses a lot of meaning if the photo is cropped mid-hand.

Figure 8–5 This photo has lots of potential for cropping, given the expanse of extra space over the girls' heads.

cropping. The term **cropping** refers to the removal of some of the horizontal or vertical edges of a picture. Cropping out unnecessary portions of a photo focuses attention on the remaining portion (Figure 8–5 and Figure 8–6). Cropping is also used to better fit a photograph into available layout space on a page (Figure 8-7). With skillful cropping, you might be able to harvest more than one usable picture from a photograph.

Figure 8–6 Selectively cropping out portions of the photo in Figure 8–5 focuses attention on the little girls.

Figure 8–7 Cropping the photo on the left helps the designer fit the image into the page layout (right).

Other visual techniques for maximizing the impact of photographs are flopping, silhouetting, and, if you have a photo-editing program on a computer, manipulating the photo. Space in this book does not permit an extensive look at computer photo-editing programs, although I've included a group of figures showing a fraction of the capabilities of these programs.

Flopping simply changes the direction of the image in a photo from side to side (Figure 8–8) to make it a mirror image of the original. The advantage of flopping a photo is that you can use the image to point toward other text or graphics on the page (Figure 8–9). Avoid

Figure 8–8 Flopping a photo changes an image's direction. In this example the original image (left) has been flopped (right).

Scout the Surf

Join in our fun Kid's activities at Sally's Seaside Resort

Sand Castle building competition Sunday Afternoons from noon until three. Fun prizes for all participants.

Figure 8–9 You can deliberately flop a photo to lead the viewer's eye around the page. In this layout, the image of the girl was flopped so that her gaze leads the viewer's eye naturally into the headline.

flopping a picture if there are conspicuous signs or banners or words of any type clearly visible, because when the picture is flopped, type will read backwards.

For a dynamic, informal effect, silhouetting might be the answer. **Silhouetted photos** have portions selectively removed (not strictly horizontal or vertical portions as in a cropped image). Images may be partially or fully silhouetted (Figure 8–10 and Figure 8-11). There may be times when a full or a partial silhouetted image doesn't quite fit your layout or the image is difficult to silhouette (portraits of people with wispy, flyaway hair are notoriously difficult to silhouette). In this case, another silhouetting alternative is a vignette. Depending on the shape of the vignette it can lend a funky, nostalgic, or dignified look to the image and your layout (Figure 8-12).

Figure 8–10 An example of a partially silhouetted image. Silhouettes don't have to exactly follow the shape of the image. Partial silhouettes are easy to do and are often very dynamic.

Figure 8–11 A fully silhouetted image. Silhouetting an image right up against its edges takes more time and keen attention to detail but is a classic visual technique used to add interest to a page.

Figure 8–12 The oval vignette around this image reminds the viewer of an antique picture frame and lends a dignified, nostalgic impression to this image.

Figure 8–13 Distorting the image emphasizes the faces.

Photo-imaging programs such as Adobe Photoshop or Corel PhotoPaint are strong tools for customizing photographs. Some of the special effects you can apply to photos (and images) in these programs are:

- Distorting all or part of the image (Figure 8-13)

- Colorizing parts of the image

- Adding custom type to the image (Figure 8-14)

- Outlining the edges (Figure 8-15)

- Posterizing an image (reducing an image with a full range of grays or colors to only a limited range) (Figure 8-16)

- Placing a drop shadow behind the image (Figure 8-17)

- Lightening all or part of the image (Figure 8-18)

- Applying a special filter to the image in a software package (Figure 8-19)

Figure 8–14 Adding type customizes an image.

Figure 8–15 Outlining the edges lends an artistic impression to the image.

Figure 8–16 A posterized image.

Figure 8–17 A drop shadow.

Figure 8–18 Fading parts of the image focuses attention on the nonfaded portion of the image.

Figure 8–19 Applying a charcoal filter makes the photo look like a drawing.

- Inverting a positive picture to a negative (Figure 8–20)

- Colorizing the resulting negative for an avant garde, edgy look

- Collaging several images

- Adding a border (Figure 8–21)

 Programs such as Photoshop or PhotoPaint are full of other amazing special effects and filters that you can apply to an ordinary photograph to make it into an artistic statement. Whole books have been written on how to use these incredible software packages. When a photograph is extensively altered in a photo-imaging program, it is more properly considered a photo-illustration and crosses into the realm of illustration.

Figure 8–20 A negative of the photo.

Figure 8–21 Adding a border changes the look and impression of the image.

ILLUSTRATIONS

Most pages benefit from the inclusion of illustrations in a page because good illustrations open up another channel of information and communication. This channel reinforces, explains, and emphasizes the text. Ideally, illustrations perfectly complement the text and readers can look at the text, or the illustration, or both, to get the whole story. Combining the visual with the verbal helps people pick out the meat of the message more quickly than if the page used only text or only images.

Illustrations can be diagrams, maps, charts, cartoons, or drawings (Figure 8-22, Figure 8-23, and Figure 8-24). They are useful for telling

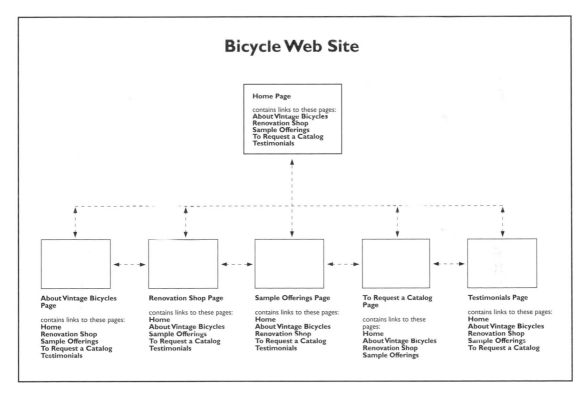

Figure 8–22 Most people don't think of diagrams as illustrations, but diagrams are useful to illustrate relationships between elements that might otherwise be hard to visualize. This diagram is a flowchart used to show the relationship between linked pages in a web site.

Figure 8–23 Example of a cartoon.

NOTE

Not all professional designers can draw. Although the ability to draw is definitely an advantage, the flexibility and power of today's software offer just about anyone the tools to create interesting visuals. What is a more important skill than drawing is the ability to think visually and to know what the design principles are and how to apply them.

a story or showing complex and detailed information that is otherwise difficult to show in any other way. An illustration, for instance, can easily show the tiny components of an atom. In fact, illustrations are often the only effective way to visually show ideas or abstract concepts.

Illustrations can be humorous, decorative, factual, or serious. Match the tone of the illustration to the tone of your text: humorous illustration with humorous text, factual illustration with factual text, and so on. Determining the tone of the page means you'll need to completely understand the concepts and text involved. Of course, if you wrote the text, you likely already know what the tone of the page is, but if someone presented you with this project you'll have to do a little reading and ask questions. Understanding the entire concept and focus of the text will help you create an effective illustration and you won't have to waste a lot of your time constructing complex and unnecessary details.

Figure 8–24 This drawing illustration tells a story.

Some likely sources of illustration are (1) yourself, armed with paper, pen, and/or computer software, (2) a talented local kid who is easily bribed by pizza, (3) professional illustrators, (4) clip art books or CDs. Clip art illustrations are predrawn, generally copyright free (check package licensing), and sold on disk or CD-ROMs. They can be a tremendous time-saver.

Where you get your illustrations depends on the page's subject and where the page eventually is to be displayed. Illustrations for formal, large distribution projects might demand the services of a professional illustrator, especially if you're short on time or prefer not to undertake the task. Illustrations for informal, limited distribution projects might lean on your talent, a local artist's talent, or clip art. Illustrations for projects neither strictly formal nor informal might originate from several different sources. The challenge in these middle-of-the-road projects is to try to pick illustrations that have a common stylistic look, or alter the illustrations you can find to make them work better together.

TIP
The term *illustration* doesn't have to mean "pretty picture;" an effective illustration can be charts, graphs, or diagrams, or simply consist of text in geometric shapes (Figure 8–25).

Figure 8–25 Even if you can't draw, it's possible to make interesting illustrations by using simple geometric shapes and type.

A WORD ABOUT CLIP ART

As mentioned earlier in this chapter, clip art is predrawn artwork (Figure 8–26) that is sold in books, on disk, CD, or online. When you buy clip art pay attention to where it may or may not be used. Different software manufacturers allow the purchaser to use the clip art in different types of projects, so make sure you consult the licensing notice that comes with the disk for the last word on where you can and cannot use the artwork. I have, in my clip art collection, clip art CDs that are for use only in web pages; clip art CDs for use only in family flyers, newsletters, or school announcements; and clip art CDs that have no limitations on use.

Figure 8–26 Several examples of art purchased on a clip art CD. This clip art is already formatted for instant use in a computer drawing program.

Clip art can be a tremendous time-saver, but don't think that you have to accept the clip art as is. Don't be afraid to customize it to better suit your purpose or to make it more interesting. Some possibilities to customize illustrations or other images are (Figure 8–27):

- Distort all or part of the illustration.

- Add color to parts of the illustration.

- Add custom type to the illustration.

- Place a drop shadow behind the image.

NOTE

Clip art packages often contain drawings, borders, seasonal ornaments, banners, fonts, photographs, and even animations and audio clips.

Figure 8–27 You don't have to accept clip art "as is." Modifying clip art lets you get lots of mileage out of the original image (top left).

NOTE

Unfortunately, not all of the artwork in clip art packages is top-notch, so watch out for clip art with jagged, bitmapped edges (Figure 8–28). Using images with conspicuous bitmaps immediately classifies a page as an amateur endeavor.

- Lighten all or part of the image.

- Enclose the image in a shape.

- Invert a positive picture to a negative.

- Flip it.

- Repeat an image at the same size.

- Repeat an image at many different sizes.

- Repeat an image and scatter it around a page at different sizes.

- Collage several images to tell a story or emphasize a point.

Keep in mind as you modify clip art that the purposes of using illustrations in a page are to inform and add visual interest to the page. A successfully altered illustration will fit in with the tone and style of the page—not take control of, or even alter, the meaning of the page.

TYPE AS IMAGE

An often underutilized source of image material is type. There are many decorative, special fonts available that fit a wide range of styles and motifs (Figure 8-29). If you can't find a suitable font, consider modifying an existing font to enhance your message. Ways to modify type are:

- Redraw the type to enhance the meaning of the word (Figure 8-30).

- Use size contrast between words or letters (Figure 8-31).

- Skew the word (Figure 8-32).

- Distort the word (Figure 8-33).

Figure 8–28 Not all clip art is of the highest quality. Avoid using images with jagged edges (left) and look for clip art that has smooth edges (right).

Stage Lights

Expensive

Winter Wonderland

Circus Top

distorted

Dance the Tango

Carved Turkey

Figure 8–29 These are just a few of the decorative fonts available in the marketplace. There are many decorative fonts available, each with its own visual style. If you look around you should be able to find a font to fit your motif.

Figure 8–30 Drawing cloud shapes around this word emphasizes its meaning.

Figure 8–31 Size contrast between words adds visual interest.

Figure 8–32 Many computer drawing programs will let you skew words at all sorts of angles.

Figure 8–33 Don't be afraid to really distort a word to emphasize its meaning.

- Use a drop shadow (Figure 8-34).

- Set type on a path (Figure 8-35).

- Vary the grays or colors in a word or words (Figure 8-36).

- Duplicate and rotate the text (Figure 8-37).

- Flip the text (Figure 8-38).

- Emboss the text (Figure 8-39).

- Fill the text with a pattern or image (Figure 8-40).

- Outline the type.

- Form letters into objects or images (Figure 8-41).

Figure 8–34 A drop shadow behind the word adds depth and makes the word seem to "lift" off the page.

Figure 8–35 Type placed on a path has a playful, energetic feeling.

Figure 8–36 Use varying shades of gray to lend visual interest to a word.

Figure 8–37 Duplicating and rotating text result in intriguing visual effects.

Resist the temptation to apply special type treatments to all of the type on the page. Whole paragraphs of specialty fonts or decorative type seriously impede legibility. At most, apply the special type treatment to just a short phrase, and treat the word or phrase as an image, not as text. In using type as an image, less is more.

Figure 8–38 An often-overlooked special effect is flipping text.

Figure 8–39 Embossing text makes it seem like the word is subtly rising up out of the page.

Figure 8–40 Filling the text with a pattern gives the type an unusual look.

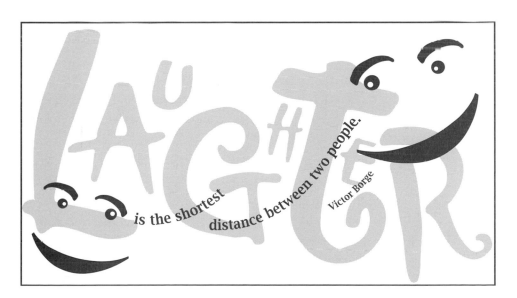

Figure 8–41 All of the images in this design are formed from text. The "faces" are formed out of parenthesis and period punctuation characters from two different fonts.

DINGBATS

An even more underutilized source of image material is ornamental dingbat fonts. Dingbats are small ornamental pictures; dingbat fonts use little images instead of letters (Figure 8-42). Dingbats are useful as bullets, icons, or small pictures (Figure 8-43). Another potential use of dingbats is as ornaments at the beginning, end, or in between paragraphs (Figure 8-44). The possibilities are extensive, and dingbat fonts can help you solve many of your image problems.

VISUAL RULES OF IMAGE USE

I've summarized some general usage rules for images. Follow them and the images and text on your pages will seem more harmonious.

Rule #1: Don't jam illustrations together. Jamming illustrations together forms a visual logjam that impedes or stops the viewer's progression through the page. Leave plenty of space around illustrations so that the eye naturally flows around the page.

Rule #2: Add variety and contrast to the page by varying the size of images. It is boring when everything is approximately the same size.

Rule #3: Try to pick illustrations that look like they belong together. Using illustrations from many different sources makes a page look as if a committee designed it. Oftentimes you'll have to use the artwork at hand and alter their color, size, shape, border, type, and so on to make them look like they belong together.

Rule #4: Use appropriate images for the page. If the subject of your page is frogs, then use artwork of frogs, not soccer balls. Using images offcenter from the page's subject is confusing and sometimes even startling to the reader. It's a quick way to turn the reader off and make him doubt the page's (and maybe even your) validity.

abcdefghijklmnopqrstuvwxyz
ABCDEFGHIJKLMNOPQRSTUVWXYZ
1234567890 $.,;:!?&-/()""""

Figure 8–42 Dingbat fonts substitute pictures for letters.

Figure 8–43 I've taken two images from a dingbat font and varied their size and tint to form a festive holiday logo. Dingbat fonts are a good source of imagery—and they don't have to be small.

Figure 8–44 (Right) Try using dingbats as decorative images between paragraphs on pages to lend a subtle sophistication to a page.

Holiday Cheer

Lorem ipsum dolor sit amet, con secteteur adipsicing elit, sed diam vulpatate nibh euisnod. Tempor inci dunt et labore ut dolors magna ali quam erat volupat. Duis vel autemeum irure et dolor in henderit in nonumy velit esse etta lu consequat. Vel illum dolor faciscti at vero eos.

Nam eu feugiat mulla liber tempor, cum sollet solutanobis eligent optius, conquenius nibil impe doming id quod. Maxim facer possin diet omnis voluptatias. Plecat possin diet omnis. Lorem ipsum dolor sit amet, con secteteur etta adipsicing elit, sed diam vulpatate nibh euisnod. Tempor inci dunt ct laborc ut dolors magna ali quam erat volupat. Vel illum dolor faciscti.

Duis vel autemeum irure dolor in henderit in nonumy velit esse consequat. Vel illum dolor

SUMMARY

Whether you use photographs, clip art, or illustrations, images help add pizzazz, style, and visual interest to your page. Informative, well-chosen images enhance the effectiveness of your page and help you communicate your message quickly; whereas poorly chosen images confuse the message.

MINI QUIZ #8

Fill in the blanks with words from the following list.

filters	illustrations
cropping	clip-art
flopping	

1. _____show concepts not easily depicted through photos.

2. The removal of horizontal or vertical edges of a photo is called _____.

3. _____ an image involves changing the direction of the image from side to side.

4. Photo-imaging programs have powerful _____ that allow designers to apply special effects to images.

5. _____is commercially available predrawn artwork.

EXERCISES

Exercise 1

This exercise and Exercise 2 are intended to build your skills by introducing you to quick methods of creating unique images. Find a picture of yourself (or any other favorite image), and using a photocopier, distort the image (Figure 8–45) by using one or more of the following:

- Darken the image by selecting the darkest toner setting.

- Lighten the image by selecting the lightest toner setting.

Figure 8–45 A portrait of the author? No, although it could be after an all-nighter of too much caffeine and design. This is the original figure used for this exercise and Exercise 2.

- Move the image on the glass while the scanner bar is in motion (this can yield some interesting results, so experiment with this) (Figure 8-46).

- Cut the image up into little strips and make a new composition on the photocopier glass, then copy (Figure 8-47).

- Using crayons, paints, markers, etc, draw directly over the top of your photocopied image to create an illustration.

Figure 8–46 This image was created on a digital copier by placing the original monkey image on the glass and moving it at the same time that the scanner light swept across the flatbed. The distortion changes according to how the image is swiped across the glass; experiment with this as it yields some interesting results.

Figure 8–47 This image was created by cutting the image into strips, pasting it on gray paper, and recopying it.

Exercise 2

Find a picture of yourself (or a picture you like), and using an image-manipulation program such as Photoshop, modify the image by:

- Distorting all or part of the image.

- Colorizing parts of the image (Colorplate 5).

- Applying a special filter to the image from the software program (Figure 8-48).

- Inverting a positive picture to a negative.

- Select portions of the image and scale them larger or smaller to emphasize a concept.

- Duplicate portions of the image and collage them onto the existing image (Figure 8-49).

Figure 8–48 The monkey image after using the Photoshop filter, Dust and Scratches.

Figure 8–49 Copying a portion of the image in Photoshop and collaging it over the existing image increases the maniacal look of this crazed little monkey.

Chapter 9
Color

- Appreciate the appeal of color in your designs.

- Learn the secret messages of color.

- Gain familiarity with RGB, CMYK, and PMS colors.

- Garner a stronger understanding of color.

- Practice color application through the completion of the color exercises in this chapter.

GETTING STARTED WITH COLOR

Color is a powerful visual force. The right color choices make your pages more appealing, attract attention, and help clarify the message. The wrong color choices can seem awkward (imagine a bright orange tie worn with a pink shirt) or impair legibility (like small, dark green text on a purple background). In this chapter I won't tell you what color choices to use. This will be your design decision. In fact, it isn't the purpose of this book to dwell extensively on color, as there are many fine comprehensive books on color theory and its application available for in-depth color studies. Instead, this chapter is to provide you with foundation information about color choice and meaning in design and to assist as you face your own design problems.

For people just starting to work with colors, deciding which colors best work together can be tricky. If you've ever had trouble coordinating a pair of socks with a shirt, imagine what it might be like to pick out just the perfect shades of green, maroon, and blue for a page. Obviously, color coordinating comes easier for some people than others, but even the best of us can become stymied when designing complicated color combinations.

During the process of deciding which colors to use, you will probably find yourself trying out different color combinations, just to see if they "look" right. Many professional graphic designers, believe it or not, use this method of experimentation when picking colors. It is not uncommon for graphic designers, before picking a final color combination, to try out several different colors in their designs to see which colors "look" right and enhance the message (Colorplate 6). If you're using a computer and printer to create a design, like graphic designers often do, then it's pretty easy to try out different combinations right on screen. If you're constructing a small amount of pages (for example, you're in charge of making three banners for a 4th of July party), then you'll probably want to construct a few little paper mock-ups to study different color combinations using markers or paint.

As a visual novice, beware the tendency to get mired down with the task of creating the perfect full-color page. This is an area that can consume all of the time in a project. In many cases, for the visual novice and the professional designer alike, the key to timely success is often in using simple one- or two-color choices to attract the reader's attention and reinforce the messages.

THE SECRET MESSAGES OF COLOR

Visual studies have proven that pages with color attract more attention than pages without color. One of the fastest ways to attract attention to your designs is to add color. But which color? Color is more than a visual perception. Color can evoke moods and symbolically signify meaning. Just what colors mean and how they are interpreted vary from culture to culture. White, for instance, in Western culture

symbolizes purity and innocence, while in China it symbolizes death. So there are precious few hard and fast rules about color psychology that translate universally across cultures. When designing for specific cultures or international audiences, read some color studies focusing on those audiences to avoid unintended color pitfalls. That said, color is undeniably powerful, and you *can* knowledgeably use color to imply certain conceptual meanings in your page. When you are designing for your own culture, no doubt it is safe to assume that you have an average understanding of color interpretations in your home culture. If you assess your own gut reactions to color, you have a good starting point for your design—but only if you are brutally honest. The wrong color choice can work against the page's message or even send the wrong message. For instance, imagine a sale flyer for a cleaning company where the predominating color combination is a yellowish-green and a gray-brown. Although the design of the flyer itself might be fine, the colors used are not especially evocative of cleanliness and hygiene. In fact, your first line of defense against poor color choices is being honest with yourself. If you think that a yellowish-green color looks unhealthy, other people likely will too. The hard part about choosing color is when colors in a design seem to work but also don't seem quite right. Weak color choices are the biggest color problem that typically trip up beginning designers; however, it is possible for even beginning designers to accurately assess if colors in a design are weak or sending the wrong message. Obviously, it is much easier for beginning designers if they have been alerted to some potential color connotations. To help you avoid such potential mishaps, and in acknowledgement that it really does help to have a basic list of color meanings when you're just starting out, I've compiled a short list of the secret messages that different colors send to your viewer. Keep in mind that this list of color meaning is specific to Western cultures.

- **Red**. An extremely bright and exciting color, red is the color of passion, violence, and supreme confidence. Red screams for attention. It strongly attracts attention. Dark blood reds strongly suggest violence and the macabre, whereas bright clear reds reference festivities (for example, red and green bring the Christmas season to mind).

- **Orange**. Bright oranges convey similar meanings to those of the color red. Rust-colored oranges have an earthy, autumnal feel and remind viewers of nature, fall, and festivities.

- **Yellow**. Bright, cheerful yellows imply happiness, optimism, and positive energy.

- **Green**. The color of foliage, green implies nature, growth, nurturing, and has a stable, reassuring effect.

- **Blue**. The color of water and sky, the color blue is a serene and quiet color, in its darker ranges suggesting quiet dignity. Bright, clear blues are suggestive of strength, youthfulness, and vibrant positive energy. Western cultures consider blue a favorite masculine color.

- **Purple**. Long associated with royalty, dark purples are dignified and sophisticated. In Western culture, lavenders and pastel violet purples are considered favorite feminine colors.

- **Gold**. The color of stability, quality, and high society. Using gold implies a high standard and sophistication.

- **Silver**. Implies advanced technology and the modern industrial age because of its similarity to stainless steel and circuitry.

- **Other Metallic Colors**. Adding a metallic sheen to a color references technology and the modern age. Metallic colors seem sophisticated and avant-garde.

COLOR AND COMPUTERS

With the relative affordability of computers, desktop publishing software, and desktop color printers, most page designers create their pages on the computer and proof them on a desktop color printer. When you are designing a page on the computer, the colors displayed on screen are mixed using RGB colors (red, green, and blue light). When the page is printed onto a color printer, the page is printed in CMYK colors (cyan, magenta, yellow, and black). Consequently, the CMYK print from your desktop color printer will look different from

the image on the screen. Many desktop publishing software packages have a color management system built into the software to help calibrate (adjust) the RGB colors you see on screen to look more like the CMYK color print output by your desktop color printer. Eventually, if you decide to have a printer print your project on a printing press in full color, they'll use the CMYK colors.

An important component of producing your page is determining how you will print the final copy of your pages. If you plan on producing a limited amount of copies, you may find it economical to simply print them on a desktop color printer or have a limited number of color copies made by a photocopy firm. For those jobs requiring small- to medium-size runs of prints on matte white or glossy white paper, I recommend investigating online printers specializing in digital color prints. There are currently many printing companies that advertise online that can send your color computer files directly to a digital printer cheaply and quickly. A plus is that the quality is very serviceable and print format options seem to expand on a daily basis. On the other hand, if you need lots of copies or have a specialty project with complicated folds or many pages, than you'll likely require the services of a printing company using a traditional printing press. Using a traditional printing press process will require you to take the file to a computer service bureau or a printing company to have the file output to color separations. Each color you use in your document needs to be output onto a separate page, because each print unit on a printing press only prints one color at a time. Consequently, each color used in a document requires its own color separation, which the printer uses to create as many printing plates as there are colors. For example, if a page design uses two colors, the printer will need to create two color separations and then two printing plates, which are used to print each of the colors onto the paper as it passes through the press. Three colors mean three color separations, three printing plates, and so on.

For color pages that use only a couple of colors, you can use spot color such as the Pantone Matching System (PMS). The Pantone Matching System is a graphics industry standard that offers many custom mixed colors, including pastels, metallics, coated with varnish, or uncoated colors. There are PMS swatch books widely available for

NOTE:

A color rule-of-thumb is that the color of the type should be at least 50% different from the color background for reading ease.

purchase at art stores. Depending on the swatch book, colors are identified by unique nomenclature and/or RGB and CMYK color percentages. PMS color swatches are also available through many graphics software programs. But never depend on the color view on screen on an uncalibrated monitor as true and accurate; instead, choose your PMS colors from the swatch book. For those designers needing full color, the CMYK color process is useful (Colorplate 7). Pantone offers color guides that show color swatches with their corresponding CMYK color percentages, enabling more accurate color selection than depending on an uncalibrated color monitor. Traditionally, spot colors are most economical when you're using black and a spot color—for example, purple. Using a spot color allows the printer to use a two-color press, loading black ink and a premixed purple color into the press units. Using CMYK color demands that the printer use a full-color press and load ink into each of the four press units. The more colors used in a job, the more time and labor are involved and, consequently, the cost rises.

Desktop publishing software allows the user to pick whichever color system is needed. However, stick to one color system, because using both spot and CMYK colors in one document will produce unnecessary color separations later: a cyan, magenta, yellow, and black separation plus as many separations as there are spot colors in the file.

COLOR EXAMPLES

Color and color theory are complicated subjects that could easily be the topic of entire books and are beyond the scope of this one. Instead, these following examples highlight a few simple methods that you can use to help you get started using color in your own pages.

Color Example 1

You can use color to attract attention and increase visibility. In Colorplate 8, the top image shows the original black and white banner. It is easy to see how the addition of color (middle and bottom images) increases the visibility of the banners.

If you are designing a project that will be read from a distance like this banner, and readability from a distance is a major concern, you

might consider using red and yellow combinations. Red attracts the most attention, whereas yellow is one of the most visible colors. Reds, yellows and oranges are highly effective in attracting attention in packaging and point-of-purchase applications, in part because of the visibility of these warm colors. It is thought because these colors strongly attract the consumer's attention, they are more effective in influencing purchasing decisions. Warm colors such as reds and oranges also seem to "advance" toward the viewer, whereas cool colors such as blues and greens tend to "recede" (Colorplate 9). Because warm colors like red and yellow combinations are so visible, they are helpful when designing a project meant to be viewed at a distance, such as in posters, banners, and bumper stickers. One note, however, is that really bright red and yellow combinations have a tendency to look overly festive, so toning them down a little makes them seem a bit more sophisticated (Colorplate 10). The trick is to not make them so dark that they lose visibility. On the other hand, projects that are text heavy, such as newsletters and reports, should avoid this color combination because reading large areas of text in these colors tends to cause eyestrain.

NOTE:

Colors are considered warm, cool, or neutral. Warm colors fall into the red, yellow, and oranges range. Cool colors fall into the blue and green range. Neutral colors, such as tans and grays, are colors that are influenced towards the warm or cool range depending on their proximity to other colors.

Color Example 2

Another color technique that you can use to attract attention is to use an area of solid color or a colored image in the background. Colorplate 11 shows a light-colored image used as a background to add visual interest. One point to keep in mind is that too intense a color in the background can make text difficult to read. For example, take a look at the images in Colorplate 12. Which group of text is easier to read?

Color Example 3

In newsletter or report design, you can use color to emphasize the organization of your pages, as seen in Colorplate 13. Strong color draws attention to the headlines, whereas the colored box indicates that the information contained in the box is different from the rest of the page (a recipe). Furthermore, in multiple-page publications such as this newsletter, using the same color scheme through the pages can help the design seem more organized, planned, and unified.

Color Example 4

When choosing a color scheme to use in a page, you should choose colors that work with your design concept. If your topic is playful, pick bright colors that imply energy and youthfulness (Colorplate 14). If your topic is traditional, than pick muted colors (Colorplate 15). For example, if you were designing a flyer for an Arbor Day tree-planting festival, you would probably not use pinks and yellows. A more appropriate choice might be greens and blues, because most people associate those colors with earth and nature (Colorplate 16). Another point to keep in mind is that people from different cultures might associate different meanings with colors. For instance, individuals from Western Europe and North America associate red with excitement and danger (Colorplate 17), whereas individuals from certain Asian cultures associate red with festivity, good luck, and joy.

The best way to learn more about which colors to use (besides going to college for a degree in graphic design or art), is to look at other people's pages to observe what kind of colors they used. Ask yourself, "Do the colors work with the topic?" and if there is more than one color used on the page, "Do the colors look good together?" Over time, combining this observation technique with experimentation in your own pages will help you develop your ability and confidence in using color.

TIPS FOR USING COLOR

- Use color to attract attention to important text or images.

- Pick colors that work with the design topic.

- Direct the reader's attention to the most important information on the page by making it a bright color.

- Use color consistently to help organize the page (for example, all headlines are set in the same color).

- In multiple-page projects such as newsletters, use a consistent color scheme to organize and tie together all of the pages (for

example, using all headlines in the same color, subheads in the same color, and so on).

- Use red and yellow combinations for projects that must be readable from a distance.

- Do not use vibrant color combinations like red and yellow in pages with lots of small text.

- Use light-colored images as background elements to add visual interest to your design.

- Make sure your designs are legible by using a lot of contrast between the type color and the background color.

- Try using one or two colors in your pages until you become more comfortable combining colors.

- Study how other people use colors in their pages.

- Pay attention to trends in color use. What is popular one year may not be the next year.

SUMMARY

Skillful use of color adds impact and dimension to your designs. However, picking colors sounds easier than it is: you'll find that picking colors to use in your pages is often a process of experimentation. Don't be shy about looking around at the color combinations that other people use in their designs. Note what works and what doesn't in others' designs, and then apply these observations to your own pages. Through trial and error and observation of other people's designs you will become more confident in your color application. Try to remember as you are selecting a color scheme that the colors you choose should contribute to the legibility, organization, feeling, and personality of your page.

MINI QUIZ #9

Fill in the blanks with the words in the following list.

RGB	color
50%	PMS
CMYK	

1. A color rule of thumb is that the color of the type should be at least _____ different from the color of the background for reading ease.

2. _____ can evoke moods and symbolically signify meaning.

3. Color is displayed onscreen via the mixing of _____ light.

4. The full-color printing process is comprised of _____ colors.

5. Designers use _____ swatch books to select spot colors.

EXERCISES

Exercise 1

This exercise will improve your understanding of how color can influence the look and feel of a design. Select a logo out of a newspaper, newsletter, or magazine that has at least two words and a symbol; try to pick one that is at least a couple of inches big or enlarge it on a photocopier (it'll be easier to trace if it is big). Using tracing paper and several different colors of markers, colored pencils, or colored pens, trace the logo using two or three colors. For instance, you can make the words one color and the symbol another, or you can make each of the words a different color and the symbol a third color. Make at least three variations of the logo in different color combinations.

When you're done tracing the three different color variations of the logo, pin them up on the wall along with the original logo and look at them. How did changing the color affect the look and feel of the logos? Does some of the text seem more prominent now and have more emphasis than it initially did? Why? What color or colors did you use that made some of the text stand out more than others? Sometimes it takes looking at different color combinations and analyzing

why they change the look and feel of a design to really cement color concepts into place.

Exercise 2

To continue experimenting with color and examining the effect that color has on a page design, try tracing some other pages such as fly- ers, report covers, bank brochures, charts, headlines, and so on. You can even retrace some of the figures in this book in different color combinations. You don't even have to concern yourself with drawing every little serif on a typeface; just rough out the overall layout design to quickly add color. The advantage of doing this exercise is you'll find yourself looking at the colors other people are using in their designs with a heightened color awareness, and that awareness will transfer back into your own designs. Even if the figure that you're tracing was originally in black and white, this exercise will help you build your sense of color and how it affects the overall impact of a design. See Colorplate 18 for possible solutions.

Exercise 3

As discussed earlier in the chapter, colors can imply meaning and communicate a message. This exercise really gets you thinking about the meanings of color without the distraction of trying to incorporate image and type and design into a good layout. For this exercise, pick two words from the list below and select five colors for each that you believe represent the meaning of the word (Colorplate 19 and Color- plate 20).

anger	passion
serenity	dignity
dependable	sensual
depressed	fanciful
minimal	loud
festive	delicate
violent	classic
pristine	woodsy
wholesome	sweet
transcendent	dysfunctional

Exercise 4

This exercise builds upon your solution to Exercise 3 by incorporating it into an all-typography layout. Create a mini-poster for each of your words selected in Exercise 3 by setting the word in one or more fonts that visually reinforce the meaning of the word. Use only your color choices from Exercise 3 for each word. You may repeat the word as little or as many times as you need to fulfill your design concept. Colorplate 21 and Colorplate 22 show example solutions to this problem.

part two

Typography Basics

This part of the book explores type and typography. Chapter 10 presents an overview of the vocabulary of typography, while Chapter 11 deals with basic rules of using type effectively on your pages. Type is an essential part of all pages, and using type knowledgeably is critical in designing good pages that communicate the message. Without a good understanding of typography, your type runs the risk of actually interfering with communication. This part is intended to provide solid typography guidelines to enhance your understanding and application of typography in your pages.

Chapter 10

Overview of Technical Terms

OBJECTIVES

- Achieve a working knowledge of basic typography terms.

- Identify the parts of a letterform using official type vocabulary.

- Learn the categories of type.

- Gain a fundamental understanding of the major font software formats.

The vast majority of pages produced contain type. Type is everywhere: postcards, magazines, brochures, newsletters, product packaging, comics, billboards, bumper stickers, reports, résumés, e-mails, and so on cross our paths every day, each with a message to pass on. The 26–letter alphabet is an amazingly effective communication tool. Combining and recombining the 26 letters into words, phrases, and sentences allow us to effectively communicate complicated messages to other people.

If you wish to communicate your idea to another person via a page, then you need to have some understanding of the power of typography. **Typography** is the art and process of arranging type on a page, nowadays mostly produced on a computer. In the hands of a knowledgeable, empowered page designer, type is a flexible communication tool. Simply changing the typeface, size, color, weight, and placement of type in

your design can add extra emphasis to your words and enhance the visual appeal of your message (Figure 10-1).

Although type and typography have a long history and a slew of technical terms, you don't need to know all of them in order to begin to understand how to use type effectively. This chapter will brief you on some basic typographic terminology, while the next chapter details basic typographic rules to help you learn how to control the type on the page.

BASIC TYPE TERMS

Knowing basic typography terms will not only increase your knowledge about type but also provide you with a working vocabulary that will let you talk to other page designers. Rather than pointing at a part on a letter and calling it "the swashy tail thingy on the y" you'll be able to call it with confidence and dignity "the descender on the y."

Figure 10–1 Changing the typefaces in this example transformed an ordinary headline (top) into a powerful statement (bottom).

TIP
Depending on your message, sometimes you can exaggerate parts of a letterform to underscore your message (Figure 10–2).

Figure 10–2

Although your friends may or may not be impressed with your new-found vocabulary, other page designers will accept you as one of their own. Best of all, knowing the terms will help you feel more in power of type and more in control of your pages.

TYPE ANATOMY

A good place to start to learn how to control type on the page is being able to name the major parts of type. Each part of a letterform has a specific name—but it isn't necessary for you to know all of them in order to use type effectively. Figure 10-3 labels the really important formal names for the different parts of letterforms.

TYPEFACES

NOTE
A graphic design rule of thumb is to avoid using italic type for more than six lines of type. Line after line of "urgent" italic type results in reader fatigue.

Each letterform in our alphabet has a particular style and form that makes it unique. The letterform of the y, for instance, is considerably different than the letterform d. It is these unique shape and form differences that make the viewer able to identify each letterform and interpret groups of letterforms as words. A **typeface** is a set of letterforms, numbers, and symbols unified by a common visual design (Figure 10-4). Some computer programs use the word **fonts** interchangeably with the word typeface. Technically, the word font means a complete set of type in a typeface, weight, and size.

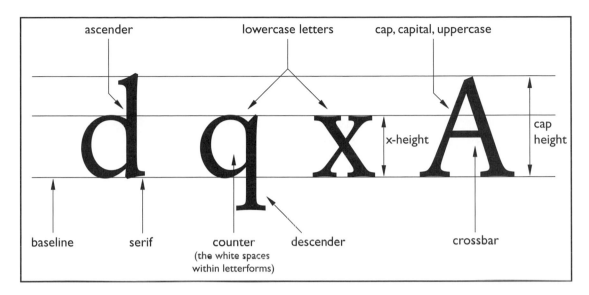

Figure 10–3 The anatomy of type.

abcdefghijklmnopqrstuvwxyz
ABCDEFGHIJKLMNOPQRSTUVWXYZ
1234567890 $.,:;!?&-/()""''

Figure 10–4 A typeface is a designed set of letterforms, numbers, and symbols. Shown here, 20 point Egyptienne Regular.

TYPE STYLES AND TYPE FAMILIES

Each typeface may also have a variety of related **type styles**, which are modified versions of the original typeface such as italic, bold, condensed, or extended (Figure 10-5 and Figure 10-6). These type style variations are specifically created to extend the uses of the type while still retaining the essential visual character of the original face. Some typefaces have even more elaborate variations such as outline, shaded, and/or decorated. The whole related group of type styles based on a single typeface is called a **type family**.

abcdefghijklmnopqrstuvwxyz
ABCDEFGHIJKLMNOPQRSTUVWXYZ
1234567890 $.,;:!?&-/()"""'

abcdefghijklmnopqrstuvwxyz
ABCDEFGHIJKLMNOPQRSTUVWXYZ
1234567890 $.,;:!?&-/()"""'

abcdefghijklmnopqrstuvwxyz
ABCDEFGHIJKLMNOPQRSTUVWXYZ
1234567890 $.,;:!?&-/()"""'

abcdefghijklmnopqrstuvwxyz
ABCDEFGHIJKLMNOPQRSTUVWXYZ
1234567890 $.,;:!?&-/()"""'

abcdefghijklmnopqrstuvwxyz
ABCDEFGHIJKLMNOPQRSTUVWXYZ
1234567890 $.,;:!?&-/()"""'

abcdefghijklmnopqrstuvwxyz
ABCDEFGHIJKLMNOPQRSTUVWXYZ
1234567890 $.,;:!?&-/()"""'

Figure 10–5 Examples of some of the different type styles of Antique Olive. From top to bottom: regular italic, condensed regular, bold condensed, compact italic, poster, and poster outline.

abcdefghijklmnopqrstuvwxyz
ABCDEFGHIJKLMNOPQRSTUVWXYZ
1234567890 $.,;:!?&-/()""""

abcdefghijklmnopqrstuvwxyz
ABCDEFGHIJKLMNOPQRSTUVWXYZ
1234567890 $.,;:!?&-/()""""

abcdefghijklmnopqrstuvwxyz
ABCDEFGHIJKLMNOPQRSTUVWXYZ
1234567890 $.,;:!?&-/()""""

abcdefghijklmnopqrstuvwxyz
ABCDEFGHIJKLMNOPQRSTUVWXYZ
1234567890 $.,;:!?&-/()""""

abcdefghijklmnopqrstuvwxyz
ABCDEFGHIJKLMNOPQRSTUVWXYZ
1234567890 $.,;:!?&-/()""""

abcdefghijklmnopqrstuvwxyz
ABCDEFGHIJKLMNOPQRSTUVWXYZ
1234567890 $.,;:!?&-/()""""

Figure 10–6 Examples of some of the different type styles of Gill Sans. From top to bottom: regular, italic, bold, bold italic, extra bold, and condensed bold.

TIP

Use the variations in the type style of a typeface to add emphasis and tone to your message. For example, the dynamic angle of italics seems urgent, the thicker letterforms of bold type emphasize the importance of the bolded words, the distorted letterforms of condensed or extended type convey an impression of stylish modernity, while the regular type style of a typeface seems sane and conventional.

TYPE SIZES

Type is traditionally measured in **points**. The term originated from the days when type was cast in lead metal slugs. It was critical that all of the baselines line up when the type was cast, therefore point size had to include space for ascenders, the body, and descenders of the type. The term is still used, even with computers, and it is useful to know that the point size measurement includes ascenders, the body, and descenders of a font. There are 72 points to an inch. The larger the point size, the larger the type (Figure 10-7). Small point sizes such as 6, 8, 9, 10, 11, and 12 are considered body text sizes, whereas larger point sizes such as 14, 18, 20, and higher are considered headline or display sizes. Determining which body copy size is appropriate for use depends upon the prospective audience. Children's books are typically set in a slightly larger body copy size as they are learning to recognize shapes of letters to read words. Setting brochures for senior citizens in a larger body copy size improves readability for an audience with impaired sight. A general rule of thumb is that a headline should be 1.5 times larger than the body copy, and at least one level in emphasis. For example, if you're using 12 point body copy in a regular type style, then an 18 point bold headline is appropriate.

6 **picas** (a traditional layout measurement) = 1 inch

12 points = 1 pica

72 points = 1 inch

WEIGHT

TIP

Where headline space is at a premium and you've already tried reducing the size of your headline type, try using a condensed font to conserve space. Condensed type has a narrower footprint and more type can fit into the space.

The letterforms in typefaces are made up of strokes. Letterforms with thin strokes have a light and airy feeling, whereas letterforms with thick strokes seem bold and heavy. The thicker the stroke, the bolder and heavier the letterform will appear. A well-developed type family often contains a range of weights, such as light, regular, semi-bold, bold, extra bold, or maybe even poster black. Other type families are limited to regular and bold. It really just depends on how much time and vision the original typographer had when designing the type family. Using a type family that has a variety of weights available increases your options because you can pick just the weight you need to add emphasis to your message. Figure 10-5 and Figure 10-6 show type families with a wide range of weights.

AaBbCc AaBbCc
8pt

AaBbCc AaBbCc
10pt

AaBbCc AaBbCc
12pt

AaBbCc AaBbCc
14pt

AaBbCc AaBbCc
16pt

AaBbCc AaBbCc
18pt

AaBbCc AaBbCc
20pt

AaBbCc AaBbCc
24pt

AaB AaB
48pt

Aa Aa
72pt

Figure 10–7 Times New Roman (left) and Helvetica (right) in different point sizes. As displayed in this figure, two fonts can be set in the same point size, yet not be the same height. Times New Roman at 72 point, is shorter than Helvetica, also at 72 point.

LETTERSPACING, LEADING, AND WORD SPACING

Letterspacing is the space between individual letters and characters (Figure 10-8 and Figure 10-9). The term **leading** refers to the vertical space between lines of type. Type with tight letterspacing and leading is often difficult to read (Figure 10-10). Wide letterspacing in short amounts of text such as a headline or a name can seem stylish and sophisticated (Figure 10-11). Increasing the amount of space between letterforms and opening up the space between lines of type can impact the legibility of your message. Columns of text with paragraph after paragraph of widely spaced letters is exhausting to read. The same is true for leading. Adding leading between lines of type also makes the typeface appear lighter and airier, while extreme amounts of leading make it difficult for the reader to track down to the next line, especially when there is a background image involved.

Figure 10–8 The same size word in two different letterspacings. Notice the awkward space between the "W" and the "y" in the top word. Reducing the letterspacing results in more graceful spacing (bottom word). Some letter combinations result in larger, more awkward spaces than others (such as the "w," "y," and "o"), and often must be custom tailored to look better.

Figure 10–9 A traditional graphic design standard for determining whether a word is letterspaced correctly is to envision pouring approximately the same amount of sand between letters.

The average horse, getting grain, should be fed ten to fifteen pounds of hay daily, but it is an error to think that horses doing light work can subsist entirely on hay.

The average horse, getting grain, should be fed ten to fifteen pounds of hay daily, but it is an error to think that horses doing light work can subsist entirely on hay.

Figure 10–10 The text on top is set in very tight letterspacing and leading, whereas the text on the bottom is set with regular letterspacing and leading. Compare the readability of the text on top with the text on bottom.

Q u i e t l y S o p h i s t i c a t e d

Figure 10–11 The wide letterspacing in this example contributes to its dignified appearance.

TIP
For a more polished and professional look, selectively adjust the space between letterforms to eliminate excess gaps. If you're working on a computer, look for the words "kern" or "kerning." These functions will let you fine-tune the letterspacing. Manipulating the space between two individual letters is called **kerning** (Figure 10–12).

Figure 10–12 Some letter combinations require special attention and kerning adjustment to the space between the letters. The top line of letter pairs is shown with normal letterspacing, the bottom line of letter pairs, after adjusting kerning.

Word spacing is, as you've probably already guessed, the space between words. Adjustments to word spacing typically occur to either tighten up the space between words so as to shoehorn more copy into a space, or to stretch out a headline to fill up more space. Figure 10–13 shows three possible variations in word spacing. To achieve a moderate amount of word spacing, imagine inserting a lowercase n (without letterspacing) between the words. To achieve tight word spacing, imagine a lowercase i (with letterspacing) between the words. Avoid spacing words so far apart that they are read as individual words instead of a phrase, or spacing words so close together that they read as one very long word. Very wide and very tight word spacing decrease legibility.

TYPE ALIGNMENTS

Type can be aligned in several different ways on your pages. Type can be centered, left aligned, justified, right aligned, or wrapped around other visual elements on the page. Centered type is popular for short amounts of text such as in flyers and wedding announcements. Left-aligned type is useful in just about any type application because designers consider it easy to read. Justified text is common in maga-

word spacing

word spacing

word spacing

Figure 10–13 Three examples of word spacing: moderate (top), tight (middle), and too wide (bottom).

zines and newspapers. Right aligned text is used more sparingly because the irregular left edge makes it slightly harder for the viewer's eye to track to the beginning of the next line. Runaround text is a natural for newsletters and magazines. Runaround text flows easily around objects on the page such as initial caps, illustrations, photographs, and even other pieces of text.

Fortunately, desktop publishing programs make it very easy for the page designer to quickly change the alignment of bodies of text with a click of a button. This allows you to try different type alignments in the layout in a short period of time. Some graphics desktop publishing programs will even let you stack type, but you should avoid this option entirely if you have more than a phrase to align on the page. Stacked typography is extremely difficult to read for Western viewers who are trained from a young age to read from left to right; furthermore, it is difficult to stack typography in a visually appealing way.

LINE LENGTH

Line length is an important component of designing readable text. Long lines of type are hard to read because the eye has difficulty tracking back to the beginning of the next line. Really short lines of type are tedious to read, especially if there are a lot of hyphenated words. The shorter the line length, the fewer characters fit on the line, and the more hyphenated words result. Short line lengths result in bad breaks and undesirable amounts of hyphenation (more than two hyphens in a row are undesirable). Fewer columns and longer line lengths will allow more words per line, eliminating many of the repetitive hyphens. Forcing justified type to fit in shorter line lengths is highly problematic, as it often results in rivers and extensive hyphenation problems. Fitting justified type into columns with longer line lengths reduces many spacing and hyphenation issues caused by short line lengths. For best legibility, line lengths should be no more than approximately 50 to 60 characters long. One way to make sure that you don't exceed this character count is to determine best line length by doubling the point size of the type. For example, if the body copy is 10 points, then a good legible line length is 20 picas long. An alternate line-length rule of thumb is that the column width should fit 1 1/2 to 2 full lowercase alphabets at the chosen point size. Figure 10-14 depicts the optimal column widths for body copy in different point sizes of the popular typeface Garamond.

CATEGORIES OF TYPE

With all of the thousands, maybe even millions of typefaces available, and more popping up all the time, it is difficult to pigeonhole every single typeface into categories. Even type experts disagree about how many type categories there are and even what to name the categories. For the sake of clarity and brevity I will divide the world of type into five major categories: serif (including Old Style, Transitional, and Modern serifs), sans serif, square serifs (also known as Egyptian), script, and decorative (some type designers call this category Occasional or Novelty). Each category has distinctive letterform and stress features that determine which category a typeface falls into (Figure 10-15).

We the People of the United States, in Order to form a more perfect Union, establish Justice, insure domestic Tranquility, provide for the common defense, promote the general Welfare, and secure the Blessings of Liberty, to ourselves and our Posterity, do ordain and establish this Constitution for the United States of America.

We the People of the United States, in Order to form a more perfect Union, establish Justice, insure domestic Tranquility, provide for the common defense, promote the general Welfare, and secure the Blessings of Liberty, to ourselves and our Posterity, do ordain and establish this Constitution for the United States of America.

We the People of the United States, in Order to form a more perfect Union, establish Justice, insure domestic Tranquility, provide for the common defense, promote the general Welfare, and secure the Blessings of Liberty, to ourselves and our Posterity, do ordain and establish this Constitution for the United States of America.

We the People of the United States, in Order to form a more perfect Union, establish Justice, insure domestic Tranquility, provide for the common defense, promote the general Welfare, and secure the Blessings of Liberty, to ourselves and our Posterity, do ordain and establish this Constitution for the United States of America.

We the People of the United States, in Order to form a more perfect Union, establish Justice, insure domestic Tranquility, provide for the common defense, promote the general Welfare, and secure the Blessings of Liberty, to ourselves and our Posterity, do ordain and establish this Constitution for the United States of America.

Figure 10–14 Optimal line length is related to point size. The smaller the type, the less width it takes up, and consequently the shorter the line length should be.

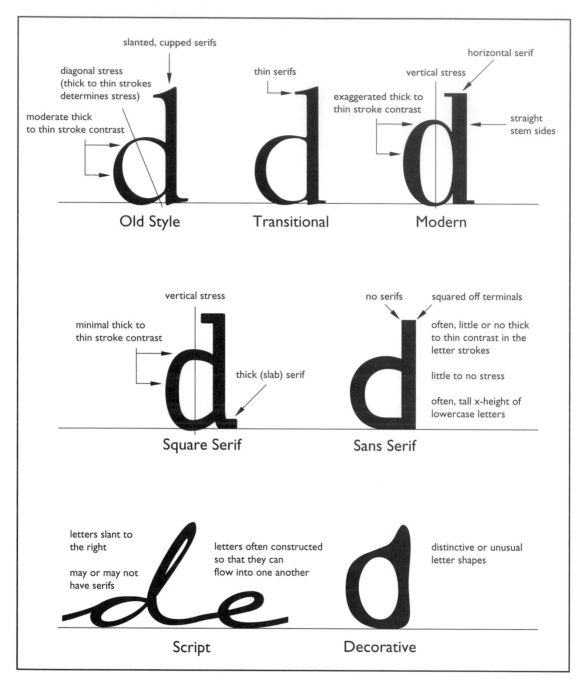

Figure 10–15 Characteristics of the different type categories.

Serif

The Roman serif typeface style originated with, you guessed it, the Romans! Back in the days when the Romans were in a construction frenzy of shrines, victory columns, villas, and all manner of public buildings, stonemasons incised phrases and dedications into the stonework. Wielding an iron chisel and a lot of patience, these stonemasons would laboriously cut letterforms into the stone. Even the best stonemasons had a hard time neatly ending the stroke, so to disguise the ragged ends, they developed a nifty trick to clean up the letterforms. They added a short extra stroke to the ends of the letterforms. This extra cut was called a **serif**, and modern-day graphic designers still use this name to refer to this letterform feature (Figure 10–16).

In part because of the way the stonemasons wielded their chisels, Roman serif typefaces typically have thick and thin variations in their letter strokes, and serifs range from moderately to extremely pointed. Over several millenniums, this style of typeface evolved into a wide range of serif typefaces that can be further subcategorized into Old Style, Transitional, and Modern typefaces.

NOTE

While the Romans first invented Old Style typefaces (they probably called them Modern), the thick to thin contrasts of the strokes in the letterforms were further developed by the penmanship of ancient scribes, monks, and scholars. Writing with a wedge-shaped pen naturally results in thick to thin strokes because of the changing angle of the pen, and the first craftsmen using printing presses imitated these letterforms, carrying on the tradition.

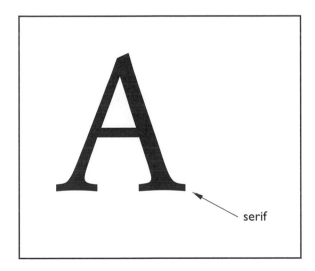

serif

Figure 10–16 Example of a serif.

Old Style typefaces are most closely related in form to the stone-incised Roman letterforms and have little thick and thin contrast in the letter strokes. Lowercase ascenders are taller than capital height, and the serifs are slanted and often cupped. Examples of Old Style typefaces are Caslon, Garamond, Palatino, and Times Roman (Figure 10–17). There is an old printer's motto that says "When in doubt, use Caslon."

Transitional typefaces were the next evolution in typographic form, and in 1757 John Baskerville, an Englishman, startled the publishing industry with a new and innovative typeface design he named "Baskerville" (Figure 10–18). What made this typeface distinctly different from the Old Style typefaces was the increased contrast between the thick and thin strokes in the letterforms and the sharp serifs. Transitional typefaces also featured capital letters the same height as lowercase ascenders, thin serifs, and short and wide lowercase letters. These characteristics are typical of Transitional typefaces. Other Transitional typefaces are Century Schoolbook and Cheltenham.

Old Style and Transitional faces are among the most familiar, and the most invisible, of all typefaces. Their familiarity of form makes them an excellent choice for long passages of body copy.

Modern typefaces further increased the contrast between thick and thin strokes in the letterforms. Thin strokes are virtually hairline thick, whereas thick strokes are big and blocky. Serifs are attached at 90-degree angles to the letterforms and are sharp-edged and unbracketed. Internal counters such as those in a, d, and b, are tall and blocky, reflecting the vigorous vertical stress of the Modern style typefaces. Examples of Modern typefaces are Bodoni and Tiffany (Figure 10–19).

abcdefghijklmnopqrstuvwxyz
ABCDEFGHIJKLMNOPQRSTUVWXYZ
1234567890 $.,;:!?&-/()""''

Figure 10–17 Old Style typeface Caslon Antique.

Modern typefaces evolved from Old Style and Transitional type-faces because of improvements in technology. Smoother paper and better printing technology in the 1700s allowed type designers to increase the thick to thin transitions in the letterforms, resulting in a more severe look. Lowercase letters are very short compared to cap-itals. Serifs are horizontal and thin; and there is a strong vertical stress to the letterforms. Because of this severity, Modern typefaces tend to have a cold, stylish, elegant look. The bolder and more exaggerated of the Modern typefaces—often called Poster—are excellent for head-lines and subheads but seem "dazzling" in body copy. When set in body copy, the thin strokes of the letterforms seem to disappear because of the intensity of the thick letter strokes.

The serif typefaces, including those of the Old Style, Transitional, and Modern subcategories (with the exception of the modern posters), are extremely easy to read in both headlines and body copy,

abcdefghijklmnopqrstuvwxyz
ABCDEFGHIJKLMNOPQRSTUVWXYZ
1234567890 $.,;:!?&-/()""''

Figure 10–18 Baskerville is a Transitional typeface.

abcdefghijklmnopqrstuvwxyz
ABCDEFGHIJKLMNOPQRSTUVWXYZ
1234567890 $.,;:!?&-/()""''

Figure 10–19 An example of a Modern typeface, Tiffany.

and these typefaces convey a sense of dignity, history, and reserved style. They are conservative in appearance, which makes them a safe choice for a wide range of projects.

Square Serif

In **square serif** typefaces, the serifs at the end of the letter strokes appear to end in blocks or slabs. The x-height (the height of lowercase letters, not including the ascender and descender) is very tall compared to capitals, and there is very little contrast between the thick and thin of the letter strokes. Some typographers name this category Egyptian or Slab Serif because many of these typefaces had Egyptian-sounding names to capitalize on the fad popularity of anything Egyptian in the early 1800s. Advertisers during the 1800s used square serifs in any and all page designs, although square serif typefaces work best in headlines or display type. When set into body copy, they appear very dense and black. Today, square serifs are most widely used in children's books because of their simplicity and unfussy clean appearance. Egyptienne, Lubalin Graph, Clarendon, and City Compress are square serif typefaces (Figure 10–20).

abcdefghijklmnopqrstuvwxyz
ABCDEFGHIJKLMNOPQRSTUVWXYZ
1234567890 $.,;:!?&-/()""''

ABCDEFGHIJKLMNOPQRSTUVWXYZ
ABCDEFGHIJKLMNOPQRSTUVWXYZ
1234567890 $.,;:!?&-/()""''

Figure 10–20 Two square serif typefaces: Clarendon (top) and City Compress (bottom).

Sans Serif

Sans serif means "without serifs" (Figure 10–21). "Sans" is French for "without." Sans serif typefaces originated as a visual response to the Industrial Revolution. During the twentieth century, many more sans serif typefaces were designed because the streamlined form conveys a modern appearance.

Sans serif fonts, because of their simplicity and clean look, work well for headline type and display type (Figure 10–22). Set in body copy, however, sans serif fonts slightly slow down reading speed. The advantage of serifs is that they help the reader identify the letterforms faster than a sans serif font. Without the serifs, there are slightly fewer

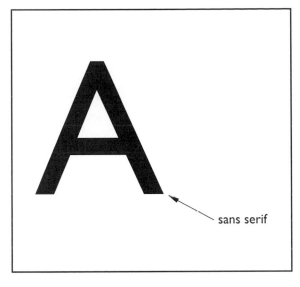

Figure 10–21 Example of a sans serif typeface.

abcdefghijklmnopqrstuvwxyz
ABCDEFGHIJKLMNOPQRSTUVWXYZ
1234567890 $.,;:!?&-/()""""

abcdefghijklmnopqrstuvwxyz
ABCDEFGHIJKLMNOPQRSTUVWXYZ
1234567890 $.,;:!?&-/()""""

Figure 10–22 Two examples of san serif typefaces: Imperial (top) and Washington Black (bottom). The extreme variations in the width of the letterforms in Washington Black (compare lowercase s to lowercase w) make this typeface suitable for headline or display type but not for body copy.

characteristics for the reader to identify, hence a slower reading speed. Medium weights of familiar sans serif faces such as Helvetica, Futura, and Gill Sans are among the less risky choices for body copy.

Script

Script typefaces convey the feeling of handwritten designs. Depending on the design of the script, the typeface can seem formal or very informal. Formal appearing scripts are commonly used in wedding invitations, while informal scripts can lend an air of immediacy and dynamic action to a design. Many script typcfaces are hard to read when set in blocks of text or in all capital letters. Another characteristic of some script typefaces is the delicate construction of the letter strokes; light and airy letterforms are difficult to read at smaller sizes. Script faces are best used sparingly in limited amounts of text, such as in a wedding invitation, or for headlines. Avoid using them in body copy because their distinctiveness = hard to read. Examples of script typefaces are Brush Stroke, Mistral, Cathedral, Vladimir, and Commercial Script (Figure 10–23).

Figure 10–23 Two script typefaces: Vladimir (top) and Commercial Script (bottom).

Figure 10–24 Combining script typefaces with other typefaces results in stunning effects.

Decorative

Those typeface designs that are hard to categorize are by default dropped into the decorative category. There are no particular design limits for this category. Many of these typefaces are extremely difficult to read and are best used for display or headline copy instead of body text (Figure 10-25). They are often quirky and/or faddish and usually

aBcoefghijklmnopqrstuvwxyz
aBcoefghijklmnopqrstuvwxyz
1234567890 $.,;:!?&-/()"""'

abcdefghijklmnopqrstuvwxyz
ABCDEFGHIJKLMNOPQRSTUVWXYZ
1234567890 $.,;:!?&-/()"""'

Figure 10–25 Two decorative typefaces: American Uncial (top) and Ice Age (bottom).

appropriate for use in a limited range of topics. Choosing the wrong decorative typeface can shoot down an otherwise well-thought-out design. The advantage of using the right decorative typeface is that you can quickly establish a mood, time period, or style. If you're in the mood to experiment, then try a decorative category typeface.

Popular Typefaces

Some typefaces are more readable than others. When you're looking for readable and attractive typefaces, consider these:

For a modern impression:

- Gill Sans
- Helvetica
- Stone Sans
- Officina Sans
- Futura

For a classic impression:

- Goudy
- Garamond
- Times New Roman
- Bookman
- Bodoni
- Galliard

FONT SOFTWARE FORMATS

With the wide availability of computers and desktop publishing software, no discussion of type technical terms is complete without a few words about font software formats. There are three main font software formats, with new font software formats in the works. The three main font formats you'll most likely encounter are PostScript Type 1, TrueType, and OpenType fonts.

PostScript

PostScript is a computer language developed by Adobe Systems to communicate complex type and graphics to a wide variety of computers and digital printers. PostScript Type 1 fonts were specifically designed to print with clean, smooth edges at any size—teensy tiny or gigantic—on PostScript printers. It is the worldwide printing and imaging standard used by many laser printers for high quality renderings of digital images. A PostScript Type 1 font is a font that draws on the best qualities of the PostScript computer language and is the preferred graphics industry font technology. Each PostScript Type 1 font has at least two separate files, the screen font file, and the printer font file. The screen font is used by the computer to draw the font properly on screen, and the printer font is used by the PostScript printer to print the font properly on paper. Both parts must be present for the font to work properly.

TrueType

TrueType is another standard digital type font that is used in both Windows and Macintosh computers. It is designed to look smooth on screen at any size, and to print with sharp edges on non-PostScript printers such as low cost ink-jet printers. The advantages to TrueType fonts are that they only use one file instead of the two required by PostScript Type 1 fonts, so they are easier to keep track of. The disadvantage to TrueType fonts is that the printing industry prefers PostScript Type 1 fonts to TrueType fonts because PostScript Type 1 fonts were specifically designed to work smoothly with high resolution PostScript printers. TrueType fonts, for numerous technical reasons, sometimes disagree with PostScript printers, and the higher the resolution of the printer, the more technical problems occur. Older printers have more trouble than newer printers.

OpenType

The OpenType format is a merging of the best of both Type 1 fonts and TrueType. OpenType incorporates both PostScript data for printing and TrueType data for screen fidelity. The format provides better cross-platform support and a larger range of characters: Type 1 and

TrueType fonts are limited to 256 characters, while OpenType technically supports 65,000 characters. This large amount of characters grants type designers the opportunity (if they choose to undertake it) to design many more alternate characters such as small caps and swash letters for their font. OpenType also features enhanced, high-quality on-screen letters, improving the look of typography in web pages. The evolution and eventual acceptance of OpenType format fonts is uncertain, not because of an inherent limitation in the software, but because designers are loath to repurchase fonts that they already own in Type 1 and TrueType formats. I have noticed, however, among my students who are purchasing fonts for the first time, a ready acceptance of the OpenType format and very few problems incorporating the font format technology into either print or web projects.

When shopping for fonts, look for font CDs that have both Post-Script Type 1 fonts and TrueType versions of the fonts. You'll have more choices. For truly excellent fonts in both formats, visit www.fonts.com, a font site that vends fonts from high-power professional type houses. The site has high-quality, professional fonts galore available for download.

SUMMARY

In this chapter you learned key technical type terms. A working familiarity with the vocabulary of typography lets you better communicate with other page designers. More importantly, knowing basic type terms gives you the power to better control your own type choices. Understanding the different type categories and when they are appropriate to use in a page empowers you to tailor the typeface, size, weight, and placement of type to best emphasize your message. Your pages will be more distinctive and more sophisticated.

MINI QUIZ #10

The following questions are a mix of short answer and fill-in-the-blank questions. Fill in the blanks with the words in the following list.

typeface	letterspacing
typography	points

Colorplate 1 In the figure on the top, all of the chickens are identical in emphasis. In the figure on the bottom, adding color to one of the chickens emphasizes it as different from the rest, perhaps even the hero of the parade!

Colorplate 2 This concert ticket for a local alternative band uses the principles of emphasis and repetition as well as typeface choice to describe its musical style.

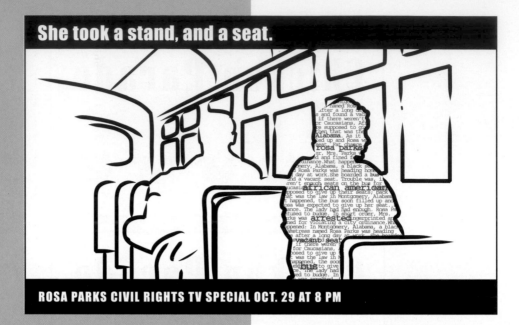

Colorplate 3 One possible solution to Exercise 2. This poster depends on a concrete text alignment to focus on the brave actions of Rosa Parks, an intrepid civil rights pioneer. The shaped text narrates her story and visually depicts her resolve. *Credit, University of Texas at Arlington student, Aaron Herrell.*

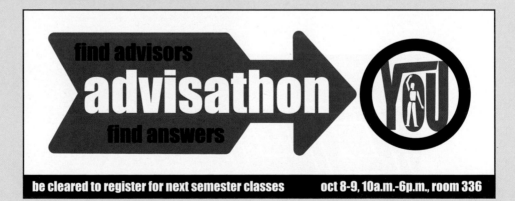

Colorplate 4 The designer of this poster drew a very large arrow to draw the reader's attention to the most important information. Even commonplace visual elements like an arrow can be modified to make them unique and eye-catching.

Colorplate 5 Simple colorization of the original black and white picture really perks up the image of this monkey.

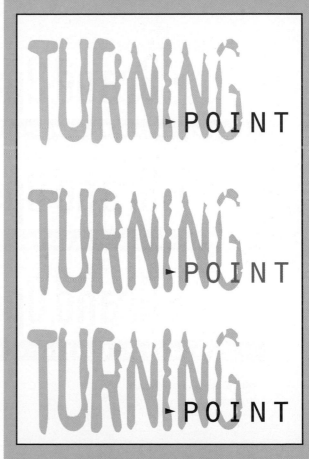

Colorplate 6 This figure shows three different color schemes for a newsletter editorial headline design. Even professional designers "try out" different color combinations to see how they look.

Colorplate 7 Cyan, magenta, yellow, and black colors combine to form the full color image of the apple.

▶ **Grand Opening Sale!**

Bargains Galore October 1⊖31

▶ **Grand Opening Sale!**

Bargains Galore October 1⊖31

▶ **Grand Opening Sale!**

Bargains Galore October 1⊖31

Colorplate 8 Adding color to your designs is a good way to draw the reader's attention.

Colorplate 9 Warm colors seem to "advance" toward the viewer, whereas cool colors tend to "recede."

Colorplate 10 The page on the left uses extremely bright yellow and red colors, which makes it highly visible but perhaps a bit garish. Darkening the yellow and red colors in the page on the right retains visibility while making the sign look more sophisticated.

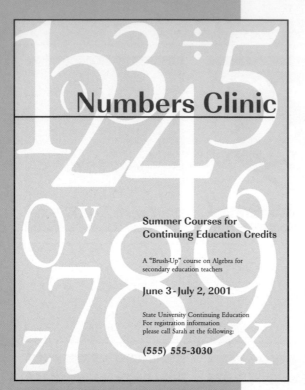

Numbers Clinic

**Summer Courses for
Continuing Education Credits**

A "Brush-Up" course on Algebra for
secondary education teachers

June 3 - July 2, 2001

State University Continuing Education
For registration information
please call Sarah at the following:

(555) 555-3030

Colorplate 11 This background is light enough that the viewer has no problems reading the text. Note that the use of color in the headline and text highlights important information.

We the People of the United States, in Order to form a more perfect Union, establish Justice, insure domestic Tranquility, provide for the common defense, promote the general Welfare, and secure the Blessings of Liberty, to ourselves and our Posterity, do ordain and establish this CONSTITUTION for the United States of America.

Colorplate 12 Text placed on an intense background color is often difficult to read (top image). The text placed on the lighter background (bottom image) is much easier to read because of the high contrast between the background color and the text color.

The Chili-Lover's NEWSLETTER

VOLUME 2 ISSUE 24 SEPTEMBER 2001

Some Like it Hot: Champion 5-Alarm Chili Recipes

Lorem ipsum dolor sit amet, con secteteur adipsicing elit, sed diam vulpatate nibh euisnod. Tempor inci dunt et labore ut dolors magna ali quam erat volupat. Duis vel autemeum irure dolor in henderit in nonumy velit esse consequat. Vel illum dolor facisdi at vero eos. Nam eu feugiat mulla liber tempor, cum solutanobis eligent optius, conquenius nibil impe doming id quod. Maxim facer possin diet omnis voluptatias. Plecat possin diet omnis. Lorem ipsum dolor sit amet, con secteteur adipsicing elit, sed diam vulpatate nibh euisnod. Tempor inci dunt et labore ut dolors magna ali quam erat volupat. Duis vel autemeum irure dolor in henderit in nonumy velit esse consequat.

Win Cook-offs With This Secret Weapon!

Vel illum dolor facisdi at vero eos. Nam eu feugiat mulla liber tempor, cum solutanobis eligent optius, conquenius nibil impe doming id quod. Maxim facer possin diet omnis voluptatias. Plecat possin diet omnis. Duis vel autemeum irure dolor in henderit in nonumy velit esse consequat. Vel illum dolor facisdi at vero eos. Nam eu feugiat mulla liber tempor, cum solutanobis eligent optius, conquenius nibil impe doming id quod. Tempor inci dunt et labore ut dolors magna ali quam erat volupat. Duis vel autemeum irure dolor in

henderit in nonumy. Lorem ipsum dolor sit amet, con secteteur adipsicing elit, sed diam vulpatate nibh euisnod. Plecat possin diet omnis. Maxim facer possin diet omnis voluptatias. Vel illum dolor facisdi at vero eos. Lorem ipsum dolor sit amet, con secteteur adipsicing elit, sed diam vulpatate ut dolors magna ali quam erat volupat. Duis vel autemeum irure

Unusual Recipes for the Adventurous

dolor in henderit in nonumy velit esse consequat. Vel illum dolor facisdi at vero eos. Nam eu feugiat mulla liber tempor, cum solutanobis eligent optius, conquenius nibil impe doming id quod. Maxim facer possin diet omnis voluptatias. Plecat possin diet omnis. Lorem ipsum dolor sit amet, con secteteur adipsicing elit, sed diam vulpatate nibh euisnod.

It Doesn't Have to be Hot--Here's the Best Black-Bean Chili in the Rio Grande Valley

1/4c.	Nonumy
1/2c.	Bexto inso it
1tsp.	Indix
4tsp.	Ondo in stinto

Illum dolor facisdi at vero eos. Nam it eu feugiat mulla liber tempor, cum inte solutanobis eligent optius.

Colorplate 13 Consistent use of color in the headlines helps organize this newsletter.

Colorplate 14 These exuberantly vibrant color swatches exude extroverted playfulness.

Colorplate 15 These swatches imply somber, traditional topics.

Colorplate 16 These light to mid-tone swatches convey a serene, natural meaning.

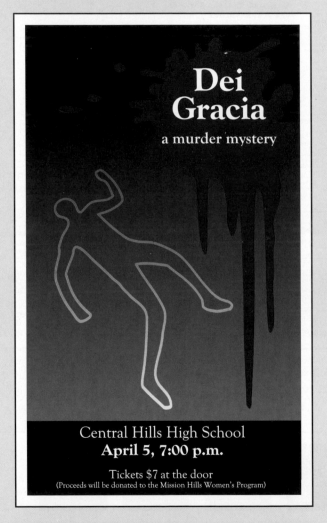

Dei Gracia
a murder mystery

Central Hills High School
April 5, 7:00 p.m.

Tickets $7 at the door
(Proceeds will be donated to the Mission Hills Women's Program)

Colorplate 17 Red is associated with excitement and danger in Western culture.

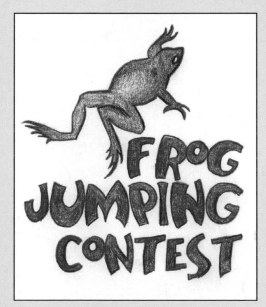

Colorplate 18 These three figures show several solutions to Exercise 2. Conclusion: changes in color dramatically affect the overall impact of the design and the visual hierarchy of the elements within the design. While none of these solutions is resolved, the uppermost left solution has the most successful color and visual hierarchy, with the solid blue text gaining visual prominence on the page. Surprisingly, the bottom pink and orange combination, despite its bright colors, lacks emphasis and hierarchy because everything is so bright the viewer doesn't know what to look at first. Plus, what kind of jumping frogs are they using? Irradiated ones?

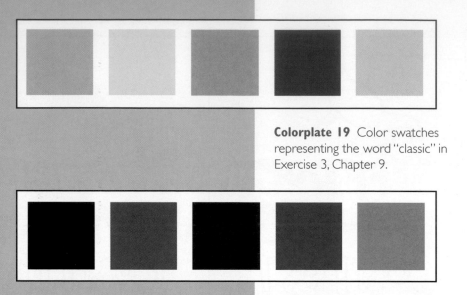

Colorplate 19 Color swatches representing the word "classic" in Exercise 3, Chapter 9.

Colorplate 20 Color swatches representing the word "dependable," for Exercise 3, Chapter 9.

classic classic **classic** **classic** *classic* classic

Colorplate 21 This all-type poster is an example of a possible solution for Exercise 4, Chapter 9. Font choice and color selection emphasize the word "classic."

DEPENDABLE
DEPENDABLE
DEPENDABLE
DEPENDABLE

Colorplate 22 This all-type poster is a possible solution for Exercise 4, Chapter 9. Setting the word "dependable" in all caps and a bold font emphasizes the meaning of the word.

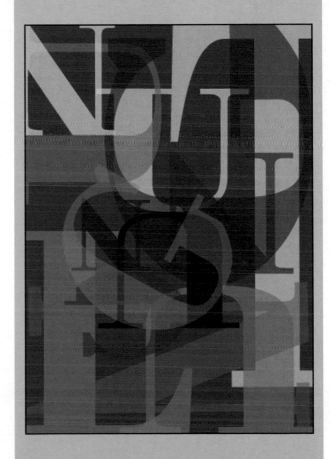

Colorplate 23 This figure shows a student solution for Exercise 1. University of Texas at Arlington graphic communication student Lung Lin uses type overlaps, size contrast, rotated text, and color to interpretively render his name in expressive typography.

Colorplate 24 This figure shows a student solution for Exercise 2. Rotating and repeating the letter Q forms a background pattern, while emphasizing an E in white with its reflection lends this composition a deceptive sense of depth. *Credit, University of Texas at Arlington graphic communication student Brandon Nielsen.*

Colorplate 25 Contrasting the color of the headline, subheads, and pullquote against the color of the body copy enhances the visual interest of this brochure.

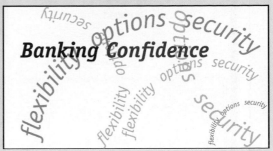

Colorplate 26 The figure on the left uses limited contrast. Notice how in the figure on the right, setting the word "confidence" in a strong color highlights its meaning and attracts the reader's attention.

WE OFFER OUR CLIENTS

KUALITY

☆ *quality* service ☆
☆ attention to *details* ☆
☆ *efficiency* and *competence* ☆

Colorplate 27 Misspelled words anywhere in a page can seriously skew the message.

Colorplate 28 The designer of this restaurant identity set incorporated some variation in the placement of the multicolor bar containing the address and contact information. Despite this variation from the "rules of consistency," the set works well. *Credit, graphic communication student Truong Le, University of Texas at Arlington.*

Colorplate 29 Logos that are first designed in multiple colors (left) often become nearly unreadable when printed only in one color (right).

Colorplate 30 This poster is only one component of a related series of designs that include a motion design ad banner. Given that the assigned space for the motion design ad banner was to be horizontal, the designer chose to make the poster horizontal in order to unify the pieces as a series.

Colorplate 31 Shown here are stills from a motion design ad banner created in Macromedia Flash. Its wide dimensions dictated that the designer orient the accompanying poster design horizontally. Knowing ahead of time that there were to be several designs in a series on this topic, the designer took care to generate a solution that would fit successfully onto all pieces.

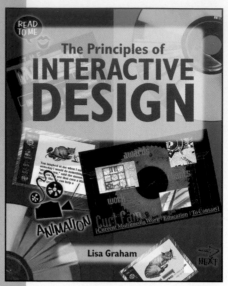

Colorplate 32 Two of the four book cover proposals I presented to Thomson Delmar Learning for the cover of one of my books. The cover on the left was selected for publication, with some slight modifications.

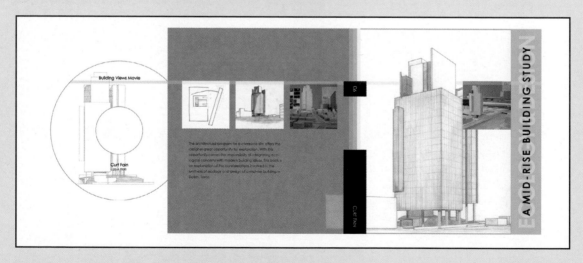

Colorplate 33 This figure shows the complete jacket of a book along with its accompanying CD. To visually tie the two different formats together, architect and designer Curt Fain used sketchy imagery, consistent typeface choice, and ample white space.

1. _____is the skillful arrangement of type on a page.

2. A single set of letterforms, numbers, and symbols unified by a common visual design is a _____.

3. Type is usually measured in _____.

4. The space between individual letters is called _____.

5. Figure 10–26 contains examples of five of the seven type categories. Write the name of each category next to the appropriate typeface.

Egyptian pyramids _____

The future is now _____

Beautiful notions _____

Broadway lights _____

Itchy scratchy fur _____

Figure 10–26

EXERCISES

Exercise 1

This exercise is intended to increase your sensitivity to the abstract line quality of letterforms and to type as an expressive, creative tool. Use the letters from your first or last name and overlap, reverse, and vary the size of the letters to create an interesting and attractive composition. Limit your font choice to one, or at most, two typefaces. You can draw the letterforms by hand or use computer software to solve this exercise. Drawing the letterforms by hand has the advantage of practicing good craft and hand skills, while using the computer will refine your software abilities. Make the final composition 8″ x 10″ in size. Color is optional.

Colorplate 23 shows one possible example of this project.

Exercise 2

This exercise continues to develop your sensitivity to letterforms as design elements. Using the principle of repetition and one other design principle of your choice, select two letters and form a pattern. Limit your font choice to no more than two fonts. Experiment with rotation, placement, and size. Color is optional. Constrain your design to a square format.

Colorplate 24 shows a student solution to this exercise. University of Texas at Arlington design student Brandon Nielsen uses repetition and the principle of emphasis to create a composition that focuses on the letter E.

Chapter 11
A Few Simple Type Rules

OBJECTIVES

- Learn nuts-and-bolts key typography rules.

- Understand that every typeface has a "tone" and increase your ability to identify and use its individual tone in your designs.

- Value the importance of contrast in typeface selection—a "harmony of opposites."

- Achieve familiarity with why typefaces clash and conflict (gotta avoid that!).

- Comprehend, through examples, what type combinations work.

- Nurture the use of type as an expressive visual communication medium.

Now that you have a working typographic vocabulary garnered from Chapter 10, in this chapter we'll move on to some basic type rules. The information presented in this chapter will help you further your understanding of typography by explaining simple, but utterly crucial, typographic rules. I'll try to be the soul of brevity in this chapter, but I'd like to insert this disclaimer: entire books have been written about typography. It is a big subject, with lots of really wonderful books out there that explore different facets of the subject.

On top of all of the books available about type, every graphic designer has an opinion of what is truly

NOTE

One of the basic
questions to ask
yourself when working
with typography is:
Does the type look good?
If it doesn't look good, it
isn't good.

good typography and what isn't. If you ask two graphic designers what is good typography, you might get completely different answers. Or you might not. This chapter is based on my decade plus of teaching graphic design students at the university level: it's a distillation of my experiences with typography. I've tried to present an overview of typography in both Chapter 10 and this chapter so that you can start to form your own opinions, your own likes and dislikes. By the end of this chapter you'll definitely be more knowledgeable about typography and better equipped to use type on your page.

Your typeface selection affects the tone of your page. When you are aware of a typeface's tone, then you can mix and match typefaces to better suit your message. Here are some general guidelines of typefaces to try when you're casting around looking for a specific look or tone (Figure 11–1):

- *Fashionably Modern:* extremely condensed (squeezed) or extended (stretched-out) letterforms.

- *Nostalgic Modern:* typefaces with tall x-heights, or all cap faces with an appearance evocative of the early-twentieth century to mid-twentieth century.

- *Futuristic:* exaggerated letterforms that are either very square or extremely streamlined and rounded; either all caps or all lower-case letters.

- *Friendly and Caring:* softly rounded letterforms.

- *Angry:* jagged, angular letterforms, usually very bold or very thin.

- *Corporate:* strong sans serif typefaces with a very regular appearance.

- *Youthful:* for a very young look, try crayon-like typefaces; for a slightly older, more teen-like look try any kind of funky typeface with irregular letterforms and letterforms that vary off of a consistent baseline.

- *Extreme:* very irregular, distressed, or otherwise degraded letterforms.

NOTE

Another basic question to
ask yourself when working
with typography is:
Is this type easy to read?
If it isn't easy to read, or
even if you just *suspect* it
might not be easy to read,
then it probably isn't.
Choose another typeface.

FASHIONABLY Modern
City Compress Craw Modern

Nostalgic Modern ANGRY
Peignot Doubt Condensed

Official Conventional
Palatino Baskerville

Friendly & Caring
Vogel Condensed

Corporate YOUTHFUL
Franklin Gothic Condensed 3 Hour Tour

extreme
Frazzle

Dignified FUTURISTIC
Goudy Red Alert

Figure 11–1 A few samples of typefaces and their "tones."

TIP

Serif fonts tend to be more readable in body copy than sans serif fonts. To enhance readability, yet add typographic variety to your pages, try using a serif font for body copy and a sans serif font for headlines and subheads. The short words and phrases in headlines and subheads let you get away with more daring and interesting (translation: somewhat harder to read) font choices than you could use in body copy.

NOTE

Type is a lot like fashion. What is considered fashionable and interesting varies over the years. Your best bet for keeping up with fashionable type is to keep an eye out on the kinds of typefaces in use in the mass media: television, movies, newspapers, books, magazines, and the World Wide Web.

- *Dignified:* traditional serif typefaces such as Garamond or Goudy.

- *Conventional:* letterforms with a small x-height and serifs.

- *Official:* typefaces with squared-off serifs.

Remember, as you are choosing type to use in your designs, you are in charge. Make type work for you. Don't be afraid of type. It's okay to use more than one typeface in a design. Look around at the typeface choices that other people are using in their designs, and decide whether or not the type works. Try to identify why the type works or doesn't work. You'll learn a lot by looking at other people's pages and learn from their mistakes instead of only from your own. Emulate (not slavishly imitate) the typeface combinations that work, and avoid the combinations that clearly don't work.

USE PLENTY OF CONTRAST

Using contrast in your pages increases visual interest because the contrast of letterforms actually forms a harmonious relationship, a "harmony of opposites." When typefaces on a page are really different from each other they tend to not compete or conflict. On the other hand, when type on a page is similar, such as using two sans serif typefaces for the headlines and the body copy, conflict occurs (Figure 11–2).

Your type will appear more sophisticated if you liberally mix in a good dose of contrast. Draw on the principle of contrast and really stress the differences between type. Be bold and focus on contrasting typefaces (such as decorative with sans serif), type sizes, weights, and color. The bolder you are, the more it will seem as if you are totally confident and totally in control of the type. Your designs will seem more professional and more visually interesting. Take a look at how much a liberal dose of type contrast in Figure 11–3 improved on the original design in Figure 11–2. The design is bolder, more dominant, and not at all visually shy. The contrast in type grabs the reader's attention. You too can empower your type designs by applying contrast alongside bold type choices.

Figure 11–2 The near similarity of letterforms in these two sans serif typefaces causes conflict. They are alike, yet not alike, and that near similarity generates visual tension.

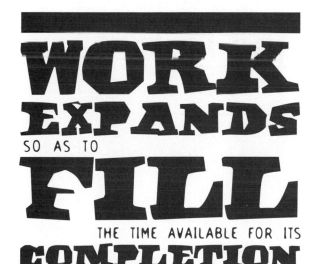

Figure 11–3 Strong contrast dramatically improves the strength of this design.

Size Contrast

Type size contrast is a simple concept and one that I won't belabor: contrast big type with little type (Figure 11-4). Don't do it in half measures. Have fun playing with size contrast. Decide which words or phrases are the most important and really emphasize them.

Compare the web page banner in Figure 11-5 with Figure 11-6. The title banner in Figure 11-5 has a complete lack of contrast. The type is the same size and face; consequently, the banner has little pizzazz. A quick contrast revision of the banner in Figure 11-6 makes a tremendous difference. Contrasting a playful decorative typeface in "Flowers To Grow" with the original typeface in "a website resource…" gives the banner a more exciting and youthful look. Varying the sizes of the type emphasizes the importance of "Flowers To

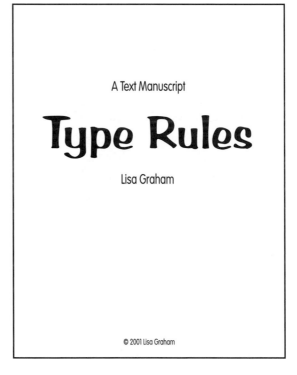

A Text Manuscript

Type Rules

Lisa Graham

© 2001 Lisa Graham

Figure 11–4 Downplaying words that have to be there but aren't that important to the message is a quick way to increase contrast in your pages.

Figure 11–5 Lack of contrast takes a toll on this design.

Figure 11–6 Applying size and typeface contrast perks up this web page title banner.

Grow" while enhancing the visual appeal of the banner. Using two different sizes of type also adds in sophisticated white space. Varying the size of type often has the additional advantage of opening up restful white space. When pages are stuffed full of text and images they seem crowded; leaving ample white space seems sophisticated and restful.

One note: for the sake of readability limit the use of size contrast in body copy. Contrast headlines, quotes, and subheads to your heart's content, but limit contrast within body copy (Figure 11-7), unless you deliberately want to lose your audience. Avoid a lot of bold type inside columns of body copy, because too many bolded words within a paragraph can overwhelm the words in regular type.

Figure 11–7 A lot of contrast within body copy is not desirable and can lead to contrast overkill.

Lorem ipsum dolor **sit amet,** con secteteur **adipsicing** elit, sed **diam vulpatate** nibh euisnod. **Tempor** inci **dunt** et **labore ut** dolors **magna** ali quam **erat** volupat. **Duis** vel **autemeum** irure dolor **in** henderit **in nonumy** velit esse consequat. Vel illum **dolor** faciscti at **vero** eos. **Nam** eu feugiat **mulla liber** tempor, **cum** solutanobis **eligent** optius, **conquenius** nibil **impe** doming **id** quod. **Maxim** facer **possin** diet omnis voluptatias. Plecat **possin** diet omnis. **Lorem** ipsum **dolor** sit amet, **con** secteteur **adipsicing** elit, **sed**

Weight Contrast

Weight contrast primarily involves the intermixing of light, regular type with heavy, bold type. Contrast bold, heavy headlines, subheads, quotes, and initial caps with body copy (Figure 11–8). You'll want to avoid using bold type in body copy because columns of bold type make pages heavy and uninviting, as you can see in Figure 11–9.

Figure 11–8 This page contrasts the weight of the typeface used in the headline, quote, and initial cap with the body copy.

Red Horse Plays Local Scene

Local Singers in Jealous Frenzy.

Lorem ipsum dolor sit amet, con secteteur adipsicing elit, sed diam vulpatate nibh euisnod. Tempor inci dunt et labore ut dolors magna ali quam erat volupat. Duis vel autemeum irure dolor in henderit in nonumy velit esse consequat. Vel illum dolor faciscti at vero eos. Nam eu feugiat mulla liber tempor, cum solut anobis eligent optius, conquenius nibil impe doming id quod. Maxim facer possin diet omnis voluptatias. Plecat possin diet omnis. Lorem ipsum dolor sit amet, con secteteur adipsicing elit, sed diam vulpatate nibh euisnod. Tempor inci dunt et labore ut dolors magna.

Coffee Menu

Espresso: Who would have thought? Our espresso is a teeney-tiny shot of pure energy! $1.50

Espresso Ristoretto: Whoa Nelly! An even stronger pick-me-up! $2.00

Espresso Macchiato: The pinnacle of espresso. A shot of espresso with a bit of steamed milk on top. $2.00

Cappuccino: Available in a variety of flavors including amaretto, mocha, and hazelnut. We also have daily specials. $2.00

Caffe Americano: A shot of espresso cut with extremely hot water for a generous serving. $2.00

Caffe Latte: The milk-and-coffee lover's delight. Our best espresso mixed with steamed milk and a topping of foamed milk. $1.50

Plain-Jane Joe: Coffee. Just coffee. Just good coffee. In a variety of flavors including amaretto, mocha, and hazelnut. $1.00

Coffee Menu

Espresso: Who would have thought? Our espresso is a teeney-tiny shot of pure energy! $1.50

Espresso Ristoretto: Whoa Nelly! An even stronger pick-me-up! $2.00

Espresso Macchiato: The pinnacle of espresso. A shot of espresso with a bit of steamed milk on top. $2.00

Cappuccino: Available in a variety of flavors including amaretto, mocha, and hazelnut. We also have daily specials. $2.00

Caffe Americano: A shot of espresso cut with extremely hot water for a generous serving. $2.00

Caffe Latte: The milk-and-coffee lover's delight. Our best espresso mixed with steamed milk and a topping of foamed milk. $1.50

Plain-Jane Joe: Coffee. Just coffee. Just good coffee. In a variety of flavors including amaretto, mocha, and hazelnut. $1.00

Figure 11–9 The contrast of bold and regular text in the left page is visually lighter and, consequently, has more white space than the visually heavy page on the right. Which page do you find easier to read?

Weight contrast also involves the strategic use of type and white space (Figure 11-10). Contrasting type with ample white space creates a clean and unfussy visual look.

Color Contrast

When budget allows, consider using contrasting colors to attract the reader's attention. Contrast bright colors with dark colors, contrast the headline color with the body copy color (Colorplate 25), highlight significant words with color (Colorplate 26). Color adds a dimension to a design difficult to reproduce in black, grays, and white. If your budget is limited, however, you can achieve interesting visual effects by contrasting heavy black type with gray type (Figure 11-11).

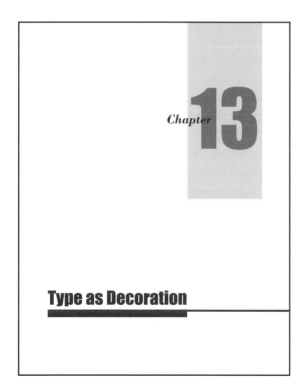

Figure 11–10 Strategic use of white space and contrast gives a page a clean, uncluttered, sophisticated look.

Figure 11–11 Can't use color? Try contrasting gray with black type.

NOTE

Use outline and shadowed type sparingly because they impede legibility (Figure 11–12). Never use outline and shadowed type in body copy; reserve their use for headline copy.

Figure 11–12 Using outline and shadow special effects on type takes away from the type's legibility because they are more fatiguing to read than normal type.

TIP

When a sentence or paragraph must have a lot of emphasized words in it, consider using italic rather than bold. Many bolded words in a sentence or paragraph result in a spotted, unbalanced look, whereas italics blend in better while still emphasizing the information (Figure 11–14). Italics are also read as the "spoken word" and convey a personal approach. A graphic rule of thumb is to avoid using italic type for more than six lines of type. Line after line of "urgent" italic type fatigues the reader.

EMPHASIS AGAIN

As was stated earlier in the book, the principle of emphasis says that the most important element on the page should be the most prominent; the second most important element should be second most prominent; and so on. When picking type to emphasize, look for key words and phrases and emphasize them by changing their size, their weight, color, and/or making them bold or italic. Using different levels of emphasis will reinforce the hierarchy of the type and make the page seem more consistent. For instance, a page that uses one size of type for the headline and another size of type for the subheads will seem more sophisticated than a page that mixes different sizes and typefaces in its subheads (Figure 11-13).

KEEP YOUR TYPEFACE CHOICES SIMPLE

A goal of typographic design is to pick legible, readable typefaces. The words *legibility* and *readability* don't refer to exactly the same thing. **Legibility** is how easy it is to identify text in short phrases such as headlines, signs, slogans, etc. **Readability** is how easy it is to read lots of text: sentences, paragraphs, and pages of text. In general, legible typefaces have well-defined ascenders and descenders

Financial Outlooks

President's
Message
zLorem ipsum dolor sit amet, con secteteur adipsicing elit, sed diam vulpatate nibh euisnod. Tempor inci dun et labore ut dolors magna ali quam erat volupat. Duis vel autemeum irure dolor in henderit in nonumy velit esse consequat. Vel illum dolor faciscti at vero eos.

Performance
Nam eu feugiat mulla liber tempor, cum solutanobis eligent optius, conquenius nibil impe doming id quod. Maxim facer possin diet omnis voluptatias. Plecat possin diet omnis. Lorem ipsum dolor sit amet, con secteteur adipsicing elit, sed diam vulpatate nibh euisnod. Tempor inci dunt et labore ut dolors magna ali quam erat volupat. Duis vel autemeum irure dolor in henderit in nonumy velit esse consequat. Vel illum dolor faciscti at vero eos. Nam eu feugiat mulla liber tempor, cum solutanobis eligent optius, conquenius nibil impe doming id quod. Maxim facer possin diet omnis voluptatias. Plecat possin diet omnis.

Investment
Changes
Duis vel autemeum irure dolor in henderit in nonumy velit esse consequat. Vel illum dolor faciscti at vero eos. Nam eu feugiat mulla liber tempor, cum solutanobis eligent optius, conquenius nibil impe doming id quod. Temp inci dunt et labore ut dolors magna ali quam erat volupat. Duis vel autemeum irure dolor in henderit in nonumy. Lorem ipsum dolor sit amet, con secteteur adipsicing elit, sed diam vulpatate nibh euisnod.

Financial
Statement
Plecat possin diet omnis. Maxim facer possin diet omnis voluptatias. Vel illum dolor faciscti at vero eos. Lorem ipsum dolor sit amet, con secteteur adipsicing elit, sed diam vulpatate nibh euisnod. Tempor inci dunt et labore ut dolors magna ali quam erat volupat. Duis

Financial Outlooks

President's
Message
zLorem ipsum dolor sit amet, con secteteur adipsicing elit, sed diam vulpatate nibh euisnod. Tempor inci dun et labore ut dolors magna ali quam erat volupat. Duis vel autemeum irure dolor in henderit in nonumy velit esse consequat. Vel illum dolor faciscti at vero eos.

Performance
Nam eu feugiat mulla liber tempor, cum solutanobis eligent optius, conquenius nibil impe doming id quod. Maxim facer possin diet omnis voluptatias. Plecat possin diet omnis. Lorem ipsum dolor sit amet, con secteteur adipsicing elit, sed diam vulpatate nibh euisnod. Tempor inci dunt et labore ut dolors magna ali quam erat volupat. Duis vel autemeum irure dolor in henderit in nonumy velit esse consequat. Vel illum dolor faciscti at vero eos. Nam eu feugiat mulla liber tempor, cum solutanobis eligent optius, conquenius nibil impe doming id quod. Maxim facer possin diet omnis voluptatias. Plecat possin diet omnis.

Investment
Changes
Duis vel autemeum irure dolor in henderit in nonumy velit esse consequat. Vel illum dolor faciscti at vero eos. Nam eu feugiat mulla liber tempor, cum solutanobis eligent optius, conquenius nibil impe doming id quod. Temp inci dunt et labore ut dolors magna ali quam erat volupat. Duis vel autemeum irure dolor in henderit in nonumy. Lorem ipsum dolor sit amet, con secteteur adipsicing elit, sed diam vulpatate nibh euisnod.

Financial
Statement
Plecat possin diet omnis. Maxim facer possin diet omnis voluptatias. Vel illum dolor faciscti at vero eos. Lorem ipsum dolor sit amet, con secteteur adipsicing elit, sed diam vulpatate nibh euisnod. Tempor inci dunt et labore ut dolors magna ali quam erat volupat. Duis

Figure 11–13 Using two different typefaces for subheads in the page on the left contributes to a messy impression. Enlarging each word in the subheads so that they are all the same width (left page) just ends up looking contrived and forced. Changing all of the words in the subheads to the same typeface and size (right page) uncluttered the design and gives it a more elegant and refined look.

If at first you **don't succeed, try, try again.** Then **quit.** No use being a **damn fool** about it.

W.C. Fields

If at first you *don't succeed, try, try again.* Then *quit.* No use being a *damn fool* about it.

W.C. Fields

Figure 11–14 The numerous bold words in the left quote gives the quote a spotty look. Switching to italics looks more graceful while retaining emphasis.

(Figure 11–15). Typefaces that lack lowercase letters are good for headlines, but in body copy the all-cap font causes legibility problems. Furthermore, all-cap fonts set on a computer often have awkward letterspacing (Figure 11–16), forcing the designer to manually adjust letterspacing in the software—a daunting, time-intensive task of adjusting paragraphs of body copy! Readable typefaces to use in body copy are generally clean, unfussy, not too visually heavy serif typefaces with well-defined ascenders and descenders (Figure 11–17). Of course, how you arrange the type on the page has a profound effect on the legibility and readability of any typeface, so don't emphasize text too much (lines and lines of letters set in all cap, italics, bold, outlined, or shadowed type is too much), avoid too small or too big type, and avoid line lengths that are very narrow or very wide.

Figure 11–15 (Right) The well-defined upper- and lowercase letters of Franklin Gothic make it a more legible typeface than Anna. The decorative font Anna only offers uppercase letters, making it more suitable for extremely short bursts of text such as logos or two- or three-word headlines.

THIS IS ANNA

This is Franklin Gothic

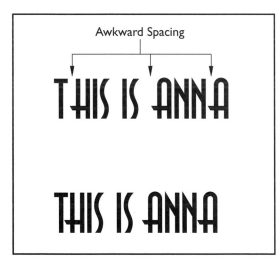

Awkward Spacing

THIS IS ANNA

THIS IS ANNA

This is PEIGNOT

This is Bodoni Book

Figure 11–16 Decorative fonts such as Anna often demand manual adjustment to letter spacing. The top example shows Anna's default letterspacing as typed into a computer, the bottom example after manual adjustment to letter and word spacing.

Figure 11–17 While Peignot has upper- and lowercase letters, the tall x-height makes it more suitable for headlines and subheads than body copy. Bodoni Book's shorter x-height, graceful ascender and descender proportions, and unfussy look make it a usable body copy typeface.

AVOID CONFLICT

Conflict in type occurs when words are similar in size, color, value, weight, or typeface. It is the near similarity of the type to each other that causes the conflict. With little or no contrast, the type design seems static, dull, boring, and lacks visual interest.

The most annoying conflict arises when a designer tries to match two typefaces together because they look similar. Because the type-faces look similar, but are not entirely similar, it just ends up looking like a mistake on the page (Figure 11–18). It is a subtle but annoying

Figure 11–18 The two serif typefaces in the top page subtly conflict with each other. Making two simple changes in the bottom page (swapping the initial cap and the name) erases the conflict. I selected a script typeface for the initial cap and name specifically because the curves in the letterforms repeated the curvature in the dog's tail (principle of repetition in action).

visual mistake. The visual effect is similar to someone scratching one fingernail lightly on a blackboard—not enough to make you jump, but enough to make you fidgety.

One possible source of conflict that is easy to avoid is using all caps. Designs that use all caps lack contrast between the height of the letterforms, and this lack of contrast slows down reading speed. All caps also looks crude and amateurish. Using upper- and lowercase letters is easier to read and draws on the strength of the principle of contrast.

TYPE COMBINATIONS THAT WORK

The point of this section is not to give you a step-by-step listing of all possible typeface combinations. The possible combinations are mind boggling and quite possibly infinite. Let me give you several pointers instead:

- I've said it before, but this is really useful advice: use sans serif type in headlines and subheads, serif in body copy.

- Use no more than two type combinations in a design. Sometimes it is possible to use three typefaces in one design, but picking a third typeface that works with the other two is extremely difficult (Figure 11–19). Because of the difficulty in selecting three typefaces that work together, designs with three or more typefaces have a higher probability of looking disorganized, and the more typefaces used, the more disorganized and messy it looks.

- Use only one decorative or novelty typeface per page (Figure 11–20).

- Avoid using two sans serifs or two serifs together on the same page. They conflict.

- Emphasize headlines, titles, and subheads more than body copy.

- Start your type experiments with classic serif typefaces such as Garamond, Goudy, Caslon, Bodoni, and Baskerville and classic sans serif typefaces like Gill Sans, Futura, and Franklin Gothic (Figure 11–21). Mix and match these serif and sans serif

Figure 11–19 The CD label on the left uses four different typefaces: the fonts in the top two words "my" and "multimedia" work well together, but those fonts conflict with the type on the bottom of the label. Because of this type conflict, the left CD label looks amateurish. Limiting the typeface choice to the best two makes the CD label on the right look stronger and is a more professional design.

Figure 11–20 The top web banner uses three decorative, conflicting fonts. The bottom web banner uses one decorative font and a sans serif font, resulting in a cleaner, more typographically harmonious design.

ABCDEFGHIJKLMNOPQRSTUVWXYZ
abcdefghijklmnopqrstuvwxyz
1234567890;:''""?!,.
Garamond

ABCDEFGHIJKLMNOPQRSTUVWXYZ
abcdefghijklmnopqrstuvwxyz
1234567890;:''""?!,.
Caslon

ABCDEFGHIJKLMNOPQRSTUVWXYZ
abcdefghijklmnopqrstuvwxyz
1234567890;:''""?!,.
Bodoni

ABCDEFGHIJKLMNOPQRSTUVWXYZ
abcdefghijklmnopqrstuvwxyz
1234567890;:''""?!,.
Baskerville

ABCDEFGHIJKLMNOPQRSTUVWXYZ
abcdefghijklmnopqrstuvwxyz
1234567890;:''""?!,.
Futura Medium

ABCDEFGHIJKLMNOPQRSTUVWXYZ
abcdefghijklmnopqrstuvwxyz
1234567890;:''""?!,.
Gill Sans

ABCDEFGHIJKLMNOPQRSTUVWXYZ
abcdefghijklmnopqrstuvwxyz
1234567890;:''""?!,.
Franklin Gothic

Figure 11–21 It's hard to go wrong using these classic typefaces. For a more adventurous look, try mixing a decorative font with one of these classics.

typefaces at will, but not two serifs or two sans serifs together. If you don't have some or all of these fonts available, look for fonts that look similar.

Most people just experiment when selecting more than one typeface in their pages. They mix and match and step back and look at the result, gauging whether it is successful or not depending on how it looks to them. This is natural considering the extremely wide range of typefaces available. If you stick to the preceding type combination suggestions, you'll have a better chance of finding combinations useful to your message.

I've already given you a listing of suggested typefaces, but it is oftentimes useful to get another designer's opinion. So to give you a second opinion, I've asked Curt Fain, a long-time design colleague (Curt's professional work includes graphics, web and multimedia projects, and architecture), to identify the top five typefaces he'd most like to be stranded on a deserted island with (Figure 11–22). Of course, he promptly asked why would he want to be stranded on a deserted island at all? After some shameless begging on my part, he produced the following list.

Figure 11–22

Top 5 Typefaces on a Deserted Island

Lisa, I absolutely must have these typefaces on a deserted island with me (Figure 11–23):

- **Garamond**: A classy, dignified serif face that is very easy on the eyes.

- **Gill Sans**: I'm cheating on this one as I'd choose the entire Gill Sans type family, including regular, condensed regular, condensed bold, bold, bold italic, extra bold. This sans serif font goes with every serif font I've ever seen.

- **Bodoni**: Again I'd request the type family. The Bodoni serif family is very readable, very flexible, with lots of different options. I especially like the Bodoni Poster Compressed face. It's nostalgic yet modern at the same time.

- **Officina Sans**: Modern and readable sans serif. Works with Garamond and Bodoni and Officina Serif.

- **Officina Serif**: A modern and readable serif. Works with Gill Sans, and Officina Sans.

And, I demand one more font beyond my allowed five. I must have Futura because it works with Garamond, Bodoni, and Officina Serif.

P.S. Set up a computer and Internet connection too before you maroon me.

TYPE USAGE GUIDELINES

In writing this section, I reviewed several sources of typographic information—and couldn't find a list of solid guidelines anywhere. So I've decided to list the guidelines I teach my own students in my university classes.

- Don't be afraid to break the rules, *but* to meaningfully break the rules you have to first understand the rules.

- Place typographic readability and communication before style. The primary purpose of a page is to communicate a message. If the type is extremely stylized, it may be a cool-looking page, but if it doesn't communicate the message it is a FAILURE.

ABCDEFGHIJKLMNOPQRSTUVWXYZ
abcdefghijklmnopqrstuvwxyz
1234567890;:''""?!,.
Garamond

ABCDEFGHIJKLMNOPQRSTUVWXYZ
abcdefghijklmnopqrstuvwxyz
1234567890;:''""?!,.
Gill Sans

ABCDEFGHIJKLMNOPQRSTUVWXYZ
abcdefghijklmnopqrstuvwxyz
1234567890;:''""?!,.
Gill Sans Condensed Bold

ABCDEFGHIJKLMNOPQRSTUVWXYZ
abcdefghijklmnopqrstuvwxyz
1234567890;:''""?!,.
Bodoni

ABCDEFGHIJKLMNOPQRSTUVWXYZ
abcdefghijklmnopqrstuvwxyz
1234567890;:''""?!,.
Bodoni Poster Compressed

ABCDEFGHIJKLMNOPQRSTUVWXYZ
abcdefghijklmnopqrstuvwxyz
1234567890;:''""?!,.
Officina Sans

ABCDEFGHIJKLMNOPQRSTUVWXYZ
abcdefghijklmnopqrstuvwxyz
1234567890;:''""?!,.
Officina Serif

Figure 11–23 Curt Fain's typeface picks. These are all very good, very usable typefaces.

- If you have a hard time reading it (and you know what the page says), then it really is hard to read. Pick a more readable typeface.

- Consider the page's format and purpose, because it will help you decide the size of the type. For example, you'd make type considerably bigger for a banner than you would for a flyer.

- Emphasize type according to hierarchy. Emphasize headlines and titles first, subheads second, quotes third, captions fourth, and body copy last. Use size, weight, color, bolded type, italic type, and regular type to indicate this hierarchy. Keep in mind that people are attracted to and will read the biggest, most colorful, most emphasized type first.

- Type should be appropriate for the tone of the page and appealing to the audience. A typeface suitable for a computer equipment sales flyer would be quite different from a font suitable for an Easter egg hunt flyer.

- Avoid all caps like the plague.

- Avoid using italics in more than six lines of type (and that's pushing it). It's tiring to read.

- Just because a computer program will let you apply bold, italic, shadowed, outline, and strikethrough at one time to a word doesn't mean it's a good idea. Please don't. See Figure 11–24 to witness the horror of too many special type effects.

- Color should improve and enhance readability, not be so strong that it overwhelms or detracts from the message.

- Alignment, column width, letterspacing, word spacing, and leading are all critical to readability. Spend a good proportion of your design time working with these parameters.

- Decorative and novelty typefaces are fun and often frivolous, but use them sparingly in headlines, subheads, and slogans. Avoid using them in body copy. Keep in mind that decorative and novelty typefaces are more subject to fad and fashion, and what is neat and nifty looking this year might look horribly clichéd and dated in three years.

Figure 11–24 This much-abused sentence has had bold, italic, shadow, outline, underline, and strikethrough special effects applied to it. (Perversely, I've always wanted to find an excuse to use all of these special effects in one place. Thank you for reading this book so I can get this evil impulse out of my system. Don't tell any of my design colleagues. They'll cast stones at me.)

SUMMARY

Choosing and using type in page designs is often a baffling task for beginning type designers. The information in this chapter gives you some basic guidelines for embarking on your own page designs. When in doubt, refer back to the typeface choices in Figure 11-21 and Figure 11-23; both listings are based on classic typefaces that are as useful today as they were to generations of graphic designers. If you don't have these exact fonts available, then study the shape of their letterforms and select out of your own typefaces those faces similar to them. On the other hand, if you are serious about your page designs, you'll want to gradually acquire these typefaces for your collection.

Check the Spelling!

Now that you know a few basic type usage rules I'd like to remind you of one of the most basic rules—check the type! From writing several books I can attest to how easy it is to misspell words and how sneaky typos can be. But nothing kills credibility like producing lots of copies of a page that is full of misspellings. Luckily, word processing programs have spell checks, so if you're using a word processing program, run a spell check. Follow up on the computer spell check by

proofreading the text: spell checks don't catch all usage mistakes such as the use of pare and pear instead of pair. If you're creating your page in a drawing program or by hand, then be sure to visually check and double-check the type. Try to round up a relative, friend, or colleague to proofread your page for you. It is all too easy not to see the forest for the trees, that is, to get so accustomed to looking at a project that you can no longer see the misspellings. Check and double-check spelling to avoid looking unprofessional (Figure 11–25). Check for misspellings even in type used as decorative or background elements (Colorplate 27).

Nothing kils credeblty like preducing lots of cupies of a page that is ful of mispilingks.

Figure 11–25

MINI QUIZ #11

The following questions are a mix of short answer and fill-in-the-blank questions. Fill in the blanks with the words in the following list.

> conflict
>
> legibility
>
> readability

1. How easy or hard it is to identify text in short phrases such as headlines is _____.

2. _____ refers to how easy or hard it is to read lots of body copy like paragraphs and pages of text.

3. When words or phrases are similar in size, color, value, weight, or typeface they lack contrast and they _____ with each other.

4. Different typefaces can evoke different tones. In Figure 11–26 draw a line between the phrases on the left set in special typefaces and the appropriate descriptive tones on the right.

EXERCISES

Exercise 1

Select a quote, proverb, or saying meaningful to you and, using several different typefaces and a variety of typesizes, interpret the quote visually (similar to what I did in Figure 11-3 and Figure 11-14). Use the principles you've learned in this book, especially the principles of contrast and emphasis. The final composition can be in any media you wish (marker, pencil, pen, or computer generated).

NOTE

The exercises in this chapter and in Chapter 12 require you to expand your typeface selection. Find a book with a variety of typefaces you can photocopy or trace. Alternately, use the typefaces on your computer or purchase a font CD.

Figure 11–26

Exercise 2

Select a word from the following list and distort all or part of the letterforms to visually depict the meaning of the word (similar to what I did in Figure 8–30 and Figure 8–33). Alter the size, shape, texture, placement, color, and value of the letterforms to reflect the visual meaning of the word. Do at least 10 thumbnail sketches before creating your final composition. The final composition can be in any media you wish (marker, pencil, pen, or computer generated).

juxtaposition	rotate
guitar	foundation
avalanche	immovable
skittery	mirror

Exercise 3

Write your name on a piece of paper, along with several adjectives that describe you. You can use all or part of your name or even a favorite nickname. Visually interpret your name through typeface choice, size, placement, color, and value. Where necessary, you may alter the structure of the letterforms themselves to enhance your visual interpretation of your name. Do at least 10 thumbnail sketches before starting on your final composition.

Exercise 4

Select a word from the list in Exercise 2; or if you prefer, select your own word. Split the word horizontally in two. Progressively shift the halves of the word apart horizontally, generating at least three examples of the word shift (Figure 11–27). The purpose of this problem is to study the effects of simple distortion on legibility.

Figure 11–27 One possible visual solution for Exercise 4.

part three

Projects &
Resources

In this part you'll learn more about design parameters for a variety of projects that beginning designers may encounter. I'll summarize specific design formats and design considerations for each type of project—enough to get you pointed in the right direction to solve similar projects. The final chapter in this book, Chapter 13, lists books, software, and tools useful to page designers.

Chapter 12
Focus On...

- Gain increased awareness of nuts-and-bolts design rules and parameters to everyday page design formats.

- Understand the usefulness of design principles in context of common design projects.

- Train your design sensibility through exposure to examples and hands-on projects.

- Apply knowledge of the design principles to practical page design projects.

A friend of mine recently decided that she needed business cards. In the interest of cost, she decided to create the card herself, using her home computer and laser printer. Despite a desk holder full of other people's business cards, she realized she had a number of questions about what you should and should not do when designing a business card. Instead of going to the library and wading through a graphic design textbook to find the information, she called a friend (me, the graphics instructor) for a one-minute summary. Five minutes later she hung up and continued with her design task.

This telephone conversation highlights the fact that even people who see logos, business cards, flyers, and newsletters every day do not always know how to create a good design for these formats. Each of these design formats has a set of standards and conventions

that you can use to guide the development of these designs, if you only know what they are. This section provides a quick overview of important standards and conventions for some common page formats. If you find yourself needing to design a business card, for example, you can turn to this section to review some of the special considerations of business card design.

For those individuals who would like more in-depth information about designing with these formats, I have also included a listing of helpful books in Chapter 13, Tools and Resources.

STATIONERY SETS

Stationery sets usually consist of letterheads, business cards, and envelopes. A well-organized and well-designed stationery set conveys a strong and positive company image. Many businesspeople feel that a visually interesting stationery set is an important image-building tool.

Standard Dimensions

> **Letterheads**: $8\frac{1}{2}''$ x $11\frac{1}{2}''$
>
> **Envelopes**: $9\frac{1}{2}''$ x $4\frac{1}{8}''$ (this size is called a #10 envelope)
>
> **Business cards**: $3\frac{1}{2}''$ x $2''$ Business cards can be tall, wide, or even folded (Figure 12–1).

NOTE

The additional panels on a folded business card can be used for more than pure decoration. Consider using the extra space as a mini-brochure for a company by listing special business services on the inside panel.

Figure 12–1 A folded two-panel business card expands the design space. The top image shows the outside cover of a folded business card; in the bottom image the inside panel contains all of the pertinent contact information.

TIP

Go ahead, be sneaky. An often-overlooked mini-advertisement opportunity is the space at the bottom left of an envelope. As people sort through their mail they quickly glance first at the mailing address and then to the sender's address. Their glance automatically tracks over the bottom left of the envelope. Why not sneak a slogan (Figure 12–2) or a mini-ad into that space? It's unoccupied anyway, and supplies the opportunity to print slogans, tips, reminders, and so on. You're paying for the space, so use it to your best advantage.

Standard Information on the Stationery Set Pieces

Because of their different sizes and purposes, the pieces in a stationery set contain similar, yet slightly different, information.

Letterheads usually contain:

- The company name

- The street address

- City, state, and zip code

- Telephone and fax number

- Internet or web address

Envelopes usually contain:

- The company name

- The street address

- City, state, and zip code

Business cards usually contain:

- The company name

- The street address

Figure 12–2 Use the space at the bottom left of an envelope for a mini-advertisement.

- City, state, and zip code

- Telephone and fax number

- The individual's name

- The individual's title

Depending on the company, the business card may also contain some or all of the following information:

- The individual's voice mail, cell phone, and/ or beeper number

- Internet or web address

- The individual's e-mail address

Design Considerations

Because the business card has the most information placed on it, it is the best place to start designing. The placement of the logo, colors used, type size, type style and size, and layout on the business card will naturally influence the design of the letterhead and the envelope (Figure 12-3). One of the basic design goals of stationery design is to

Figure 12–3 The type style, type size, type alignment, and logo size used in the business card has influenced the layout of the envelope and letterhead. Consistent use of design elements on the pages contributes to the unified look of this stationery set

create a unified, consistent style. For example, if you use a particular size of type in one piece, you should strive to use the same size in the other pieces. This is not always easy given that the dimensions of the three pieces are radically different. Practically, there may be projects where the only way to shoehorn all the required information into the business card is to slightly reduce the size of the type. Many designers feel that some variations among the three pieces are okay as long as the stationery set has a strong sense of continuity—looking like they belong together (Colorplate 28).

Design Zones

There are specific areas where you should and should not place information within each piece of the stationery set. The letterhead, for instance, needs certain areas reserved for correspondence, while the envelope has areas reserved for postal information such as bar codes and postmarks. The shaded area in Figure 12-4 indicates zones where you can place your designs. Even considering these design zones, there are many different possibilities for designing stationery sets (Figure 12-5).

Figure 12–4 Design zones. The shaded areas indicate potential areas in which you can place design elements. The white area on the letterhead indicate the area generally reserved for correspondence, while the white areas on the envelope indicate areas reserved for federal purposes such as postage and bar codes.

Figure 12–5 Three stationery solutions out of an almost infinite number. Notice in the stationery set at the bottom that it is possible to use a large graphic (in this case, a light version of the logo) as a background image. Take care, however, to use a light color or tint in a background image to avoid interfering with the readability of the letter that will eventually cross over the image.

LOGOS AND LOGOTYPES

Logos are combinations of type and graphics that represent a business's, group's, project's, brand's, or individual's identity (Figure 12–6). Logos are created by using typography, images, symbols, shapes, and lines in any combination to express a client's character, product, and style. They should be as simple as possible in order to reproduce well across a wide variety of pages, from newspaper ads to business cards to newsletters. Logos are also informally called logotypes, marks, or trademarks, although technically the terms don't mean exactly the same thing (these are defined later in this section). Logos are present on nearly every product and printed material produced, from pencils to shoe boxes. Designing an effective logo is to visually distill a company's essence into a compact, legible, memorable, and stylish mark. This is not easy and often requires numerous thumbnail sketches and round after round of refinement. The reward of diligent hard work is a design that at a glance expresses the character and essence of the company, organization, product, or individual.

Technically Speaking

There are subtle, technical differences in the meanings of the words logotypes, symbols, pictographs, trademarks. If you don't care to know what they are, then just skip over this section. The graphic design professor in me insists on explaining this technical nitpicky detail. Many designers just clump all of these words into the term "logo."

Figure 12–6 Examples of logos.

- A **logotype** is a name constructed out of unique typography or lettering.

- A **symbol** is a simple sign that represents another thing. For example, a valentine's heart represents the concept of love.

- A **pictograph** is a symbol used internationally to cross language barriers, examples of pictographs are easily found at any major airport (such as the male and female restroom icons).

- A **trademark** (a.k.a. **mark**) is a unique name or symbol used by a corporation to identify a brand or product. Examples of trademarks are the swoosh Nike mark and the eye of CBS.

Design Considerations for Logos and Logotypes

Although it is not uncommon for logotypes to use exclusively special type, many logos use a combination of unique typography or lettering with a distinctive image or symbol to express the spirit of a company. The style of the type and symbol used should fit in with the character of the business, for example, a logo for a medical clinic would look quite different from the logo for a natural grains bread maker. Less common are logos that are just symbols—without identifying type; symbols take longer for people to get used to and to identify with a company or product (Figure 12-7). The success of a symbol logo often depends on not only the appropriateness of the image but also the advertising budget of the company. The larger the budget, the

Figure 12–7 Two versions of a logo: an all symbol logo (left) and a type and symbol logo (right). Logos that use combinations of type and symbols are easier for the viewer to interpret than logos that use only a symbol.

more page space the company can purchase and the more often readers are exposed to the symbol: recognition depends on repetition.

Logos are meant to be reproduced in a wide range of sizes and formats, from very small on business cards to very large on billboards and from cheaply produced one-color flyers to expensive full-color posters. Given those requirements, the best ways to ensure that your logo will reproduce well in many different situations is to keep the design simple and to make the logo work in black and white with very limited shades of gray (fine differences in gray tones are often lost during the photocopying process). The temptation is to design a logo to work in color first; unfortunately, many logos look great in color but are less successful when reproduced in just black. Imagine the dismay of a client when her full color logo turns into a gray, lackluster block when printed only with black ink (Colorplate 29). Do you really want to deal with a disgruntled client? Save yourself a future headache and make sure your logo design works first in black and white. Once you have that base covered, it'll be a home run to make it work in color (and your client can't grump at you, at least not for that reason)!

While working on a logo design, it is a good idea to periodically reduce it in size to see if it is readable at small sizes (approximately ½″ to 1″ in size, about the size it would be used on a business card), and to enlarge it to see if it works at a larger size (approximately 8″ x 8″, or about the size it might be used on a banner). Some designs look great at the larger sizes, but lose legibility when reduced to a small size (Figure 12–8).

Figure 12–8 This logo is legible at the larger size, but the small letters are hard to read at the small size. Good logos must function at very small sizes as well as large sizes.

Logo Design Suggestions

The following list is presented to give you a checklist of logo design considerations. Use them to judge the successfulness of your logo designs. A successful logo should:

- Have clear and legible typography or lettering

- Have an easily recognizable image (if the logo has an image)

- Express the style, spirit, and character of the client

- Be unique from the client's competitors

- Be aesthetically pleasing (it has to look good) or have extreme visual impact

- Have strong negative and positive shape relationships (which will help it reproduce well in black and white and will give it a stronger visual impact)

- Be memorable

- Reproduce well when very small and very big

- Reproduce well in black and white as well as color

FLYERS

Flyers are typically one-sided simple pages advertising a special limited-time offer or a special one-time event. Flyers are also called circulars, because they are meant to be distributed widely ("flying" about or "circulated") and can be seen in a wide range of venues such as:

- Placed on car windshields

- Hung on walls

- Piled on counters

- Wrapped around doorknobs

- Inserted into shopping bags

- Mailed out as a supplemental piece in business correspondence

- Bundled with newspapers, newsletters, and magazines

- Hand distributed

- Even folded and mailed directly to a customer mailing list

Flyers are perfect for advertising a car wash, dog grooming specials, a vitamin sale at the local health food store, an activist's meeting, an appearance of an entertainer at a club, carpet-cleaning specials, and so on. A flyer's main purposes are to attract attention through simple information and motivate readers to act immediately on the offer by informing them of the offer's time limit (Figure 12–9).

Standard Dimensions

Flyers are mass-produced and meant to be seen widely. One way to keep costs down is to base a flyer sheet on standard paper sizes, usually letter $8\frac{1}{2}''$ x 11″, legal $8\frac{1}{2}''$ x 14″, or tabloid 11″ x 17″. By far the most common size is the $8\frac{1}{2}''$ x 11″ sheet. These standard sizes cost less to print and fit standard photocopy machines. For reasons of economy, photocopying flyers is a popular production method.

An even more economical way to produce flyers is to divide a standard size sheet into halves, thirds, or quarters (Figure 12–10). By dividing pages up you can get a lot more flyers for your buck.

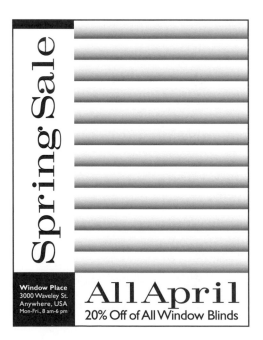

Figure 12–9 This sales flyer uses large type, a designated time span, and an illustration of the product to inform readers about the sale.

Standard Information on the Pieces

Flyers should be as simple as possible to quickly convey the message. Use large type or evocative attention-grabbing visuals to inspire the reader to scan over your message. People are so swamped with paper that unless your flyer is interesting there's a good chance it'll get thrown away. Come to the point quickly using some catchy phrase, image, or coupon to increase the chance that the reader will read and maybe even keep the flyer. Flyers usually have the following information:

- Very large, catchy headline

- An attention-grabbing phrase or slogan

- Strong visuals or graphics to capture the viewer's attention

- Time-sensitive phrase (the limited time offer)

- Coupon (optional)

- The business name

- The business address and phone number

- A fax number, e-mail, or web address, which are optional depending on the business type; for example, an Internet service provider would need to provide e-mail and web address because their customers might like to contact them via these channels.

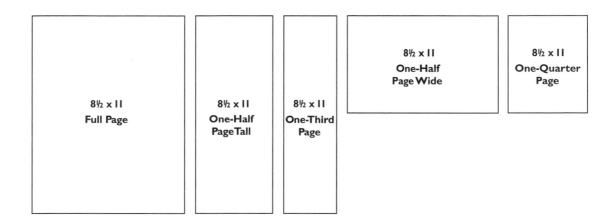

Figure 12–10 Standard flyer sheet sizes.

Design Considerations

Flyers don't always need to have visuals such as illustrations, photographs, or clip art, but in their absence concentrate on interesting and readable typography that presents a concise message. Use type to appeal to the viewers and motivate them to consider taking you up on your offer. Strategically place coupons to make them easy to clip out of the flyer (Figure 12–11).

If you're planning on using a coupon, read and reread the copy to ensure that the text is unambiguous and that there aren't any loopholes in the coupon's offer. Don't leave a coupon offer open-ended; limit the time frame, clearly spell out what products or services are covered by the coupon, and at what location the coupon is

Figure 12–11 Place coupons in a flyer where it'll be easy for readers to clip them. Compare the poor placement of the coupon in the flyer on the left to the good placement of the coupon in the flyer on the right. Optimal placement for coupons is in a corner or the entire top or bottom third of the sheet of paper.

redeemable (Figure 12-12). Repeat your business's name, address, phone number, and slogan on the coupon along with the coupon's offer. It is not uncommon for readers to clip out a coupon, shove it in a pocket, and throw away the body of the flyer, so make sure the coupon is a little microcosm of your flyer. Review the information on the flyer and repeat the essential information on the coupon, albeit at a smaller size.

Coupon Guidelines

Be extremely specific in writing the text for coupons—you don't want to give away the farm by opening up a loophole through vague wording. Coupons should have:

- The value of the coupon's offer (i.e., $2.00 off; 20% off; buy 1 get 1 free)

- An expiration date that includes the year

- Any rules or exclusions for redeeming the coupon

- The company's name, logo, and address where the coupon is redeemable

- Telephone number (optional)

- Company's slogan (optional)

Figure 12-12 Avoid designing coupons like the uninformative one on the left. A well-designed coupon will not only be visually interesting but will spell out the offer, its time frame, the business's logo, address, store times, slogan, and phone number.

Flyers are based on standard paper sizes or fractions of standard paper sizes. Small flyers (quarter, third, or half of a standard paper sheet, usually $8\frac{1}{2}'' \times 11''$) demand that the page is stripped down to only the most essential of information design. You'll have to balance graphics with type while trying to shoehorn in all the information. The goal is to include necessary information without making it look cheap by packing too much stuff on the page. Large $11'' \times 17''$ flyers offer more space for information and a poster-like opportunity for design.

Consider printing flyers on cheaper grade of paper to cut costs. An economical way to simulate two colors in a flyer is to print in one color on colored paper stock. Usually the one color is black, because printers often charge less for black ink, but if you're producing them on a photocopier, you can copy black ink, or for only a few color copies, then a color photocopier or on a digital printer.

BANNERS

Banners are large signs meant to quickly convey a simplified message. They are commonly hung in stores, draped across building facades, strung up in gymnasiums and across bleachers, and dangled from lightposts. Their messages and themes range from grand opening sales to Fourth of July parades to homecoming slogans and beyond.

Sizes and orientation of banners vary, depending on the available hanging space and the proposed reading distance. For example, a homecoming banner, in order to be readable to several hundred people from possibly a football field distance, would be much larger than a banner hung from a ceiling in a store meant to be viewed from a few feet away.

Design Considerations

Banners, because of their simplicity, demand effective use of graphics, type, colors, shapes, and visual elements such as lines. Meant to be viewed from a distance, copy should be short and to the point (Figure 12–13). The fewer the words, the larger they can be, increasing readability from a distance. Small words on a banner are often unreadable from a distance and the message is lost. Type, correspondingly, must

Figure 12–13 Keep the amount of copy in a banner short and make the point size as large as possible. In this banner, the single graphic and large text enhance the style and legibility of the design.

increase in size with reading distance. Try to use less than eight words on a banner, preferably less than six. Use bold sans serif fonts to increase legibility from a distance.

Horizontal banners work best with type because the type can flow naturally across the space, instead of hyphenating or breaking as it would in a vertical space (Figure 12-14). People read type on a horizontal line faster than hyphenated type. Banners with very small amounts of type, however (one to three words), that are meant to be

Figure 12–14 Tall vertical formats result in hyphenated type. Compare the awkward type treatment in this vertical banner with the more graceful type treatment in the horizontal banner in Figure 12–13.

viewed from shorter distance can have a vertical orientation with little loss of legibility. Again, the proportion of a banner depends on the project; if you're painting the banner onto a long roll of paper, then you can make the height and width whatever you desire. If you choose to use a computer, be aware that many photocopy or quick print shops can print black print banners up to 18″ x 48″. If you have a big budget you can print out your full-color file at a computer service bureau, such as what professional graphic designers use, on rolls of paper $3\frac{1}{2}′$ x 12′ or even larger. The printing industry is in the throes of a digital technological revolution and new printers capable of different size prints are coming on the market almost daily. For a clearer picture of what print sizes your local computer service bureau can print, call them and ask. Alternatively, if you are cost-conscious and have only one banner to make, you might try printing your full-size file into "tiles" on your ink-jet or laser printer and then reassemble the pieces and glue them onto foamboard or poster board (Figure 12–15).

A major design consideration with banners is the environment in which they will be hung. Choose colors contrasting with the environment to make your banner stand out. For example, if the banner is to hang across the reddish bricks on a building's front face, then you'd want to avoid a red background in the banner for fear that the color

Figure 12–15 Large banners can be printed out in "tiles" on $8\frac{1}{2}″$ X 11″ paper and then reassembled to form a large banner. The lines on this banner indicate the edges of tiled pages.

would blend into the bricks; a pure white or yellow would contrast better, making the sign more visible from the street. One word of warning here, cities often have very strict regulations about hanging banners and signs on the exterior of a store or building, so make sure you consult a city official before hanging a banner. The fines can be quite expensive if the banners do not conform to city code or if a permit was needed but not purchased. Consult city officials, school officials, landlords, and neighborhood review committees before hanging banners. A little research into the suitability of hanging a banner on an exterior surface might help you keep from wasting time and effort on a project that can't be hung.

POSTERS

Posters are large, single-page formats used to inform readers about schedules, special events, current offerings, or to promote awareness about causes, companies, service organizations, and special places (Figure 12–16). They are displayed in public places and are meant to

Figure 12–16 An example of a special event poster. The playful treatment of the image and type indicates the spirit of the event.

NOTE

Posters are produced in all sizes and proportions. Some of the most common poster sizes are 11″ x 17″, 12″ x 16″, 13″ x 19″, 16″ x 20″, 18″ x 24″, and 25″ x 38″.

be seen from a distance; therefore, information must be easily legible and type and graphics arranged to catch the reader's attention. Good posters often outlive their original purpose—people often hang posters in their offices and homes as decoration alongside photographs, paintings, and prints.

Design Considerations

Posters are primarily displayed in public places and meant to be viewed from a distance by passersby. Therefore, the design must be tailored for maximum legibility from a distance while still communicating the spirit of the message. Text should be simple and concise; images evocative and interesting. Images you use should complement the subject matter and appeal to the proposed audience. A well-designed poster is stylish, legible, communicates the message, and uses imagery pertinent to the subject.

At times poster designs are but one piece of a whole related series of designs, such as t-shirts, baseball hats, coffee cups, or even motion designs. In this circumstance it is extremely helpful for the designer to know ahead of time how many related objects are required, as this may affect the final poster solution. For example, if a designer knows that a poster design will also be presented in a motion design ad banner, she may chose to orient the poster horizontally to better work with the predominantly horizontal format of motion design ad banners (Colorplate 30 and Colorplate 31).

It is inevitable that some posters will have a lot of text to shoehorn into the space. In this situation the best way to cope is to pick out the most essential words, phrases, or sentence and emphasize them, establishing a visual hierarchy of information (Figure 12–17). Use color,

Figure 12–17 The most important words and phrases are emphasized in this poster to convey the meat of the message to the reader as quickly as possible.

alignment, and interesting typography to catch the reader's eye. The intent is to interest passersby in the design long enough that they draw closer to read the rest of the text.

NEWSLETTERS

Newsletters are limited page publications commonly used by businesses to provide business and personnel updates, inform clients about product releases and upgrades, and review business services. Newsletters don't have to be massive multiple-page publications to be effective in updating your mailing list on business activities—often one- or two-page newsletters work great. Smaller newsletters are quick for the recipient to read, and easy to produce. Not too long ago (if you're an old-timer like me) before computers were on every desktop, newsletters were time-consuming and expensive to produce. They were pretty much the realm of the professional graphic designer or the public relations specialist, mostly due to the costs of typesetting and mechanical paste-ups. Nowadays, however, newsletters are easily produced using computers and printed via a number of means, primarily photocopying or quick printed at printshops.

Newsletters are often much more complex than they appear, with multiple elements that must be integrated into a pleasing and readable overall design. The easiest newsletters to design are one- or two-page newsletters. For those who must design—or are contemplating designing—longer newsletters, I advise you to start working on the project earlier rather than later. It takes an amazing amount of time to fit all of the newsletter elements together and make them look good. Keep a steady work pace, organize the varied newsletter elements, and apply the design principles to the task for better newsletters.

Standard Elements in Newsletters

The most consistent, organized newsletters repeat elements from issue to issue. Some of these elements are nameplates, slogans, table of contents box (whose listed contents change reflecting the issue), publication information, and mailing information if the newsletter is a self-mailer. Nameplates are usually located at the top of a newsletter,

TIP

Using a condensed typeface for headlines and subheads will let you use a larger type in the same amount of space.

or even sometimes approximately a third of the way down the page, and occasionally set on their side and placed on the left side of the page (Figure 12–18). Slogans are often incorporated into the nameplate design and treated as one unit with the nameplate (Figure 12–19). Publication information contains the name of the organization, logo, address, and telephone number, so readers can contact the publisher with comments, opinions, or feedback. Mailing information is critical in a self-mailing newsletter and must be accounted for in the design scheme. Leave room for your business's name, logo, and street address, as well as an addressee-mailing label. Other possible elements for inclusion in newsletters are (the content in these elements changes from newsletter to newsletter):

- Short articles, quick facts

- Jokes and short humorous anecdotes

- Quotes

- At least three articles per page (keep articles short for easy scanning)

- Questions and answers sections

- Kudos and awards

Figure 12–18 This newsletter uses a sideways nameplate placement for a distinctive look.

Figure 12–19 (Above) This slogan is an integral part of the nameplate design.

Standard Dimensions

Newsletters come in a variety of sizes, but by far the most common sizes are either a single $8\frac{1}{2}''$ x 11" page printed front and back, or an 11" x 17" sheet folded into four $8\frac{1}{2}''$ x 11" pages. Additional sheets are easily added to the latter newsletter size format by folding additional 11" x 17" sheets; in this manner 8-, 12-, 16-, or 20-sheet newsletters are possible (Figure 12-20). Thicker newsletters, however, take much longer to create and approach in complexity that of a small magazine.

Design Considerations

One common design pitfall that beginners fall into with newsletters is that they try to make every issue look unique. They change around the nameplate; they play with the number of columns and column widths and experiment with different headline and text type in every issue. This rapidly becomes a huge time sink.

A better way to approach designing newsletters is to strive for consistency. Repeat features and elements such as the nameplate, logo, contact information, and table of contents box from newsletter to newsletter, keeping their size and alignment consistent. Pick a size and typeface for the text and another for the headlines and subheads and use them in every issue. Establish a grid structure that clearly defines column widths and page margins. Choose an alignment scheme and zealously stick to it. Strong alignment visually strengthens the body copy, creating clean, organized body copy that is easy for the reader to follow. Strong alignment also makes the whole page look cleaner and planned.

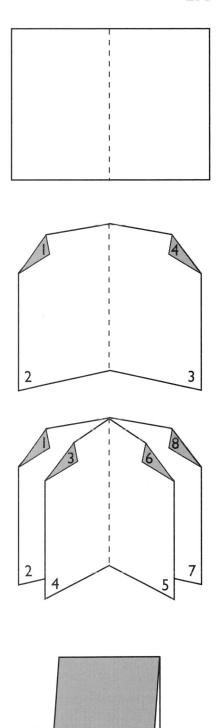

Figure 12–20 How newsletters are folded. The top image is the unfolded 11" X 17" sheet; when folded, the 11" X 17" sheet produces a newsletter with four $8\frac{1}{2}''$ X 11" pages (second from top); an eight-page newsletter uses two folded 11" X 17" sheets (third from top); and, finally, the $8\frac{1}{2}''$ X 11" newsletter is folded in half, resulting in a self-mailer (bottom).

NOTE

Large newsletters that are folded to 11″ x 17″ size from an original sheet size of 22″ x 34″ are called tabloids.

TIP

To test the durability of paper that you're considering using for your newsletter, fold a dummy newsletter out of blank sheets of paper (use the same number of sheets you're planning to use in the newsletter) and mail it to yourself. If the dummy newsletter withstands the rigors of the post office, then proceed with using the paper; if not, then try a thicker paper stock.

NOTE

When using drop caps in a newsletter, try to use no more than three a page. Also, glance at them to make sure that the drop caps don't spell out something embarrassing.

Another important design consideration that you must determine early on in the project is how you'll distribute the newsletter. Newsletters intended for mass distribution are either self-mailers or mailed in envelopes. Self-mailers are folded-in half newsletters whose back page is reserved for mailing purposes; usually the bottom half contains the preprinted business's name, logo, address, with ample space left for postage and addressee label. The ends of the folded-in half newsletter are secured by round stickers holding the paper together. These newsletters usually go through postal machinery in good condition. Avoid, however, using lightweight papers because these papers often arrive in mailboxes rumpled, creased, and sometimes torn. Other newsletters remain unfolded and are inserted into an envelope and sent through the mail.

There are special considerations you should take into account when designing each type of newsletters. Self-mailers avoid the cost of an envelope, but you'll have to avoid putting editorial content on the bottom half of the back page of a self-mailing newsletter because that space must be reserved for mailing purposes. Some visual impact is lost by the viewer having to unfold the newsletter to view the nameplate and the front page.

You'll also need to ensure that enough circular stickers are applied to secure the loose edges of the folded newsletter so that it will travel smoothly through automated postal machinery. Usually, one works fine but lighter weight paper stocks may require two, one near each end. One sticker used with lightweight paper stock runs the risk of the ends splaying out and potentially creasing or even ripping.

Newsletters mailed in envelopes cost a little more, but they have the advantage of presenting a full, unfolded, full-page view of the front page. There is more editorial space available because, unlike the self-mailer, no portion of the back page must be reserved for mailing information. The sealed envelope also allows for the inclusion of small or odd-sized objects such as coupons, stickers, tickets, or product samples more practically than a self-mailer.

RÉSUMÉS

Résumés are pages summarizing an individual's achievements including education, career, and activities. Intended for quick reference by prospective employers, résumés should optimally be one page but no more than two pages in length. Any more pages than that and prospective employers begin to suspect résumé padding at work.

Résumés are fairly tedious documents for employers to scan. They are typically fact-filled summaries of an individual's work history, and are inherently dry and business-like in nature. Their purpose is not to entertain or to amuse, simply to convey essential career information. To make reading your résumé less of a chore, apply the design principles to the typography and layout on the page, especially the principles of alignment and emphasis. Use plenty of white space, subheads, and visual elements such as boxes and lines to organize the page and to establish a clear visual hierarchy. Clear organization will assist a potential employer to focus in on the information pertinent to their requirements. Résumés that lack clear organization force prospective employers to wade through the text—and, frankly, many of them simply won't do it.

Consistent alignment schemes are especially important in résumés. Strong alignment creates a clean line that the reader's eye can follow through the page. The strength of the layout also visually speaks of your organizational skills and improves the overall impression of the page. Avoid using centered type in résumés. Centered type almost always looks formal and the irregular edges make the type look weak. Closely inspect the résumé for the smallest errors in type alignment and spacing as well as for more serious errors. Regard the résumé as a mini-advertisement of your skills and proofread it carefully.

One final note about résumés: Always, always check spelling. The résumé is often your only chance to communicate your qualifications to a prospective employer—misspelled words do not attest to quality and attention to detail.

TIP

Organize the résumé into distinct keyword sections such as Education, Skills, Employment, Honors and Awards, Present Position, and so on. Using keywords emphasized as subheads helps readers quickly locate categories of interest to them.
Use keywords that relate to the position you are applying for; for example, a graphic designer might use instead of the generic category Skills, the keywords Computer Skills.

BOOK JACKETS

Book jackets come in a wide array of sizes, topics, and visual solutions. Since books cover an incredible range of topics, they allow the designer exciting opportunities for exploration, innovation, and creative latitude. They can be simple, complex, experimental, limited in color, or multicolor. Most book jackets are a mix of type and image (Figure 12–21); however, there are all-typographic jackets, illustrated jackets, and photographic jackets. No matter the visual style, successful visual solutions tie in with the content and topic of the book and encourage the consumer to pick up and thumb through the text.

Many books are single products and allow for distinctive, stand-alone designs, while others may be part of a series constrained by an established series style. The cover functions under many of the same design requirements as a poster in that it must be successful from a distance as well as at arm's length. Whether a consumer decides to

Figure 12–21 Most book covers, like this one, are a mix of type and imagery. *Credit, Curt Fain.*

pick up a book in a bookstore depends on the attractive visual quali-
ties of the cover; consumers often make that decision while still
approaching the bookrack. Competition is fierce in the book indus-
try, so the visual appeal of a book jacket is a critical sales tool. In gen-
eral, the book front cover is designed for eye appeal, while the back
cover displays informative copy highlighting the content of the book.

Design Considerations

Given the incredible creative latitude with book jacket design, it is
nearly futile to define a series of hard and fast rules. The fierce com-
petition drives designers to break rules with the intent of achieving a
distinctive product. Furthermore, each publisher has its own set of
requirements and conventions, so before attempting a book jacket
design it is necessary to inquire about job parameters such as size,
number of colors, budget, and so on. Possible limitations on a jacket
design include whether the book is a first, second, or third, etc., edi-
tion, for first edition covers establish an identifiable look for the text
that most publishers are reluctant to drop in subsequent editions. This
is not to say that publishers wouldn't entertain experimental or inno-
vative solutions to any edition's book jacket. Often publishers, despite
their requirements, are eager for new and unique visual solutions as a
way to increase sales and to present a fresh, updated look. Designers
commonly present a small pool of jacket choices to the publisher
(Colorplate 32), allowing for the presentation of a range of possible
solutions, from safe to edgy and everything in between.

 Despite the wide range of visual solutions in book jacket design, a
survey of book jackets in a shop reveals some common characteris-
tics. Front covers typically display the book title and author's name;
back covers contain descriptive text about content; spines list title,
author, publisher logo; and imagery communicates important infor-
mation about the text. Books that are part of a series often have the
series name or logo and standardized design elements that visually
mark them as part of the series. Coordinating designs across a series
of jackets means establishing a consistent style in layout, type choice,
colors, and image choice (such as all covers using photos or all covers
using illustrations). Designing for a series of book covers involves
consideration of the item both as an individual text and as part of an
identifiable series. Selecting typefaces and images that will work

across a complete series of books involves considerable forethought. Along those same lines, a book that is bundled with an accompanying CD should have a common visual style (Colorplate 33).

In any book, whether it is part of a series or not, typeface and image choice must visually work together to convey a message about the book's content and the designer's concept. As the cover is in essence a mini-poster, typeface and image choice are the designer's primary tools in establishing a visual look that is informative and an effective sales tool. Successful solutions for book jackets will be visually appealing, stand out from the competition, and convey a strong sense of the book's content.

CD COVERS AND LABELS

CD covers perform many of the same functions as a book cover, and for the same competitive reasons. Like book covers, they must be visually attractive, communicate a sense of the contents, stand out from the competition, and display critical title and author information. In the case of software CDs, compatible platforms and requirements are commonly listed on the cover, while a music CD's cover displays imagery evocative of musical style. Like book covers, possible visual solutions range from illustrative to photographic to typographic to a mix of type and image. Unlike book covers, music CD covers often feature some image specific to the band or author: a photograph, a portrait, or a band's logo. Music CDs, because of the wide variety of musical styles, offer opportunities for designers to focus on creative and experimental illustration. Many recording covers become collectors' items not only for the content of the recording but also for the cover illustration. Additionally, recordings that coordinate with a concert series may spin off into one or more posters.

Design Considerations

Two important criteria for CD covers are that they must be attractive and visually express a sense of the CD's content. Coordinating the typography and visuals on the CD cover, label (Figure 12–22 and Figure 12–23), and pamphlet (if present) is imperative. As mentioned previously, when a CD accompanies a book, the visual style of the CD and book should coordinate.

Figure 12–22 This CD label lists platform compatibility. Note how it coordinates with the CD cover in Figure 12–23. *Credit, Curt Fain.*

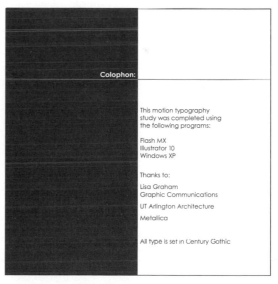

Figure 12–23 The figure on the left shows the front panel of a CD cover, while the figure on the right shows the inside panel. The design style coordinates tightly with the visual styling of the contents of the CD (not shown) and with the CD label depicted in Figure 12–22. *Credit, Curt Fain*

SUMMARY

No matter what type of page you are designing, whether it is a flyer, poster, newsletter, résumé, or so on, it is important to remember the purpose of your page and your audience. The most visually exciting page can fail to communicate a message if too much emphasis is on producing a "cool" page rather than a page that speaks to your audience. It's easy to get caught up in arranging the visual elements on the page: moving around type, graphics, and experimenting with layout and alignment. Step back once in a while, however, and ask yourself, "Does the design work?" "Does it say what I want and need it to say?" and, most importantly, "Will my audience be attracted to the page and understand the message?"

EXERCISES

Exercise 1

This exercise will help you learn how to create simple symbols or icons. Choose a word from the list below and create four separate and distinct symbols that visually depict the meaning of the word. Create the design in black and white only, no gray or color. Try to develop simple, clear, and attractive symbols.

eye	light bulb
hand	automobile
man	woman
tree	

Exercise 2

Invent a name for a pet grooming company. You can be as creative as you want with the name; the exact words are your choice. Design a logo for the pet grooming business. Your logo can be an all-typographic solution, or it may be a combination of type and symbol. Do at least 20 thumbnail sketches, then select two of the better sketches and develop them into roughs. Select the better of the two roughs and create the final comp.

Part of deciding how a logo should look is determining what the overall spirit of the business is and what sort of clientele they service.

You'll need to decide if the company is a formal company that pro-vides service to an exclusive, dignified, perhaps very wealthy clien-tele, or if it is an informal company that grooms the pets of everyday, ordinary people. Does the company groom dogs and cats, or will they also groom exotic pets? Will the company also sell grooming products and pet supplies, or do they only groom animals? Write down your thoughts on the spirit of your invented company, then proceed with designing the logo. Jotting down your thoughts on paper will help you plan your visual strategy for designing the logo. Focus your efforts on formulating a logo that you like because the next few projects are based on your logo and business concept.

Exercise 3

Design a stationery set for the pet grooming company. Use the logo you created in Exercise 2, and create a business card, letterhead, and envelope for the company. Make up the address, telephone, fax, and contact person's name for the set (consult the stationery set section of this chapter to determine exactly what goes on each piece). Exper-iment with alignment, contrast, and emphasis, with an eye on achiev-ing a consistent look and style among all three pieces. Do at least 20 thumbnail sketches to help you try out your various design ideas. Consider the effect colored paper could have on a stationery set design.

Exercise 4

Design an $8\frac{1}{2}''$ x $11''$ sales flyer advertising 20% off all pet grooming for a week span. Use the logo and the address you developed in the previous two exercises, and write appropriate copy to support the concept. Use imagery if it adds to your concept.

Consult the section "Hints for Effective Copywriting" in Chapter 1 for ideas in fleshing out the copy for this assignment. Do at least 20 thumbnails that rough out the flyer's layout before settling on a final design for the comp. Generate the final comp using any media of your choice, including markers, colored pencils, pens, pencil, or a comput-er and printer.

Exercise 5

Rearrange your flyer design and add in a coupon—with the offer of your choice. Make sure to specifically limit the coupon's offer in order to not "give away the farm" with an ambiguous or open-ended coupon.

Exercise 6

Find a newsletter, and redesign the newsletter's nameplate. Concentrate on the principles of contrast and emphasis, and use at least two different typefaces in the redesigned nameplate, choosing from a serif, sans serif, and/or decorative font. Do at least 20 thumbnail sketches that explore size, placement, color, and value before creating the final comp.

Exercise 7

Using the newsletter you found for Exercise 6, redesign the newsletter. Analyze the existing grid and reuse it as the skeleton for your design. Add in any imagery you feel is necessary to support the topics of the articles. Use the nameplate you designed in Exercise 6 in the new newsletter. Select one of the typefaces from the nameplate design and reuse it in your newsletter design in the headings and subheads. When necessary, sprinkle in rule lines, triangles, dingbats, or other visual elements to enhance the principles of repetition and flow in the newsletter design. Focus on the flow, balance, repetition, and contrast of the elements in the newsletter. Sketch as many thumbnail sketches as you feel are necessary to arrive at a workable design solution. Produce the final comp either on the computer or use markers, colored pencils, or pens to mock up the newsletter. Here's a hint. If you're drawing your comp out by hand, replace the body copy with a simple line. Don't spend eons carefully hand lettering 8 point body copy. Just draw a line that simulates the height of the body copy and how wide you want the columns, and spend your time lettering out the headings and subheads.

Exercise 8

Identify a special event such as a music festival, fund-raiser, parade, holiday, or theater production and design two posters advertising the event. Copy on the poster should include the name of the special event; dates, time and location; and any other special information pertinent to the specific event such as if there is a special speaker or celebrity, or if interested individuals must purchase tickets beforehand, and so on. Design one version of the poster where the concept of the poster is conveyed primarily through images. Design the second version of the poster where you use typography, focusing on the color, size, weight, placement, and typeface choice to convey the concept. Do at least 20 to 50 thumbnails before creating a final comp. Final poster designs are typically limited by the environment in which they are viewed, but for convenience sake, keep the posters to no larger than 18″ x 24″. This is large enough to explore the larger size formats of posters without becoming unwieldy in your workspace.

Exercise 9

Drawing on the topic and poster designs you created for Exercise 8, create a series of two to four banner designs for the special event. The sizes of banners, like posters, are usually dictated by the concept and environment in which they are viewed. For this exercise, limit the size of the banners to, again, no larger than 24″ in any dimension (for instance, your banner size might be 14″ x 24″ or 24″ x 10″ or any other combination of sizes, just no larger than 24″ tall or high). Few banners, by the way, are square; they are usually tall and thin or long and thin. Do at least 20 thumbnail sketches for the banner series.

Exercise 10

Optional: special events sometimes have special flyer, nametag, and ticket designs. Design at least one of each of these pieces for your special event. Do at least 20 to 40 thumbnail sketches.

Exercise 11

This exercise uses visual research as a means of enhancing your awareness of book covers. Visit your local bookstore or library and find at least one example of the following types of book covers: type and image, illustrated, and photographic. Glance through the contents of the book. Does the visual style of the book cover seem appropriate with the contents of the book? Does the cover give you, the viewer, a strong and accurate sense of what this book is about? Were you drawn to this book cover? Is it visually attractive? Make a mental note of which style you prefer and why. Be prepared to discuss it, if needed.

Exercise 12

Select a book of your choice and redesign its book cover. Instead of recycling the imagery on the existing book cover, locate and use images that you feel support the style and personality of the contents of the book. Size, visual style, and color should be appropriate to the book. Sketch at least 20 thumbnails before working on your final comp. Be prepared to discuss and justify your visual solution: consult the critique guide in Chapter 13 to assist in clarifying your thoughts.

Exercise 13

Repeat Exercise 11, except this time you're researching CD covers. Note the differences, if any, between visual styles in music CDs and data CDs (such as software CDs). Again, be prepared to discuss your thoughts.

Exercise 14

Invent a musical group, or select an existing one, and design a music
CD cover and label for one of their CDs. If you made up the band for
this project, then listen to an existing band's music whose work is sim-
ilar to what you envision as your band's style. If the band you choose
is an existing one, then listen closely to their music. Write down any
concepts or imagery that comes to mind. Locate support imagery that
correlates with your notes and impressions about the band. Sketch at
least 20 thumbnails before working on your final comp. Explore a
wide variety of concepts in your sketches—music CDs offer great
opportunities for expressive potential, so push your design concepts.
It is important in this exercise that the CD cover and the label look
like they belong together as part of a series.

Chapter 13
Tools and Resources

OBJECTIVES

- Boost your ability to critique your own work—and see it with an informed eye based on stronger design sensibilities.

- Survey a pragmatic list of what typical design tools are necessary to get started in designing pages.

- View various industry standard software packages with descriptions of what they do with an eye towards your own potential needs.

- Become acquainted with image, type, and literary sources for further consideration and study.

This chapter contains a variety of resources you can glance at to garner more information about critiquing your work and others; what kind of design tools you'll need to pursue designing your own pages; a listing of design software; and useful books.

CRITIQUE GUIDE

When you critique a page, you are evaluating the success and merits of a solution. Critiquing your projects as well as other people's projects forces you to step back and look at your work with new eyes, to reexamine the success of the solution. Ask yourself these questions when you are assessing your project. What are the

purpose and goal(s) of the page? Does the page fulfill those purposes and goal(s)? Who is the proposed audience for the page? Does the page communicate to that audience in words or visuals that they would understand? For example, if you are creating a company report on quarterly financial losses, it would be grossly inappropriate to use playful balloon and ribbons graphics. When in doubt, ask a friend or colleague if he or she understands the message. Do the type and images support the page's concept? Is the type easy to read? Is the page attractive, legible, and readable? Did you use the design principles? Is the page's style, color, size, and format suitable? Is the page well crafted and presented professionally? Do not underestimate the importance of good craft—making sure everything is neat and clean, with all visual elements aligned that are supposed to be aligned. You want people to notice the message, not be distracted by a poorly constructed page.

Critiquing your own and others' work is a process that becomes easier with practice. The more you critique, the more critique questions will occur to you and the more you will learn. You'll start to notice that you are drawn to particular styles and solutions more than others, and perhaps even strive to include the strengths of that style into your own work.

TYPICAL DESIGN TOOLS AND TECHNOLOGY

Years ago, graphic designers spent most of their work time at a drawing board using traditional tools like markers, ruling pens, technical pens, T-squares, triangles, rulers, and X-acto knives. These are still valuable tools that have a place in the page designer's bag of tricks, but nowadays, most page designers create the majority of their work on a computer. Virtually everything that can be created by hand can be created on a computer. Powerful software packages offer special effects virtually impossible to achieve by hand or that are so time-intensive that most people balk at the thought of dedicating days to drawing a special effect so easily achievable on a computer.

There are two types of computers in use by graphic designers: Apple Macintosh and personal computers. Most professional graphic designers use Macs because of their powerful graphical interface and

long-term use as a graphics industry computer, although PCs now offer similar power and a picture-oriented interface. Either computer will work for both the every-so-often page designer and the professional graphic designer. In general, more software is made for PCs than Macs (especially games), but major graphics software manufacturers such as Adobe and Macromedia make design programs for both platforms.

What Will You Need to Get Started Designing Pages?

Hand Tools

- Sturdy drawing board or drafting table

- Paper to sketch ideas on, either tracing or plain white paper (don't use ruled or lined paper because the lines inevitably seem part of the design)

- Assortment of soft black pencils and colored markers to use for your sketching

- Pencil sharpener

- Stainless steel ruler, preferably 18″ or longer (a large enough ruler that you can use to measure items on an 11″ x 17″ tabloid paper)

- Several triangles of different sizes and angles

- Compass and protractor set to draw circles

- T-square

- Low-tack masking tape or drafting tape (to tape pages to board while you're drawing on them)

- Clear magic tape

- Good, clean, plastic eraser (I like the big pink ones)

- Craft knife such as an X-acto and plenty of fresh, new blades

- "Self-healing" cutting mattboard (to prevent scarring surface of drafting table)

- Assortment of different colors and weights of papers

- Rubber cement and a glue stick

- Black, white, or grey mattboard (to mount pages on in case you need to present the page formally to a committee)

- Spray adhesive to mount pages onto mattboard (NEVER, NEVER use spray adhesive in an enclosed space; use in a well-ventilated area, lay down plenty of newspapers to protect the surroundings from overspray, and NEVER breathe the adhesive spray in because the fumes are very dangerous! I mean it!)

Computer and Software

- Computer

- Scanner to scan artwork, photos, and so on

- Printer

- Drawing program such as CorelDraw, Illustrator, or Freehand

- Page layout program such as InDesign, or QuarkXPress

- Image manipulation program such as Photoshop or Photoshop Elements

- Font and clip art CDs

DESKTOP PUBLISHING SOFTWARE

The variety of desktop publishing software available is staggering. A trip to the local computer store will reveal a bewildering array of design and publishing software. The software listed in this section is some of the best. I've omitted software version numbers because the software industry is always churning out updated versions of the software. When buying software, try to buy the latest version (information easily obtained by walking down the aisles of a computer store), or the second to latest version (sometimes available at used computer stores).

Adobe Photoshop

345 Park Avenue, San Jose, CA 95110-2704, (800) 833-6687, (408) 536–6000, Fax: (408) 537–6000, www.adobe.com

The graphic design industry standard software for photo-editing and manipulation.

Adobe Photoshop Elements

Elements is a simplified version of Photoshop and is very usable for beginners.

Adobe Illustrator

A professional level illustration program for use in print, web design, and presentations. It is very powerful and files are easily transported into Photoshop for further image manipulation. Adobe Illustrator is widely used by graphic designers.

Adobe InDesign

Very powerful page layout program that can handle a wide variety of word processing and image files. InDesign is suitable for multiple-page publication projects such as newsletters, magazines, and books.

Canvas

ACD Systems of America Inc., 1150 NW 72 Avenue Suite 180, Miami FL 33126, (305) 596–5644, Fax: (305) 406–9802, www.deneba.com

A well-rounded collection of tools for design, illustration, photo-editing, page layout, and web publishing. The program is surprisingly cheap, and ACD is pretty good about running price break specials periodically on the product. Actually, given the flexibility and power of Canvas, I'm surprised more professional graphic designers don't use it. Web and Internet page designers are cannily picking up on the flexibility and affordability of this product and are using it more and more.

CorelDRAW

Corel Inc., 8144 Walnut Hill Lane, Suite 1050, Dallas, TX 75231, (800) 772-6735, www.corel.com

A graphics program that includes illustration, photo-editing, and page layout tools. An economical and powerful graphics program.

Corel Print House

A home publishing software program with templates to produce greeting cards, calendars, banners, labels, and so on. It is a great product for people with the occasional need to create a page but who do not want to spend extensive amounts of money on a professional graphic software program.

Corel Painter 8

Painter is a digital imaging program that emulates the look of handmade art like paintings, drawings, watercolors, inks, etc. The program is complex with many layers of features, but rewarding to learn, and even more rewarding to make cool images that look like real images without the mess.

Jasc Paint Shop Pro

Jasc, 7905 Fuller Road, Eden Prairie, MN 55344, (952) 934–8888, Fax: 952-930-9172, www.jasc.com

Paint Shop Pro is a digital imaging and photography program with capabilities for print and for web.

Macromedia FreeHand

Macromedia, Inc., 600 Townsend Street, San Francisco, CA 94103, (800) 470-7211, www.macromedia.com

A professional level program for use in print, illustrations, and presentations.

QuarkXPress

Quark, Inc., 1800 Grant Street, Denver, CO 80203, (800) 676–4575 (within the United States), (307) 772-7100, www.quark.com

QuarkXPress is a professional page layout program for creating advertisements, reports, books, newsletters, catalogs, and more.

CLIP ART AND TYPE SOURCES

Dover Publications

Dover Publications, 31 East 2nd Street, Mineola, NY 11501–3852, Fax: (516) 742-6953, www.doverpublications.com

Dover publishes an extensive collection of clip art books, some with CDs. Dover is a classic source of economical clip art for graphic designers.

Fonts.com

www.fonts.com

This site offers a wide variety of fonts by major type manufacturers, along with useful links to a variety of graphics resources, including links to free font sites.

Getty Images

www.gettyimages.com

Getty Images is a major source of illustrations, photos, film, and archival images for professional graphic designers. The site is incredibly rich with many exciting collections of professional images.

IMSI HiJaak PhotoART

IMSI, Inc., 100 Rowland Way 3rd Floor, Novato, CA 94945, (800) 833-8082, Fax: (415) 897-2544, www.imsisoft.com

A collection of web graphics, animations, photos, and sound clips for Mac or PCs.

Nova Development Art Explosion

Nova Development Corporation, 23801 Calabasas Road Suite 2005, Calabasas, CA 91302-1547, (818) 591–9600, Fax: (818) 591–8885, www.novadevelopment.com

Nova offers a product line of comprehensive clip art collections for both Mac and PC. What I really appreciate about their products is that they offer a printed catalog of images to accompany the clip art CDs, making it much easier to locate the image that you need.

USEFUL BOOKS AND MAGAZINES

There are lots of good books and magazines out there that explore typography, layout, design, desktop publishing, and advertising in further detail. This is my short list of the books and magazines I've found the most useful over the years. They're presented in no particular order. Just peruse and see if anything appeals to you.

Ames, Jim. *Color Theory Made Easy*. New York: Watson-Guptill Publications, 1996.

A fine artist's guide to color that nonetheless provides a good foundation understanding of color mixing and color theory.

Beach, Mark, and Kenly, Eric. *Getting It Printed: How to Work with Printers and Graphic Imaging Services to Assure Quality, Stay on Schedule and Control Costs,* 3rd ed. Cincinnati, Ohio: North Light Books, 1999.

This excellent book delivers exactly as promised in the title.

Berry, Susan, and Martin, Judy. *Designing with Color: How the Language of Color Works and How to Manipulate It in Your Graphic Designs*. Cincinnati, Ohio: North Light Books, 1991.

An information-packed introduction to color that shows you how to achieve just the right look and feel you want.

Bruno, Michael H. *Pocket Pal: A Graphic Arts Production Handbook,* 17th ed. Memphis, Tenn.: Graphic Arts Technical Foundation, 2004.

A concise guide to graphic arts production.

Cohen, Sandee, and Williams, Robin. *The Non-Designer's Scan and Print Book*, Berkeley, CA: Peachpit Press, 1999.

This book is an excellent resource on how to take designs through the production and prepress stages.

Communication Arts Magazine, Menlo Park, CA: Coyne & Blanchard, Inc.

Communication Arts is an excellent visual resource for students and professional designers alike. The magazine commonly features up-to-the-minute advertising design, graphic design, and interactive design. The work featured in its design annuals on illustration, photography, interactive design, and design are awe-inspiring, and yes, even a little depressing to those of us who are average joe-schmoe designers. The web site is www.commarts.com.

Eiseman, Leatrice. *Pantone Guide to Communicating With Color*. Cincinnati, Ohio: GrafixPress Ltd., distributed by North Light Books, 2000.

This book discusses the psychology of color and is accompanied by lots of color combinations and examples.

HOW Magazine, Cincinnati, OH: F&W Publications, Inc.

Another excellent magazine resource featuring contemporary graphic design, advertising design, and multimedia design. Its annual self-promotion design issue showcases the incredible diversity of creative marketing and self-promotion. Its website is www.howdesign.com.

Landa, Robin. *Graphic Design Solutions*, 3rd ed. Clifton Park, N.Y.: Thomson Delmar Learning, 2005.

A thorough overview of graphic design and advertising. Lots of photographs of professional graphic design projects by well-known designers. Landa really knows her stuff and knows how to pass her knowledge along to the reader.

Photoshop User, Dunedin, FL: The National Association of Photoshop Professionals.

This magazine focuses on all things Photoshop, including practical tips and tricks. Want to learn something neat about Photo-

shop? Buy this magazine and work through one of its many tutorials for a fast sense of achievement. The website is www.photo-shopuser.com.

PRINT Magazine, New York, NY: F&W Publications.

Articles feature contemporary and historical designers, contemporary design issues, and design research. Of interest to beginners are *PRINT*'s annual student cover design competition, and its New Visual Artists Review: 20 under 30. The web site is www.printmag.com.

Spiekermann, Erik, and Ginger, E. M.. *Stop Stealing Sheep and Find Out How Type Works*, 2nd ed. Mountain View, CA: Adobe Press, 1993.

A very entertaining and informative tour of type. Type is explained in everyday language, with clear explanation of how to select and use type to improve communication with the reader.

Glossary

Accents: The secondary, tertiary, and so on, focal points in a layout that accent other important points in the page.

Alignment: The visual connection among words, shapes, graphics, images, and lines on a page when their edges or axes line up (align) with each other. A major design principle whose use dramatically improves the organization and professional appearance of a page.

All caps: Abbreviation for "all capital letters."

Asymmetric: A typographic composition form in which the lines of type are set in an irregular shape with few, if any, of the text lines aligning with each other.

Asymmetrical balance: A layout in which the visual weights of visual elements are distributed on the page to achieve a harmonious balance.

Balance: The equal distribution of the visual weight of elements on a page in order to achieve a pleasing and clear layout. Pages may be symmetrically or asymmetrically balanced.

Banners: Large signs meant to quickly convey a simplified message typically hung in stores, draped across building facades, strung up in gymnasiums and across bleachers, and dangled from lightposts.

Body copy: The small type that carries most of the information in ads, flyers, brochures, newspapers, and so on. Other names for body copy are body text, text type, or simply body. Body copy commonly ranges from 8 to 12 points in size.

Centered: Lines of type whose midpoints are aligned and right and left edges are allowed to flow naturally ragged.

Closure: The gestalt principle that draws on the natural human tendency to visually close gaps in forms, especially familiar forms.

Comprehensive (comp): A very detailed, polished mock-up of a page design, used to present the page design to a client.

Concrete: Type alignment in which the text is shaped into a form or object.

Content: The words and phrases and graphics on a page.

Continuation: Continuation occurs when the eye follows along a line or a curve, even when it crosses over negative and positive shapes.

Contrast: The design principle of contrast states that visual elements on a page should look distinctly different from one another. Contrast is used to add visual interest to your layouts and to keep everything on the page from looking alike.

Copy: The written text on the page, including all headlines, subheads, body text, picture captions, pull-quotes, and so on.

Cropping: The removal of some of the horizontal or vertical edges of a picture.

Dingbats: A font in which small ornamental pictures are substituted for letters.

Emphasis: The design principle of emphasis states that the most important element on the page should be the most prominent, the second most important element should be second to the most prominent, and so on.

Figure/ground: A fundamental gestalt law of perception that helps us visually identify objects (figure) as distinct from their background (ground).

Flopping: Changing the direction of an image making it a mirror image of the original.

Flow: The visual and verbal path of movement (the order) in which the reader's eye tracks through a page or pages. A major design principle.

Flush left: Text aligned on the left while the right edge is allowed to flow naturally into a ragged edge; also called left aligned or, classically, flush-left/ragged-right.

Flush right: Text aligned on the right while the left edge is allowed to flow naturally into a ragged edge; also called flush right, align right, right or, classically, flush-right/ragged-left.

Flyers: One-sided simple pages advertising a special limited-time offer or a special one-time event.

Focal point: The visual element or part of a page that is most emphasized and that first attracts and holds the reader's attention.

Font: All the characters (letters, numbers, caps, small caps, and symbols) in a typeface at a specific point size.

Format: The size, shape, and function of a design. Different kinds of projects are different formats (a business card at $2''$ x $3\frac{1}{2}''$ is considerably different in format from a poster at $16''$x$20''$).

Gestalt: A structure, configuration, or layout whose specific properties are greater than the simple sum of its individual parts.

Grid: A nonprinted system of horizontal and vertical lines that divide the page and help the page designer align elements consistently.

Justified: Type whose left and right edges are aligned. Justified type is also classically called flush-right/flush-left.

Kerning: Adjustment of the space between two individual letters to improve appearance.

Layout: The placement (the design) of visual elements—headlines, body copy, images, lines, and so on—in the page.

Leading: The vertical space between lines of type.

Legibility: How easy it is to identify text in short phrases such as headlines, signs, slogans, and so on.

Letterspacing: The space between individual letters and characters.

Logos: Combinations of type and graphics that represent a business's, group's, project's, brand's, or individual's identity.

Logotype: A name constructed out of unique typography or lettering and used to represent a business's, group's, project's, brand's, or individual's identity.

Nameplate: The area usually at the top of the front page of a newsletter that holds the newsletter's title in a designed type treatment.

Newsletters: Limited page publications, typically four, eight, or twelve pages, used by businesses, nonprofit organizations, or groups to provide business and personnel updates, inform clients about product releases and upgrades, review business services, and review the activities and successes of the organization.

Pica: Traditional layout unit of measurement: 12 points equal 1 pica, and 6 picas equal an inch.

Pictograph: A symbol or icon used in international signage that is intended to cross language barriers.

Points: Traditional type measurement system. There are 72 points to an inch.

Posters: Large, single-page formats used to inform readers about schedules, special events, current offerings, or to promote awareness about causes, companies, service organizations, and special places.

Proximity: Items that are spatially located near each other seem part of a group.

Pull quotes: A sentence or two "pulled" from the text and set in a larger point size than the body copy and placed in the text column or in a margin.

Readability: How easy it is to read lots of text: sentences, paragraphs, and pages of text.

Repetition: The design principle that states that repeating lines, shapes, images, colors, textures, and other visual elements within a layout helps establish a unified, cohesive design.

Roughs: A refined version of the original thumbnail sketch, usually half size or full size. Roughs are constructed with an eye toward refining the layout, typography, placement, and overall concept of the original thumbnail sketches. An intermediary step between the first crude ideas of a thumbnail and the refined polish of a comprehensive.

Runaround: Lines of type that wrap around a photo, image, graphic, or some other element. Some computer programs call this option text wrap.

Sans serif: "Without serifs." A style of typeface without serifs.

Script: A style of typeface with flowing letter-strokes.

Serif: The little ending stroke on letterforms that sticks out from the bottom or top of a letterform.

Silhouetted photo: An image or photo with portions selectively removed (not strictly horizontal or vertical portions as in a cropped image).

Similarity: The gestalt principle that asserts that we see visual elements that are similar in shape, size, color, direction, and motion as part of a group.

Square serif: A category of typefaces in which the serifs are shaped as slabs or squares.

Stationery sets: Letterheads, business cards, and envelopes. Also called business identity sets, corporate identity sets, or business systems.

Symbol: A simple sign or icon that represents another thing, for example, a dove represents the concept of peace.

Symmetrical balance: A layout in which visual elements are placed in such a way as to create a mirrored image from side to side or top to bottom.

Thumbnails: Small, quick exploratory sketches created by designers in order to rapidly generate and capture ideas.

Trademark (a.k.a. **mark**): A designed name or symbol used by a business or a corporation to identify a brand or product.

Typeface: A set of letterforms, numbers, and symbols unified by a common visual design.

Type family: A whole related group of type styles (such as italic, bold, condensed, expanded and so on) based on a single typeface.

Type style: Modified versions of a typeface such as italic, bold, condensed, or extended.

Typography: The art and process of skillfully arranging type in a layout.

Unity: Unity is achieved when all of the lines, shapes, images, headlines, body copy, and objects on the page look like they belong together.

Visual elements: The individual objects on the page. Lines, shapes, images, headlines, body copy, and anything else on the page are visual elements that help you build your design. Elements can be individual objects, such as an image, or a group of objects that are close enough together that they are perceived as a single element (such as a grouping of body copy).

Visual hierarchy: The arrangement of visual elements such as type, shapes, graphics, lines, and objects on the page according to their order of emphasis.

Visual weight: The illusion of physical weight of an element on the page. A bold headline, for example, will have more visual weight than the author's byline.

White space: The space in the page that does not contain visual elements such as text, images, shapes, or lines.

Word spacing: The space between words.

Index

A Final Thought.

history

yesterday is

mystery

tommorrow is a

today is a gift

the present

that is why it is called